MW00783366

COLOUR IN CLAY

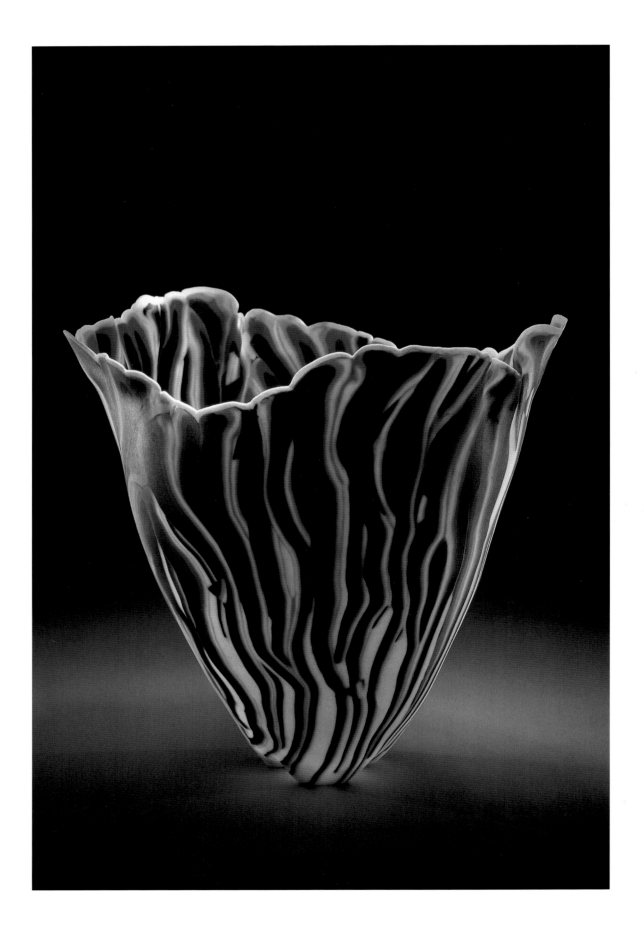

Colour in Clay

Jane Waller

The Crowood Press

First published in 1998 by
The Crowood Press Ltd
Ramsbury, Marlborough
Wiltshire SN8 2HR

www.crowood.com

This impression 2006

© 1998 Jane Waller

All rights reserved. No part of this publication may
be reproduced or transmitted in any form or by any
means, electronic or mechanical, including
photocopy, recording, or any information storage
and retrieval system, without permission in writing
from the publishers.

British Library Cataloguing-in-Publication Data
A catalogue record for this book is available from
the British Library.

ISBN 1 86126 136 5
EAN 978 1 86126 136 6

Photograph previous page: *Black Tulip*, by Curtis
Benzle.

Typefaces used: text and headings, ITC Giovanni;
chapter headings, ITC Tiepolo.

Typeset and designed by
D & N Publishing
Lambourn Woodlands, Hungerford, Berkshire.

Printed and bound in Malaysia by Times Offset (M)
Sdn Bhd.

Dedication

Colour in Clay is dedicated to the contributors them-
selves who have most generously shared their ideas,
mixes and tips for the benefit of others. I hope that
each will find, in return, information that is valuable
to their own future work.

I am privileged to have been able to include many
brand-new methods which have not been published
before. The researchers of these methods are now
offering their own personal discoveries, the fruits of
many years of hard work.

Acknowledgements

Particular thanks to Michael Vaughan-Rees; Tony
Birks; Harry Fraser; Bill Hall; Michele Zacks; Reg
Batchelor; Frank Hamer; David Cann; Nigel Wood;
Paulus Berensohn; Vicky Newman; Emmanuel
Cooper; Anita Besson; Crispin Thomas; Garth Clark
and Cyril Frankel.

Photographic Credits

Most photographs were taken and supplied by the
artists. Other photographers are given below in
parentheses following the artist whose work they
have photographed:

Hans Munck Anderson (Mogens Gad); Felicity
Aylieff (Sebastian Mylius); Eva Blume (Imago
Photography); Orla Boyle (Errol Forbes); Judith de
Vries (Claude Cromm); Andrew Davidson (Mark
Swallow); Dorothy Fiebleman (Thomas Ward);
Teena Gould ('Flying Rock' by Stephen Brayne);
Ewen Henderson (David Cripps); Thomas Hoadley
(Paul Rocheleau); Lucy Howard (Robert Hamilton);
Christine Jones (Martin Williams); Jennifer Lee
(Michael Harvey); Naomi Lindenfeld (Tommy
Eloer); Gabrielle Amy Mumford (Pat Morrow); Susan
Nemeth (Stephen Brayne and Steve Speller); Eileen
Newell (Rob Newell); Christine Niblett (Stuart
Pearce); Elspeth Owen (Nicolette Hallet and James
Austin); Frederick Payne (Alan Bye); Vanessa Pooley
(FXP); Lucie Rie (Jane Coper); Inger Rokkjaer (Erik
Balle Poulsen); Clare Rutter (Dick Hodgkinson);
Hanna Schneider (Hugo Jeger); Prudence Seward
(Crispin Thomas); Sabina Teuteberg (Stephen
Brayne for jiggered and jollied work; Nick Morris for
lobby pic and Roland Allig for Egyptian wall piece);
Patricia Tribble (Michael Oliver); Sue Varley (David
Varley); Emma Vaughan (Richard Hodgkinson); Jane
Waller (Crispin Thomas); Henk Wolvers (Rene Van
Haeften); Claudi Casanovas (Anita Besson).

Contents

Introduction

Today, the world of ceramics has been enriched by breaking down the barriers which separate it from other disciplines. The dull brown pot has been knocked off the shelf in an explosion of painting, sculpture, weaving, paperclay, metalwork, textiles and so on, all of which have been effortlessly absorbed into the ceramics mainstream. In fact, when you look through this book at the diversity, experimentation and individuality of the artists' work, you may well agree with me that the artificial distinction between the Ceramic Craft Tradition and the world of Fine Art is increasingly difficult to justify.

What, however, unites the fifty artists gathered together in this book is the particular magic that happens when pattern, colour and design are fused with form, having the colorants and patterning as part of the clay body itself. As the work came in, I was intrigued and delighted to discover that every contributor had a different way of working. The result is that *Colour in Clay* is a pooling of information as well as a celebration of the artists themselves.

I hope, therefore, that the extraordinary range of recipes, ideas and tips which the contributors have been so willing to share, will help to inspire not only them, but all the new young artists and established artists who are interested in approaching the Ceramic Tradition in this way.

'Silk Scarf' (38 × 25cm/15 × 15¾in) Christine Niblett (Palma de Mallorca, Balearic Islands).

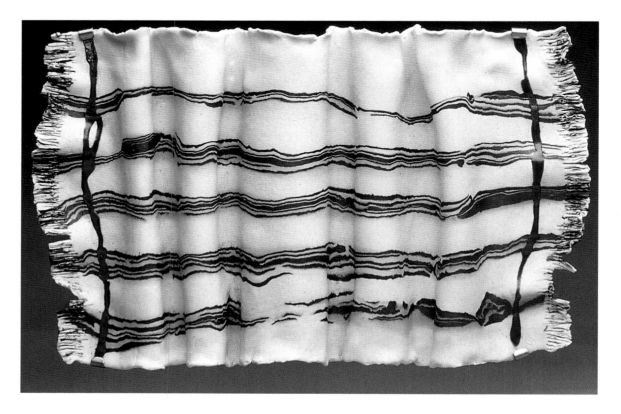

The Ceramic Artists

TOVE ANDERBERG (Sulstead, Denmark)
Thrown porcelain and stoneware with fire-brick inlay.

HANS MUNCK ANDERSEN (Gudhjem, Denmark)
Coiled porcelain slab-built inlay.

FELICITY AYLIEFF (Bath, England)
Semi-porcelain press-moulded with aggregate and glass inclusions.

ALISON BATTY (Worcester, England)
Slabbed white earthenware and stoneware sculpture.

CURTIS BENZLE (Ohio, USA)
Inlaid laminated porcelain.

EVA BLUME (London, England)
Thrown agated stoneware.

ORLA BOYLE (Cork, Ireland)
Press-moulded porcelain inlay with slip-trailed drawing.

CLAUDI CASANOVAS (Catalonia, Spain)
Press moulded or thrown sculpture with inclusions.

LINDA CASWELL (Tranwsfynydd Gwynedd, North Wales)
Marbled, slabbed and hump-moulded porcelain.

JO CONNELL (Warwickshire, England)
Slabbed and press-moulded porcelain inlay.

ANDREW DAVIDSON (Dorset, England)
Thrown agate-ware.

JUDITH DE VRIES (Amsterdam, Holland)
Laminated porcelain inlay. Also woven porcelain sculpture.

JACK DOHERTY (Herefordshire, England)
Thrown coloured and textured clays.

DOROTHY FEIBLEMAN (London, England)
Laminated porcelain inlay.

FRED GATLEY (London, England)
Moulded porcelain with inclusions and metals.

TEENA GOULD (Carmarthenshire, Wales)
Slabbed, painted inlaid sculpture with inclusions.

EWEN HENDERSON (London, England)
Printed and painted sculpture with paperclays and inclusions.

DAVID HEWITT (Newport, South Wales)
Thrown porcelain agate ware.

THOMAS HOADLEY (Massachusetts, USA)
Porcelain nerikomi.

LUCY HOWARD (London, England)
White earthenware inlay.

CHRISTINE JONES (Swansea, South Wales)
Coiled white earthenware and Y material.

PETER LANE (Hampshire, England)
Incised thrown and inlaid porcelain.

JENNIFER LEE (London, England)
Coiled stoneware and T material.

ANNE LIGHTWOOD (Fife, Scotland)
Porcelain inlay. Also porcelain paperclay sculpture.

NAOMI LINDENFELD (Vermont, USA)
Incised, laminated porcelain.

SYL MACRO (Cumbria, England)
Textured inlaid stoneware.

MAL MAGSON (Yorkshire, England)
Agated, inlaid, painted porcelain paperclay
sculpture.

AMY MUMFORD (Derby, England)
Chlorided paperclay sculpture.

SUSAN NEMETH (London, England)
Press-moulded porcelain inlay.

EILEEN NEWELL (Carmarthenshire, Wales)
Brick clay paperclay sculpture.

CHRISTINE NIBLETT (Palma de Mallorca,
Balearic Islands)
Press-moulded laminated sculpture.

ELSPETH OWEN (Cambridge, England)
Pinched white earthenware, porcelain and
other clays.

FREDERICK PAYNE (Somerset, England)
Laminated porcelain with fibreglass and lino-
block embossing.

VANESSA POOLEY (London, England)
Sculpture using C Y or T material.

LUCIE RIE (1902–95)
Thrown agate ware.

INGER ROKKJAER (Hadsten, Denmark)
Thrown and rakued engobed clays.

CLARE RUTTER (Chester, England)
Porcelain millefiori inlay.

HANNA SCHNEIDER (Zurich, Switzerland)
Thrown agate ware; also coiled stoneware.

PRUDENCE SEWARD (London, England)
White earthenware and porcelain millefiori.

SABINA TEUTEBERG (London, England)
Press-moulded inlaid stoneware/earthenware;
also sculpture.

PATRICIA TRIBBLE (Bedfordshire, England)
Sculpture of mixed clays and mixed inclusions.

SUE VARLEY (Middlesex, England)
Pinched T material, stoneware, and terra cotta.

EMMA VAUGHAN (Denbigh, North Wales)
Porcelain paperclay sculpture with mixed
inclusions.

JANE WALLER (Buckinghamshire, England)
Mixed clay millefiori. Also pinched mixed
clays.

LINDA WARRICK (Kent, England)
Laminated porcelain sculpture.

JOHN WHEELDON (Derbyshire, England)
Thrown and lustred china clay and ball clay.

HENK WOLVERS (KN's – Hertogenbosch,
Holland)
Slabbed porcelain lamination.

MIGNON WOODFIELD (Bristol, England)
Slabbed white earthenware inlay.

MICHELE ZACKS (Massachusetts, USA)
Recycled stoneware sculptural bowls.

A tribute to PAULUS BERENSOHN, the
inspiration to us all (*see* page 57).

An Introduction to Commercial Stains & Metal Oxides

Staining clay bodies gives the maker the satisfaction of structure and decoration being combined. The practical aspect is enjoyable because all the processes that involve forming and decorating the pot can be realized together step by step during construction. The emotional content of the pot, too, is somehow enhanced when colouring or pattern go through the body to fuse intimately with form. One of the chief delights of using colour inside the body is that it is almost impossible to make two pieces alike, since in many methods, the inlaid or mosaic pieces are moved with a rolling-pin, pestle or from just the pressure of a squeezing finger or thumb. This results in something special being made every time: a different statement, a fresh idea, an advance on the piece made before.

Metal Oxides

Metal oxides may be used singly, but it is often when they are combined that the excitement of colouring clay really begins, and this intensifies when you know that oxides will react with different types of body, glaze or firing technique. Colours can be partially mixed in order to marble colours together, or mixed thoroughly to make a completely new shade.

Commercial Stains

Metal oxides have always been one of the main sources of colour for pottery and clay-based sculpture, but in the last fifty years with the advent of modern technology – notably X-ray crystallography – the source of ceramic colour has become better understood and commercial stains have been developed.

Slice through a rock agate. Linda Warrick (Kent, England).

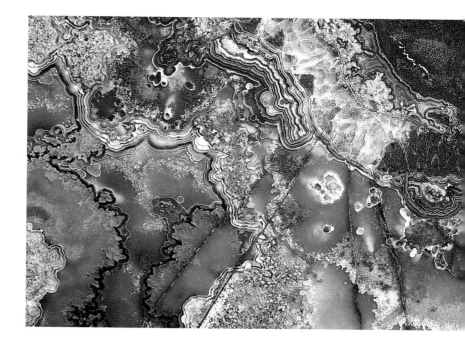

Scientists discovered that the colouring matter in stains such as iron or cobalt could be latched into a stable crystalline lattice, for example zircon, or alumina. This quality could then be used to produce commercial stains which remained stable in the clay body or glaze during all types of firing.

Commercial stains are therefore mixtures of oxides combined with materials such as clay, silica and alumina, heated up, fritted, ground to a fine powder, and then water-washed to remove any remaining soluble material. Although they are expensive, the resulting colours are consistently even; you know what you are getting every time. Nowadays they come in an extensive colour range including bright pinks, yellows and turquoises that could never be achieved by simple mixes of oxides. And there are special high temperature colours : bright reds, oranges or yellows; Potclays 4590, for example, is an encapsulated cadmium pigment able to hold its red at 1,280°C. In addition, there is a massive choice of colour from the 'Minerva' and 'Masons' range that 'Scarva Ceramics' have available; besides which several companies will mix any colour you desire (*see* page 157).

Stains or Oxides?

If what you want is predictable and you need an even colour, then stains are for you, since they produce a clean, uncluttered, pristine colour. If you like experimental work and the excitement of finding out what will happen when you mix A with B or C and E, then go for the oxides.

I often mix stains with oxides, 'dirtying down' again all the clean hues that commercial stains provide, yet gaining a colour which I am unable to get with an oxide alone. The result can often be much livelier. It is rather like the difference between using a commercial emulsion paint for your walls, for which the paint companies have bent over backwards to produce a consistent mix, or making your own. I use an old-fashioned 'distemper', adding my own colorants, and the result suggests walls like the painted gesso frescoes from Herculaneum or an ancient Egyptian tomb, or perhaps hand-dyed wool … you achieve a fantastic variation of tone, giving depth to the surface. It is this type of colouring which I aim for in my ceramics.

Not all stains listed in suppliers' catalogues can be used for staining bodies, because a few only work with glazes. Usually, pale glaze stains work well in clear glazes, but not very well with clay bodies. Underglaze colours can work with clays that fire very white. Most of the chrome tin pinks and cadmium selenium bright reds and oranges are designed for use with glazes and are unsuitable for use with bodies. Instead, go for the high-firing body colorants.

Choice of Clays

Every clay can be stained – though the paler the body the brighter the colour effect – unless you want to mute them to produce subtler tones. Porcelain, stoneware, raku, clay mixtures, white earthenware – even red earthenware – can be stained. Lucie Rie coloured red earthenware for her spiral pots. Bill Hall of the London Guildhall University recommends that small amounts of stain in bone china will give wonderful effects. In her long ceramic career, Mal Magson appears to have tried everything:

> I have used many different clay bodies, but find now that the most useful ones are basically those which are white, for example, Valentine's plastic and Potclay's powdered white stoneware. White clays take the stain better, and since stains and oxides are now so expensive, it is essential to achieve the most effective and economic colouring. When I'm mixing a more earthy range of colours, using oxides, whiteness is less important, and in fact iron-bearing clays can produce a softer, warmer palette; for instance crank, School's Buff and any other general purpose stoneware bodies are useful.

Red Clays

Andrew Davidson, who throws spirally coloured clays, is well aware that the type of red clay used makes quite a difference to the finished pots, 'presumably due to different amounts of iron in the body. I am constantly experimenting with both bought ar ` `cal clays, which means I am never totally sure how a pot will turn out – but then who is?'

Until recently, Inger Rokkjaer used, in most of her pots, clay containing a lot of red colouring from her own garden in Denmark.

Crank

Before using porcelain, Linda Warrick worked using a crank body for her coloured clay and tested it with numerous colour combinations and percentages of oxides: 'all very drab and unexciting, barely differing in colour from the usual range of unstained stoneware bodies'. Now she uses Harry Fraser porcelain from Potclays and gets better colour results.

Many years ago when I first started to put colour into the body clay of my raku pots, I used mixtures of crank, T material and stoneware or porcelain, to make a very richly toned body. I found putting stains inside made the colouring much gentler and softer than if this had been added only to the surface. I still use this for raku.

Found Clays

Sue Varley says, 'One of the most beautiful slips I had was from a lump of clay I picked up from the roadside and used just washed and sieved.'

Hand-building

If you are hand-building, use a clay with high plasticity such as Potclays 1141-LT 25, or Scarva's Earthstone-F, or their porcelain P2, which is surprisingly plastic for a porcelain body. Be wary of clays which contain a deflocculant: they become too 'short' to work with and will crack on rolling out.

Powdered Clays

A good quality powdered clay, such as Doble's DWE from St Austell, Cornwall, or a Dutch clay such as WB 30 from Potterycraft Ltd, could be chosen. Again, check that no deflocculant is included; sometimes manufacturers use a method of slip-housing and filter-pressing white earthenware clays, in which the clay slip is sprayed onto hot, stainless-steel cylinders and deflocculated to assist with screening.

Many ceramic artists will break up dried clay in order to make its weight with the stains the same every time before soaking it down to plastic clay once more. I have found it very much easier to mix my colours with bought clay already powdered: the quantities can be weighed accurately, and additives such as molochite powder can be added in precise amounts to each colour batch.

Parian Clay

Dorothy Feibleman has her own factory-mixed range of Parian porcelain colours produced by Potterycrafts Ltd (*see* page 157). It vitrifies at $1,116\,°C$ and fires to around $1,160\,°C$ before it starts to flux too much, but the stability is also dependent upon the firing cycle and the thickness and the construction. She fires the same clay when it is laminated with a high fire porcelain to $1,220\,°C$ in an electric kiln and $1,280\,°C$ to $1,300\,°C$ in a wood kiln, but the laminated layer is only used as a surface lamination on a layer of porcelain (which on its own, fires to $1,380\,°C$ without distorting) for stability. 'However,' she advises:

> Porcelain reaches a certain point where the die is cast and you cannot turn back. Although the lower-firing Parian is more fragile and does not take the stress like porcelain, it is translucent, and easier to work with for longer periods; it is also more co-operative and flexible for working on forms, remaining pliable for a longer period. Because of this, you have more of a chance to change direction.

Linda Caswell finds interesting effects by firing Parian to the top of the range 'which gives deep, self-glazed colours', or to the bottom of the range 'giving pastels with a matt finish'.

Porcelain

Porcelain is a difficult medium to work with, and it takes a great deal of patience and experience to get to know its possibilities. Judith de Vries advises people not to use porcelain for a complex hand-building technique like hers unless they are already familiar with it.

Peter Lane advises throwers to be cautious, too: 'Porcelain must be well lubricated if it is not to snag suddenly and distort on dry fingers – but if too much water is absorbed it will become unable to hold its form during the shaping process.'

Mixtures and Additions

Many potters have experimented with mixing different clays together to get interesting effects. Ewen Henderson, for example, will sandwich together different clays such as bone china, stoneware and porcelain, before folding them into a volcanic form. Many, including Alison Batty, combine white earthenware and white stoneware. Elspeth Owen has tried body mixtures from raku to porcelain to achieve 'a range of colours', and, of course, throwers who marble clays together find ways of combining red and white earthenwares.

Paper and Coloured Grogs
(*see* Chapter 11, page 117)

Alumina

Christine Niblett mixes 10 per cent alumina with her porcelain if it contains a high percentage of colour oxides, to avoid problems in high-temperature firing.

Feldspar

Feldspar added to the body helps the main clay match the coloured clay by preventing shrinkage; try adding from 2–5 per cent (*see* Lucie Rie, Chapter 7).

Molochite and Sand

For neriage, nerikomi or millefiori work there needs to be some kind of bonding addition to allow for different colours shrinking back when you are using coloured clays next to one another in a single piece of work – or in my case, when different types of clay are also abutted. I add molochite or calcined china clay, which has already done all its shrinking, and this ensures that the shrinkage rate is the same. Molochite is sold in sorted grades down to the powdered variety, which is the one I use.

Molochite is made by the calcination of specially selected china clays fired to peak temperatures of 1,525°C for over twenty-four hours to ensure a uniformly consistent product excellent to use in ceramics. Its low, uniform thermal expansion rate gives resistance to thermal shock, while the rough surface texture of the particles gives excellent keying properties for clay or chemical bonding.

Generally, a good addition of any grog will open a body and help allow for expansion and contraction. Sand can be a cohesive addition, but needs plastic clay to make it not too short. A surface covering of a thin slip is also good to help hold different clays together. Also, if the colour pieces are physically interlocked with another piece of patterning, instead of just lying next to it, then this will help key each colour together. The easiest way of overcoming this is to use inlay, when there is a backing blanket of mother clay into which clay patchwork pieces can be well pressed.

'*B*utter Dishes'. Inlaid white earthenware. Lucy Howard (London, England).

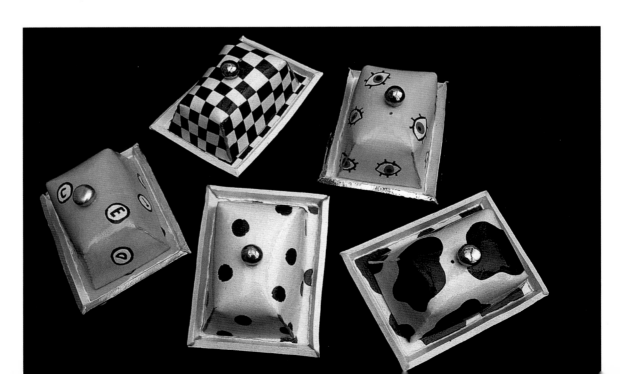

2 Properties & Percentages of Stains & Oxides

Safety Rules

It is important to stress right away that a mask *must* be worn when working with dry stains and clays, and also when scraping or sandpapering the pot before or after bisque-firing. And John Wheeldon suggests 'a good quality dust-mask, not one of the cheaper throw-away types, as all oxides are toxic'.

Do not allow dry, scraped, stained clay to accumulate around the work area: it should be vacuumed up, preferably before it dries – or you could recycle the material (*see* Chapter 5). Remember to clean towels and overalls regularly. When mixing large quantities, wear close-fitting disposable gloves. (I was first introduced to these when a surgeon friend of mine pressed a great packet of surgical gloves into my hand as a gift … an interesting change from chocolate or flowers.) Linda Warrick says that you can find 'disposable medical gloves' in many chemists in boxes of a hundred, so they cost only a few pence each. 'Provided these are dried and lightly dusted with talc on removal,' she says, 'they are reversible, and allow workable levels of sensitivity to touch.'

If you are working with small quantities and want to keep the feel of the clay, rub one or two layers of a good barrier cream into your hands first: many of the oxides are poisonous, and it is not good to have them in close contact with your skin. Some, notably chrome oxide, are caustic when wet and will be absorbed into the skin, so it is always advisable to wear gloves when wedging it into the clay. Moreover, Sue Varley recommends not to work with oxides 'if you have a cut or open wound on your hands'.

Dorothy Feibleman describes her safety rules for cleanliness in the studio:

I wear a Japanese cook's clothing, which I leave in the workshop along with workshop shoes and saki company aprons. Masks are worn any time there is dry clay or dust being dealt with, and I use a vacuum cleaner with a silica filter. All these things, along with the numerous cloths, are cleaned or thrown away regularly. My sink is a sitz bath with a raised tube drain with a filter so that the heavy metals and clay fall to the bottom and clear water goes into the drain. This is also cleaned regularly.

A mask must be worn while working with dry stains and clays (Linda Warrick).

The Value of Test Tiles

Recipes indicating the various relationships between mix and proportion and the resulting colour and shade have been collected from almost every ceramic artist in the book, and generously shared so that others can benefit. Note, too, that colours will darken with temperature as well as with amount, and will only reveal their full intensity when fired to maturity. And Peter Lane reminds us that 'wet slip always appears darker than when it is dry', so it is better to know the power of your stain, and advisable always to make test tiles.

<div style="border:1px solid">

TIP

Mal Magson provides a sound starting point:

Remember, when working out ratios for adding colorant to clay, that there has to be a different set of test pieces for each type of clay. Also if you alter the temperature then the colour will develop further, giving a different set of results.

</div>

Although some wonderful shades are provided here, it must be understood that test pieces need to be made to suit individual styles: it is only by testing your own colours that a personal palette can be formed. Jack Doherty painlessly integrates test tiles into everyday work by simply putting one into every firing, marked with a single cross of colour. If this turns out interesting, then he will make more sample pieces combining it with other colours. When Dorothy Feibleman makes her own clay, she works from dry weight with 10–20 per cent commercial stains or oxides, usually at lower percentages, and she makes test tiles of her colorants all the way from 10–20 per cent. 'In this way,' she says, 'I have a treasure-trove to delve into.'

*J*ennifer Lee's work-bench shows hundreds of test tiles 'hanging in bunches'. Her tip to all workers of colour in clay is to test every batch and record everything.

Keeping Colours Separate

Coloured bodystained porcelains all appear the same colour in the raw state, and the pattern only comes alive and can be seen after firing.
Christine Niblett

It is essential to keep each stained clay separate on your work-bench. A grey stoneware, for example, may have been stained with such small amounts of colour that the stained clay itself will appear grey, in which case you are working purely from labels. Linda Caswell finds that mixing porcelain with cobalt, particularly when tiny amounts of stain are needed, 'causes problems, as there is very little difference between the colour of the wet stained clays. I have tried and used the water which onion skins have been boiled in and various food colourings but have not yet found an ideal solution to the problem, as the clays tend to go rather unpleasantly mouldy if kept too long.'

During twenty-five years of staining clays I have festooned the area above my work-bench with necklaces of coloured clay circles, working

up an extensive palette of possibilities for different bodies. Each is numbered so that the exact recipe can be consulted; also, the necklaces are 'undoable'. Thus I can choose the 'mood' of a new pot simply by placing test tiles next to one another until the colour scheme is worked out, the decoration of the pot decided before its construction, so to speak.

Percentages of Stains to Use

Even small amounts of oxide or a commercial stain will colour well; in some cases as little as ½ per cent can be adequate for both dark and light clays. Jack Doherty says:

> Most manufacturers recommend 10–20 per cent, but interesting colours can be had using 0.5 per cent with light clay stoneware bodies. The benefit of using prepared stains is their ease of use and stability – qualities which I found useful at the start; however, I felt that the colour response was sometimes rather bland, and I have experimented a lot with the addition of oxides.

I suppose that on average, the normal quantity to use is between 2–5 per cent, but it really depends on the strength of the stain or oxide and the clay it is to be used for. Dorothy Feibleman will halve, quarter, or even double the manufacturer's recommended quantities to see what effects she can get.

Anne Lightwood discovered that stains have a saturation point above which the colour is no longer enhanced and the behaviour of the body may alter because the stain acts as a flux. Also, of course, it is expensive to add more colour needlessly.

Thomas Hoadley makes test tiles of his mixes as ½, ¼, ⅛ and ¹⁄₁₆-strength tiles of the same colour, so the full range of the stain's potential can be seen. He, like myself, mixes stains and oxides together.

Linda Warrick often ignores the suppliers' recommendations of percentage additions and uses, as a starting point, 1oz or 2oz (28 or 57g) dry clay plus one level teaspoon of stain: 'Most stains I have tried work well at this ratio,' she says. 'All this measuring may seem tedious, but it allows me to select and repeat colour accurately,

provided the suppliers are able to maintain consistency in the ingredients … which doesn't always happen. Mixing by eye would certainly be quicker, if less reliable.' She has discovered, in fact, that 'to achieve a noticeable gradation in colour value, the amount of stain added should follow a geometric progression, that is (according to the amount of clay) plus one teaspoon; plus two teaspoons; plus four teaspoons; plus eight teaspoons, and so on.'

Linda finds that envisaging the final effect is never easy, mainly because in an unfired state, most stains are of a slightly different value. She therefore considers it important to experiment, as 'blue-green is of a completely different value, whilst certain dark blues are a different colour entirely – no doubt due to cobalt carbonate being lilac-coloured.'

Colour at Low-temperature Firing

Sue Varley has found that commercial stains do not give very strong colours at low temperatures of about 960°C when put into a mix of 50 per cent each of St Thomas Body and T material. She suggests using strong oxides instead, such as manganese, red iron, rutile, nickel, cobalt carbonate and chromium oxide.

A selection of colour samples from Linda Warrick – each one is mixed to different ratios or combinations of stains and HF porcelain.

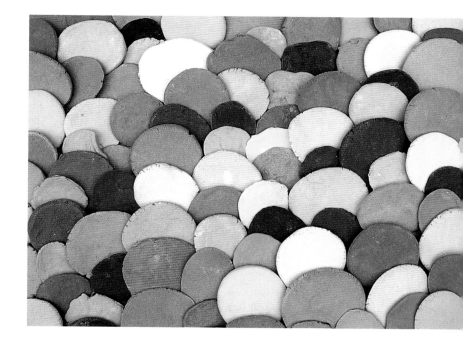

What Metal Oxides Can Do

Metal oxides, if used in an imaginative way, can give tonal variation over even a small area. Mixes of oxide and stain will do the same. Bill Hall teaches his students at the London Guildhall University some recipes which show the colour range produced from some powerful oxides. He thinks it important to see first what one oxide will reveal when used on its own, and says: 'Some of the heavily loaded, stained clays, like red iron oxide, can give extraordinary, very lovely colours.' He uses porcelain, and mixes his colorants into a plastic body; this makes his hands get 'rather stiff, mixing test after test.' Beginners may like to try his 'fully comprehensive' way of testing the basic metallic oxides:

Four test colours are produced for each colour, to see what will happen at 10.60; 11.40; 12.20 and 12.60. If you try these unglazed, clear glazed, and with a translucent glaze (by dipping the two ends and leaving the middle of the tile clear), you will then see how the glaze changes each colour. The results could hang on a board above the work-bench, with the recipes written on the back of each tile.

The following proportions were tried using porcelain:

1. **Cobalt oxide**: into 100 parts clay, try 0.25, 0.50, 0.75, 1.50, 2.50, and 3.50.
2. **Copper oxide**: into 100 parts clay, try 0.50, 1, 2, 3, 4, 5, and 10.
3. **Red iron oxide**: into 100 parts clay, try 1, 2, 4, 8, 10, 20, 30, 40, and 60.
4. **Manganese oxide**: into 100 parts clay, try 1, 3, 6, 10, and 20.
5. **Chromium oxide**: into 100 parts clay, try 0.25, 0.50, 1, 2, 4, and 10.

Overloading

Adverse effects can be had from overloading the body; it can lead to bloating and warping, especially when using fluxing oxides, and unless that

is the effect you want, it is wiser to keep to normal percentages. Anne Lightwood, for example, used to find that if she made wide, shallow shapes from clays holding a high proportion of certain stains or oxides, these were liable to warp at her high temperatures. 'Because of this,' she says, 'I tended to use rather pastelly colours – but got tired of them. Now I mostly use WG Ball's High Temperature ones at 10 per cent. Green, however, is an exception, when I use 5 per cent for darkest.'

Linda Warrick notices that the higher she fires, 'the more saturated the colours, and the more likely it is that the clay will warp when worked in my way.' Molochite can help stabilize this problem to some extent. An addition of 10 per cent powdered molochite will help neutralize the effect.

Shrinkage

Stains and metal oxides are non-plastic, and therefore make clays shorter, reducing workability. Mal Magson has noticed that her agate-patterned porcelain will often shrink, then split from the neighbouring clay, which is 'sometimes acceptable, but often not'. She has learnt by trial and error which colours do this, and tries not to combine them directly. She concludes that 'the more the colorant acts as a flux and the greater the percentage of staining, the greater the shrinkage … Generally the darker stains are strongest'. She once had a bad experience with Harrison Meyer's Nazarine Blue used at full strength, when a whole kilnful of ware bloated and bubbled; so now she uses it at half strength, and still achieves a good colour.

Using Black

I have found that black – in my case, black stain – seems to have a pacifying effect on colours around it, which stops the splitting, so I sometimes wrap colours around with it if they are difficult. This also emphasizes the colour by surrounding it in a kind of frame.

Mixing Oxides & Stains

Even Mixing

Stains and oxides need to be thoroughly dispersed, otherwise stain particles will clump together, causing dry patches and specking. Oxides need to be finely ground to give an even dispersal. Some potters, including Jennifer Lee and Judith de Vries, grind theirs with pestle and mortar using a little water, before mixing them into the clay body. 'The finer the particles are, the less you will need to wedge,' Judith advises.

Thorough Mixing

Jennifer Lee is very strict with her stain calculations. She uses Brongniart's formula to ensure exact duplication of colour, and a colour test tile is made and consulted every time a new pot is made. The formula is thus:

$$w = (p - 20) \times \frac{g}{g-1}$$

Where w = dry content of one pint slip; p = weight of one pint slip; g = specific gravity of dry clay.

Potterycrafts Ltd filter-press and pug mill Dorothy Feibleman's Parian clay thoroughly. She herself mixes a small amount of dry clay (removed from the whole amount of dry clay) with the whole amount of the colourant. This is put in a blender with water, then added to the whole batch of clay, which has had water added to it and blended using a propeller drill. It is then put through a sieve (sometimes a vibratory sieve if dealing with large amounts), then poured onto plaster. She only wedges it a small amount because it is compressed further when she works with it.

Mixing Carbonates

Carbonates are easier to mix than oxides because they are generally more finely divided. However, they do not 'wet' so easily, and tend to float in dry form on your well of water.

> **TIPS**
>
> - Harry Fraser finds that a few drops of washing-up liquid are useful as a wetting agent.
>
> - Many potters use warm water to mix carbonates, which helps enormously.

Mixing Small Amounts of Colour

Well Method

(This is usually the method chosen for pinch pots.)
Make a well in the centre of a ball of plastic clay, add the wetted oxide or stain, then ease the pigment in, folding little pieces over to meld with the surrounding clay before wedging more vigorously. Elspeth Owen uses this method, but adds wryly, 'I rely on my memory to reproduce a recipe – not always accurately.'

Sue Varley tells us that if she 'weighs a small ball of clay of about 80g–1kg (3oz–2lb), then one to no more than three teaspoonfuls are enough, plus half a teaspoonful of slurry made from the main body, so that it's not just dry powder. If the mixture is too wet, it will squirt over the floor – or your face – and waste the oxide.'

Sue likes to make four or five of her small balls of clay, and only then wedge them together, slicing through with wire to check that they are completely mixed. This is fine if you can *see* the stain, but if you can't then a good idea would be to time how long it takes to mix a weighed amount of a stain you *can* see, then wedge for the same amount of time for the one you can't see. Is this a good new tip?

Orla Boyle often mixes in her Scarva body-stains by eye. She defends this practice by saying that 'it is much easier to judge when using commercial stains, rather than oxides, since they resemble the final colour.'

When I make pinch pots for raku, I find it always pays to spend time smearing the colour into the clay around the rim of the well first. I mix with a fairly wet ball of clay, doing so over a large, thick plaster slab, so that any leakage of precious colour will settle and dry enough to be incorporated. Then the plaster surface can be used to wedge the colour in more thoroughly. This method has the added advantages of picking up any stray colour and allowing excess moisture to be received into the dry plaster.

I also find that the warmth of a barrier-creamed hand helps to dry the clay from the effort of working it. This puts me in the mood to start the pot straightaway instead of leaving it for later.

Jug Method

Prue Seward puts 500ml (18fl oz) of warm water into a jug and finds that 'that measurement of water is enough to measure all the other ingredients.' The clay is added in small pieces and whisked with a French metal whisk, 'like making a sauce without lumps. Colour is mixed with a little water, then added and whisked together.'

Ice-cream Container Method

Linda Warrick adds water to unsieved stain and dried clay in a 2-litre (3½pt) ice-cream box, or similar, and leaves it until there are no lumps when it is stirred.

Jam-jar Method ... and Hot Water

Sabina Teuteberg dissolves 5–12 per cent of her W.G. Ball's stains and underglaze stains into a few teaspoonfuls of hot water, then shakes them thoroughly, adds some liquidized scraps of base clay, and re-shakes. She mixes more white plastic clay to get the right colour tone – by eye!

Bucket Method ... and Hot Water

Jack Doherty puts his weighed oxide and colouring ingredients – already mixed with a small amount of hot water and sieved (100s) – into a bucket holding 4 pints (2.3 litres) of hot water. Once this oxide mix is stirred in, the weighed quantity of dried clay is added gradually ... 'the process works faster using hot water and if the dried clay is pulverized – not necessarily powdered. I usually mix 3kg (about 6½lb) quantities, the scientific reason being that this is the amount which will fill a plastic ice-cream container with a strong snap-on lid, and these stack easily for storage.'

Liquidizer Method ... and Hot Water

Linda Caswell says, 'I weigh out the oxide and stain I want to use – the maths is easy because it's to 1kg (2lb 3oz) dry weight – and add this to my slip, which is mixed using a hand-held liquidizer in a tall jug. Then I sieve it through a 120s mesh sieve. Next, the sieved slip is left in a covered jug until the water rises to the top. After draining this off, the thick slip is poured onto a "Masterboard" bat before wedging. This board is placed on an old oven shelf to keep it off the bench, which speeds up the drying process.'

Kenwood Chef Method ... and Boiling Water

Syl Macro dissolves her measured stain in boiling water, and then puts clay plus stain into an old Kenwood mixer which 'does the job well and saves having to sieve the mixture.' Syl ·chooses to use Sneyd oxide bodystains

since 'they are the best value, and the raw colour is similar to the fired effect which is helpful in the making stage.' She has a most pragmatic attitude to mixing stains: 'When I'm not feeling creative I enjoy a day mixing colours,' she says, 'and always like to try out some new colour combinations – it gives an element of chance.'

Mixing Large Amounts of Colour

One efficient method is first to mix the pigments with water, which is then passed through a 200-mesh sieve. The clay body to which this is to be added is made into a slip, then everything is combined with a power mixer. For a really even mix, pass the resulting mixture finally through a larger 80s to 150s mesh (to avoid sieving out some of the body constituents), then dry on plaster slabs or in moulds.

TIP

If there is still a lot of surface water in your mould after the slip has settled, Mal Magson recommends lifting it off with a slip trailer.

Heather Graham at first added oxide to her dry clay so that she could control the percentages properly. Then one day, she writes, 'I weighed the plastic clay and found that 500g (18oz) of dry material yielded about 640g (22oz) of clay at the consistency that I like to throw, and so I now use this information to add my oxides wet.'

Most ceramists add colorants to clay which has been dried out and crumbled, adding as much water as is needed to form a thick slip. Jo Connell says that 'this quickly breaks down, is mixed to ensure dispersion, and then dried on a plaster bat. This is wedged into a larger amount. I have tried many ways, and find this is the most hassle-free. I record all my recipes in grams per kilo of wet clay – which weighs roughly 800g (28oz) when dry. Supreme accuracy is, thankfully, not required.'

Dustbin Method

John Wheeldon makes his black body as follows: a dustbin is two-thirds filled with water. Into this is first sieved (to ensure they are well mixed) 2lb (907g) iron, 2lb (907g) manganese, 1lb (450g) copper and 1lb (450g) of cobalt. At this point he adds any dry scraps and /or turnings, and allows them to break down; he then adds 50lb (22.6kg) of HVAR ball-clay and stirs well; then 15lb (6.8kg) china clay, and mixes again; then 30lb (13.6kg) molochite and mixes again. This he leaves to stand overnight, then mixes yet again, and finally dries out on plaster bats. (As long as the *proportions* of the oxides are strictly observed, more or less can be added to give different densities of black. John likes the non-plastic, over-grogged body because of its texture.)

Christine Jones prefers to slake her mix for a few days. Then she dries it on plaster bats, and wedges and kneads until the colour is completely even.

But there is a simpler way, and that is to buy powdered clay.

Powdered Clay Mixing

Except when staining raku, I prefer to mix all my ingredients dry. The weighed, powdered clay (plus 10 per cent molochite) is put into a high-sided plastic bucket, covered with water and mixed. Into this base I add the stain which has been soaked and made into a slip beforehand, then re-mix.

I was lucky enough to have a 'setting-up' grant from the Craft Council, and spent some of it on a clay mixer which mixes whole batches of coloured clays with ease, and is so robust that it will last me my whole pottery career. To anyone mixing large amounts of clay, I recommend getting one because it will soon pay for itself in the time and energy it saves over the years. Also it is most useful if you want to start using paperclay.

I do a mammoth staining of about thirty colours, an incredibly tedious procedure, probably only one degree worse than doing one's income tax. I arrange each colour batch according to shade. Starting with a pale blue, I leave the bucket and mixer unwashed as I move to the next shade darker. At the darkest I will switch to a dark brown and go back gradually to light brown, then switch to a further colour and proceed in

the same way, to dark and back. You can end your staining with white, that is, using the clay natural, only a mere blob of the pale shade used before; then there is very little washing to do.

I was delighted to find that Susan Nemeth follows a similar progression with her porcelain, starting with the palest and working through to the darkest, also 'to save washing up'. However, she uses hot water and a food blender, adding the wet clay second. Heather Graham does the opposite, mixing batches of the maximum percentage of what she is likely to want, then blending mixtures or lighter shades with her uncoloured clay.

Anne Lightwood will mix a massive 15 gallons (68 litres) of white slip. 'This lasts for weeks,' she says, 'and coloured bodies are made by adding a measured weight of stains mixed with water to litres of slip, and sieving through 80s or 100s mesh. Knowing the weight of dry materials per litre, it is easy to calculate the percentage of stain needed.' Anne mixes her colours to their greatest concentration first, adding white slip to make paler tones. She will then combine these slips to make more interesting colours.

Pancake Method

Harry Fraser recommends cutting the plastic clay into slides like pancakes, painting on the pigment mixed with water, stacking the pancakes and then hand-wedging. Alison Batty adds her grogged (molochite) stain, as she says, 'to a mountain of sandwiches of one or more clays which I squash down and then make another one until it's easy to wedge with.' Because she is mixing different clays as well as oxides, Alison likes to use very soft clay. 'I soak the clay a little before this, so it will take in the grog and oxides without being hard to work.'

If you can afford a pugmill, Harry Fraser suggests pugging the pancakes two or three times until the clay mass is sufficiently homogeneous for use. The pugmill must then be scrupulously washed.

Storing and Maturing

All artists who use colour in clay are of one mind when it comes to maturing coloured slip or clay: **the longer the better … and … always label every batch**. Mal Magson, who runs a studio with a fast turnover of work warns that 'the premature use of building with 'short clay' is beyond suffrance. Losses are too great. Store for three months.'

I pour my liquid-stained slips into every conceivable plaster mould, writing each colour's number in pencil on one side. When dry enough to form a pat, the clay is wrapped in soft polythene, labelled and put into a carrier bag, labelled again, and stored in a large plastic dustbin. I like to 'lay them down' for up to six months before use to make the clay more malleable, and the laying-down also allows the stain to migrate right through.

Dorothy Feibleman stores her clay wrapped in cleaner's plastic in buckets with lids or just in the buckets with plastic over the clay and a lid.

Anne Lightwood used to mix only enough for one series of pieces, and she found that fairly tedious, since 'it can take most of a morning to mix a group of colours and make up the laminated blocks, and two or three days to work through that material.' Now she makes up more, and stores her slips in plastic containers for months – these can be dried out to plastic clay when needed. So staining large amounts, for use when you want it, is not only easier in the long run, but better for the staining process itself.

Containers

Linda Warrick stores clay and slips in plastic containers 'which all had a former life in my kitchen. Parmesan cheese jars are particularly useful.' She even stores agated slabs indefinitely by wrapping them first in a damp cloth, then plastic or clingfilm and laying them down in a recycled fridge. Ice-cream containers have come out on top for storage: Linda Caswell and Jack Doherty among many others recommend them for perfect size and stacking.

4 Colour Recipes & Slips

Colouring Porcelain

Anne Lightwood: Staining a Special Porcelain Slip

Anne uses an excellent basic white slip, given by her friend, Donald Logie, which she calls 'Dundee Porcelain'; it consists of the following: grolleg 45; hyplas 20; feldspar 20; quartz 15; bentonite 2; and molochite up to 5 per cent. This slip is passed through 100 mesh before being coloured.

The oxide stains for Anne's mix are these:

Blues: cobalt carbonate – .50–1 per cent.
Greys: iron chromate – .50–1 per cent or less. (Good for modifying cool colours, or with cobalt in stronger concentrations for blacks. Too much causes warping and slumping.)
Browns: from iron ochre – 5 per cent or less. (Mostly used to modify warm colours, and to mix with pinks or yellows. Too much can cause bloating.)

Anne also recommends W.G. Ball's high temperature colours: lemon, amber, pink 179, coral, rosso, turquoise and green.

David Hewitt: Colouring Porcelain for Agate Ware

All colorants are added to 1kg Potclays 1147 porcelain:

Blue: 0.6 per cent cobalt oxide – 6g per 1kg (0.2oz per 2.2lb).
Pink: 7 per cent Blythe strong red – 70g per 1kg (2.5oz per 2.2lb).

Green: 1 per cent chrome oxide – 10g per 1kg (0.3oz per 2.2lb).
Brown: 5 per cent B126 tan brown – 50g per 1kg (1.8oz per 2.2lb).

Linda Caswell: Colours for Marbling Porcelain

'I particularly like working with a combination of white, black and brown: Potter's connection black (3306) and sepia (3302), Potclays carbon black (4580) and Potterycraft's sepia (P4178), which I fear is now discontinued.

Blue: 0.50; 1; 3 together with plain clay.
Grainy brown and soft green: 3 per cent and 5 per cent manganese dioxide and 3 per cent copper oxide work well together, but be careful to fire to only 1,200°C to avoid bloating.'

Christine Niblett: Unglazed Stained Porcelain (Reduction)

Black: iron oxide 3 per cent; copper oxide 1 per cent; cobalt oxide 2 per cent; alumina 10 per cent.
Brown: iron oxide 3 per cent; alumina 10 per cent.
Green: cobalt oxide 0.1 per cent (or 0.35 per cent); chrome oxide 0.35 per cent.
Pale blue: cobalt carbonate 0.2 per cent.
Strong blue: cobalt carbonate 2 per cent; alumina 10 per cent.

'I prefer cobalt carbonate and copper carbonate rather than the oxides for blues as they give better colour and warmer blues.'

Pink: copper oxide 0.5 per cent.
Purple: copper oxide 0.5 per cent; cobalt oxide 0.1 per cent.

Christine avoids using manganese oxide 'as it is inclined to bubble.' Like myself, Christine cannot achieve yellow as a natural colour, and we both find this very frustrating. She says, 'I've tried so many times using the full range of black, red and yellow iron oxides, and even crocus martis, but it always comes out another variation of brown.'

Naomi Lindenfeld: Unglazed Porcelain Stains (Reduction)

Added to cone 10–11 porcelain:
Pink: 8 per cent mason stain 6020.
Lavender: 12 per cent mason stain 6317.
Peacock: mason stain 6266.
Turquoise; mason stain 6364.
Peach: mix together ¾ pink with ¼ brown.
Teal: mix together ⅔ turquoise with ⅓ peacock.
Raspberry: mix together ⅔ pink with ⅓ lavender.
Naomi also uses some oxide mixes:
Brown: 4 per cent yellow ochre and 1 per cent rutile.
Blue: 2 per cent cobalt and ½ per cent rutile.

'I often combine certain stains to achieve more subtle hues. Layering colours next to one another in the blocks that I make up results in merging shades; one colour breaks as another colour shows through.'

Jack Doherty: Coloured Porcelain (Reduction)

For cone 10 base clay, Potclay's H.F. porcelain:
Soft Blue: Bath potter's pale blue stain, 1 per cent.
Pale yellow: manganese dioxide, 3 per cent.
Delicate pink: pink stain, 0.5 per cent.
Grey/pink: copper oxide, 3 per cent.

For cone 10, reduction or soda:
Speckled grey: rutile ore, 1 per cent. The following colours are for a 3kg (6.6lb) mix (as described in Bucket Mix, Chapter 3).
Black: chrome 50, cobalt 20, alumina hydrate 50, iron 60, manganese 30.

Dark brown: chrome 25, iron 25, manganese 20, alumina 40.
Dark green: chrome 35, cobalt 10, tin oxide 15, flint 15, alumina 25.
For soda firing:
Russet: porcelain clay 33, china clay 33, 4T ball-clay 33.
Yellow gold: porcelain clay 90, titanium dioxide 10.
Orange: grolleg china clay 50, 4T ball-clay 50.
Strong speckle: ilmenite, 1 per cent

Some Browns and Blacks

Bill Hall has learned that there are different kinds of black – warmer, colder, richer, softer. He gives four recipes, all in 100 clay:

1. 3 cobalt oxide, 3 copper carbonate, 2 manganese dioxide.
2. 8 manganese dioxide, 2 cobalt dioxide.
3. 10 iron oxide, 3 copper carbonate, 4 manganese dioxide.
4. 4 cobalt oxide, 10 iron oxide.

SUSAN NEMETH
Susan Nemeth will use cobalt, iron and chrome oxides to make brown/black, as they are more subtle than buying black stain, which anyway is fearfully expensive. But Linda Caswell recommends using different percentages of black stains for laminating together … 'there is a variety of black stains at different prices, and it is worth experimenting to find which ones work best for you.'

JOHN WHEELDON BLACK MIX
2 iron oxide, 2 manganese, 1 copper oxide and 1 cobalt oxide.

HANS MUNCK ANDERSON
A good black slip for cone 9 reduction to be used on porcelain: Aluminium oxide, 3.7 per cent; chrome oxide, 3.7; cobalt oxide, 7.4; iron oxide, 11.1; ball clay, 74.1 per cent.

LINDA WARRICK
A good grey using black measured with her 'teaspoon method':
Grey stain: one teaspoon of black stain in 7oz (198g) dry porcelain clay.

Colouring Stoneware

Jo Connell: Colouring a Stoneware Body

A lemon yellow, orange , pink and bright blue, plus small amounts of cobalt, iron and copper can give you almost every colour you need. By mixing stains and introducing oxides it is possible to achieve an enormous range of colour – though of course it is not like mixing paint, and many tests have to be done.

Jo Connell gives some recipes, all to 1kg (2.2lb) of white stoneware:

Blue: cobalt oxide, 1–10g (5g gives a strong blue)
Sky blue: No. 1215 S Roy bodystain 10–20; or 919 sky 10–20; or yellow stain 20, cobalt oxide 1.
Turquoise: 1215 sky blue 10, 1292 yellow 20/30.
Green: 1292 yellow 20, 1215 sky blue 20.
Olive: Deancraft egg yellow stain 10, cobalt oxide 4 (for a lighter olive, make it cobalt oxide 2).
Terra cotta: Potclays orange stain 20, red iron oxide 8.
Black: black bodystain 45; or cobalt oxide 15, copper carbonate 15, manganese dioxide 15.
Purple: pink stain 25, cobalt oxide 2 (light) or 4 (dark).
Grey brown: crocus martis (purple iron oxide), 10–20g.

Mal Magson: Colouring Stoneware

Mal's favourite oxide is copper carbonate:
1 per cent copper carbonate in Potclays P1145/2: pale, cool, **lime green**.
3 per cent in P1145/2: warm **greeny-brown**.
1 per cent in P1119/2: light **greeny-buff**.
3 per cent in P1119/2: rich **tobacco-brown**.
Vanadium pentoxide ½–1 per cent gives warm buffs to dark **chocolate brown**.
5 per cent W.G. Ball's black bodystain: **black**.
Pure Valentine's porcelain: **white**.

Hanna Schneider: Colouring White Stoneware

Hanna uses a white firing T87700 Limoges French body; to this she adds 20 per cent Gerstly borate which will render her work watertight when fired at 950°C. To 1kg of the above she adds her metal compounds in the following percentages:

Copper carbonate: 3 or 5.
Chrome oxide: 1.50 or 4
Cobalt carbonate: 0.25; 0.50; 2.50; 4.
Red iron oxide: 5.
But Hanna uses commercial stains for her pinks and yellows:
Yellow stain: 10 per cent of No. 10078 Bodmer Ton AG (Einsiedlen, Switzerland).
Pink stain: 10 per cent of No. 279337 Lehmhus AG (Basel, Switzerland).

Eva Blume: Throwing Agate Stoneware; Combinations of Underglaze and Oxides

(Used in 1,000g of Potterycraft's white stoneware P1555)
Cobalt 2, chrome 4: **green** with a hint of **blue** and **blue speckles**.
Copper 4, black underglaze 40: **green stripes** bleeding into **dark grey stripes.**
Iron 12, cobalt 8, copper 8: **blue lines** with **greyish-brown** (this goes **black** in broader stripes).
Copper 4, cobalt 4: **light to dark blue** with broad stripes of **green** bleeding into white clay. (Lower the amount if it bloats.)
Cobalt 3, chrome 3: **bluish grey-green** with **blue speckles.**
Copper 4, turquoise underglaze 20: light **turquoise** with **green stripes** bleeding into white clay in places. (Lower the turquoise amount if it bloats.)

Emma Vaughan: Colouring Stoneware for Sculpture

Medium brown: 4 per cent red iron oxide.
Dark browny-black: 6 per cent manganese dioxide.
Sooty black: 3 per cent copper oxide.
Warm mid-brown: 10 per cent yellow ochre.
Grey-brown: 3 per cent nickel oxide.

I also use a black stain as a colorant of clay:
Black iron 20; manganese 20; cobalt 20; chromium 20. Add kaolin (or red clay) 8, feldspar 8, and flint 4 (if using as a stain, not an additive).

'This stain is very effective, deep dark black, and can have a green tinge when put on a white background. I use it brushed over wax resist print on a white-slipped, raw paperclay sheet before construction; it gives the form a pleasing "painted" look.'

Reg Batchelor: Colouring a Clay/Quartz or Feldspar Body

2 per cent black iron oxide: **pale pink** going to **tan brown** at 5 per cent.
8 black iron oxide, 3 manganese dioxide, 1 cobalt oxide: **black.**
2.5 manganese dioxide, 2 iron chromate: **light grey with specks.**
6 iron chromate: **grey-brown.**
2 copper oxide, 2 red iron oxide: grey-**brown.**
3 rutile: **tan,** darkening to 6 per cent.
6 ilmenite: **buff with specks.**
3 manganese dioxide: **light brown with specks,** changing to **dark brown with specks** at 6 per cent.
2–5 black copper oxide: **pale olive green,** darkening to a **charcoal** at 5 per cent.
3 chromium oxide: **grey-green,** darkening to **olive green** at 5 per cent.
2 nickel oxide: **tan,** darkening to 5 per cent.
5 red iron oxide: **tan,** darkening to **rust** at 8 per cent.
5 vanadium pentoxide: **grey olive-green.**

Jennifer Lee: Colouring with T Material

Jennifer uses oxides brought from abroad as well as Britain. With them she obtains her various shades of olive greens, slatey green-blues, pale ambers with speckled grey, and more recently, blues and bluey-greys.

1–1½ per cent cobalt.
½–2½ per cent copper oxide or carbonate or red copper oxide.
½–2½ per cent manganese oxide (or dioxide or carbonate).
½–2½ per cent vanadium pentoxide or oxide.
1–4 per cent iron oxide or red iron: **burnt sienna, burnt umber.**
1–4 per cent of basalt, or ilmenite, or iron spangles, or crocus martis.
Also mixtures of the above, such as copper and manganese or cobalt and manganese.

Sue Varley: Colouring 50 Per Cent St Thomas Body and T Material for Pinch Pots and Raku

Pink: very small amounts of red iron oxide.
Darker browns: 50 per cent terra cotta clay to 50 per cent of main body clay, and add red iron/manganese – but not too much red iron or bloating will result.

Andrew Davidson: Throwing Using T Material 3 to Red Clay 2

Oxides:	copper	¼–½ per cent
	cobalt	¼–1 per cent
	iron	1–5 per cent
	manganese	1–5 per cent

Bill Hall: for Colouring Both Earthenware and Stoneware

(Best temperature around 1,260°C.)
0.5 cobalt, 3.00 iron oxide: mid-tone to dark **grey** with a touch of **brown** underglaze.
0.25 cobalt, 0.50 nickel: mid-tone **greyish.**
0.25 cobalt, 0.50 chrome oxide: mid-tone **chromiumy-green.**
0.25 cobalt, 1.00 iron oxide: mid-tone to light tone **brown.**
1.00 copper carbonate: light, rich **brown.**
2.00 iron oxide, 1.00 nickel: rich mid-**brown.**
1.00 cobalt, 1.00 nickel: mid- to dark **greeny-blue.**
0.5 chromium, 2.00 iron oxide: mid-**brown.**
3.00 copper carbonate, 1.5 cobalt: dark **greeny blue.**
0.5 cobalt, 1.00 chromium oxide: mid-**chromium green.**
3.00 chromium oxide, 1.00 cobalt: dark **chromium green.**
3.00 copper carbonate, 3.00 chromium oxide: very dark **green.**
2.00 iron oxide, 1.00 chromium: mid-**brown.**
2.00 copper carbonate, 3.00 iron oxide, 1.00 chromium oxide: dark **brown.**
(These mixed into plastic clays)

Elspeth Owen: Colouring at Low Temperatures (reduction)

Elspeth mixes only small quantities at a time – never enough for more than two or three pots. 'I use two basic clays, one porcelain, one raku. Sometimes I colour [the coarse clay] by adding other strongly coloured earthenware clays; sometimes I just add oxides.'

Copper and vanadium together will produce yellows, reds and blacks.

Cobalt, chrome and vanadium together create greeny-blue and bluey-green.

Colouring Earthenwares

Alison Batty: Colouring at 1,180°C (Cone 4 Reduction)

In a body of 24kg (53lb) white earthenware; 9kg (20lb) stoneware St Thomas body; (Potclays) and 350–400g (12–14oz) molochite grog (medium).
Green: 330g (11oz) chrome oxide; 100g (3.5oz) cobalt oxide.
Green grey: 330g chrome oxide; 100g cobalt oxide.
Brown brown/pink: ⅔ sanded red Potclays 1131/40; ⅓ reduction St Thomas (Potclays) 1104; up to 5 per cent iron.

Alison Batty: Recipe for Vitreous Slip

White ball-clay SMD, 43; china clay, 43; lead bisilicate, 14; tin oxide, 8.

Jane Waller: Colouring White Earthenware at 1,120°C

Into a body of 1,000g with 100g molochite:
Apple green: 10 copper oxide, 10 nickel oxide.
Buff: 10 ilmenite.
Powdery mid-blue: 5 cobalt oxide, 20 black iron oxide.
Powdery mauve: 30 crocus martis.
Duck-egg powdery blue: 10 nickel, 5 cobalt carbonate.
Powdery pink: 5 black iron oxide, 5 red iron oxide.
Speckley mid-green: 20 manganese oxide, 50 copper carbonate.
Rich olive green: 10 chrome oxide, 5 zinc oxide, 5 cobalt carbonate.

Prue Seward: Slips for Earthenware Millefiori

Prue says that her pieces are usually her colour tests! But here are four recipes for making colour slips:
Blue: white earthenware 100; cobalt carbonate 5.
Green: white e/w 100; chromium oxide 7; cobalt carbonate 0.5.
Yellow: white e/w 100; W.G. Ball yellow bodystain 12; rutile 2.
Black: red clay 100; manganese dioxide 5; chrome 2; cobalt carbonate 1.

Effects & Economics

Different Tones

'Active' ingredients such as cobalt oxide, copper oxide and manganese oxide will nearly always give a lively surface. Stains can be darkened, too, by adding in black iron oxide, manganese dioxide or cobalt oxide. Some oxides can modify others; I find that nickel will produce fine shadings. And, of course, there is always variety if oxides are mixed with commercial stains. Over the past twenty years the colour range of stains available to the ceramic artist has increased enormously, and most colours are intermixable.

Speckling and Uneven Mixing

An obvious way to create speckling is to use coloured, grogged clay inclusions. Bill Hall's method is to use a low-fired coloured clay that has been pulverized and sieved, then mixed into different coloured plastic clays. Fred Gatley and Felicity Aylieff also use this method, but introduce their crushed grogs of various grades into white porcelain. Felicity also adds twinkling pieces of borosilicate and ballotini glass.

Both Alison Batty and myself have found that a quicker way to produce speckling is to add the stain to the grog before it is added to the body – you can do this either dry or damp. I find that if you dissolve the stain first with a little water, add the grog and leave it to soak overnight, then the grog gets coloured. This is lovely in a pinch pot where little speckles of grog stand out in an attractive manner, particularly if you use it in a body of a different colour.

Iron spangles and sometimes rutile will produce speckles of an interesting nature. Mal Magson has discovered that if 1 per cent vanadium pentoxide and 1 per cent coarse ilmenite are used together, they create a lovely brown speckled body.

Frank Hamer writes that rutile or titanium dioxide will pull colour in patches into the glaze, although this is only effective with a glaze covering. He gets colour variation by mixing some of his oxides dry then kneading into plastic clay; this ill-mixing of the oxides leaves the colour in specks, 'giving a bit of life' as he says. It will not work with commercial stains, however, as these are very refractory and produce 'dry' spots which resist the glaze.

Jennifer Lee always grinds her colours, but often leaves them unsieved to achieve what she calls 'surprise speckling'. On one occasion she tried incorporating filings from iron machine shops, but found they ripped her hands!

Linda Warrick leaves her stains to dissolve unsieved because, she says, 'stains not entirely homogenized produce a more interesting surface'.

I believe that variety in a single area gives richness of tone. This I achieve by not wedging my colours once they have dried sufficiently in my plaster moulds; instead, I pat them roughly into shape and then wrap them in polythene.

Colours from Contamination

Mal Magson likes the way that porcelain is often 'contaminated' when it is laminated. The layers

of stained clay can develop an attractive shadowing on the plain porcelain layers 'like bruised skin'. Mal and I have discovered that if certain stained oxides are left for a very long time to mature, sometimes the iron in the body oxidizes to form speckles; the clay also smells particularly mouldy.

Jennifer Lee finds that a halo effect can be created above a band of copper. This oxide 'leaks' or bleeds into the surrounding uncoloured stoneware in an enigmatic way.

Overloading

Dorothy Feibleman discovered that 'overloading with, say, copper oxide, produces a certain volatile effect in clay which contrasts with the layer of more stable clay next to it. Overloading with vanadium pentoxide, copper oxide or a lead-based frit in my Parian porcelain also creates tiny, even air-bubbles under the surface and a raised texture above it, as well as travelling.'

Bill Hall also notices that overloading with oxides brings interesting results, only you have to be rich to do this! Frequently the colorant acts as a flux, and obviously the greater the percentage of stain used, the greater the fluxing – and the greater the shrinkage. Usually it is the darker stains which are the strongest and can be used at less strength to avoid this.

Mal Magson, who runs a studio with a fast turnover of work, warns that 'the premature use of building with "short" clay is beyond sufferance and losses are too great. I find that three months is necessary for plasticity to develop.'

Modifications

Variation within the clay body can be achieved by including ingredients that will help modify colours; barium carbonate added to coloured clay will alter colour, and so will nepheline syenite. Bill Hall suggests adding alkaline materials. Opacifiers such as tin oxide, zirconium silicate, titanium dioxide or zinc oxide can also be used as modifiers.

Zinc

Zinc is an interesting addition, and its use has drawn different responses. It is especially active in mixes involving cobalt, where it is meant to sharpen and brighten the colour – but both Frank Hamer and I find in our tests that it seems to have the opposite effect, that of dulling the colours. For instance, when I need mid-powdery tones, I find that zinc softens many harsher colours.

Reg Batchelor advises not using zinc oxide for this very reason: he says, 'it will give you no colour, it can be a vicious flux, and destroys many other colours … this also applies to zinc glazes.' Alison Batty, on the other hand, finds that a glaze containing zinc oxide will produce interesting brown hues over her chrome/cobalt bodies in a reduction firing. Finally, however, Frank Hamer warns against using any mix that would bring chromium and zinc together; for example, a zinc glaze over a chromium green stained body will produce an unpleasant khaki brown.

Vanadium Pentoxide

Vanadium pentoxide is perhaps the most exciting stain to experiment with, but it is toxic and highly volatile. It has the advantage, however, of achieving an Indian or 'hay' yellow at high temperatures. Jennifer Lee produces some subtle yellow tones by using vanadium, and will 'add it to any oxide'.

Mal Magson gives it as one of her favourite oxides despite, she says:

> … its expense and tenacious yellow stain; the latter can be accommodated, however, provided you treat it with great respect, wearing rubber gloves because of its water solubility. Best of all is the pattern of drying which arises out of its solubility; it migrates with the evaporating water into the upper surfaces and edges of the form, creating a two-tone pot which stays light-coloured underneath. But beware: used at too great a strength, it forms a hard coating when dry which cannot be scraped off, so the form must be modelled and refined at leather-hard stage; ½–1 per cent is sufficient. For instance, ½ per cent vanadium pentoxide and 1¾ per cent copper

carbonate creates a lovely brown which often dries in an interesting and uneven way.

Alison Batty has discovered that a vanadium slip over an iron body often turns out like an orange Shino glaze in a reduction firing.

At lower temperatures, yellows can be obtained where the iron oxide is already bleached to ochre by calcium chloride (lime); if sufficient lime is present, the colour remains, even under a glaze. But the lime must not become involved in fusion, so that this makes it mostly a low temperature colour (under 1,100°C). At higher temperatures the glaze must contain over 20 per cent calcium carbonate – thus it is a matt glaze.

Elspeth Owen cannot resist using vanadium in her low temperature firing: 'Although highly volatile and toxic,' she says, 'it seems to have the effect of softening and making other colours more diffuse.' But she says, 'I am looking for a vanadium to use with my white clay, so if any-one knows of a source of vanadium oxide – a white, not an ochre-coloured powder – please let me know.'

Modifications with Reduction Firing

Christine Niblett offers two exciting ideas to try with porcelain:

i) By overfiring slightly in reduction, a stripe of black, body-stained porcelain will stand raised from its background because of the excess of oxides in this colour body; this gives an interesting, slightly textured effect.
ii) Flashes of copper red can be obtained in a black and white piece by placing a black body stripe alongside a plain body, because the copper in the black will sometimes flash into the plain in reduction.

Jack Doherty has produced reactive, interesting, but often unpredictable colours in his reduction firing by adding oxides to the body-stains, for example materials such as rutile or iron spangles at 1–3 per cent. Then both are added directly to the clay body, though he admits to having occasional problems with these fluxing glazes.

I often add iron spangles to other oxides for my pinch pots, and find interesting pitted effects occur when I raku the results.

Cutting the Cost

Water-soluble Chlorides

Harry Fraser and Amy Mumford offer advice on using cheaper chlorides with startling effects (*see* Chapter 11).

Painting Pigments

Jack Doherty has been modifying painting pigments to produce more subtle colours; he says, 'Making "home-made" bodystains has been most interesting, and I've found I can produce very intense colours, blacks, browns, sea-greens . . . because for the past seven years all my work has been soda vapour glazed.'

Ewen Henderson has been buying pigments for his work from a shop in East London that sells pure pigments cheaply (*see* page 157).

Saving on Colour in Porcelain

Judith de Vries uses a white background, to save the expense of using coloured clays for the whole of the piece. This, she says, has the added advantage of 'showing the patterns up'.

In my millefiori pieces I often surround the pattern with the body clay. This prevents one pattern from being melded into another, but it can also throw the pattern forwards, like pieces of heated glass millefiori picked up and blown as part of the walls in a plain glass goblet or bowl.

Recycling Oxided and Stained Clays

Every artist who uses colour in the clay body knows that the cost of staining clays is high, so

oxided or commercially stained scraps should never be thrown away, but kept to be recycled, even if it is only to make a further colour or a background colour. All ceramists hate waste – Dorothy Feibleman, for example, has several kitchen blenders used specifically for quick reprocessing of small batches.

Anne Lightwood tells us that 'all the bits from making my bowls are kept in boxes labelled "mostly pinks" for warm colours, or "mostly greens" for greens and blues. These are then soaked down, wedged lightly –not too much or it goes muddy, like plasticine – then used again.' Anne produces wall-pockets and vases from marbled clays from these reconstituted scraps, making her largest bowls first, then smaller ones, 'gradually getting down to the tinies from scraps, which make good kiln fillers.'

Making Black and Grey

Linda Warrick says, 'My stained clay for recycling gets made into black. In that way I try to avoid waste.'

Mal Magson dries her laminated scraps right out, then mixes them with 50 per cent dry clay to give a good grey.

Thrown Leftovers

Jack Doherty uses scraps to make the darker colours. 'Trimmings of coloured clay from the wheel are already of a reasonable size to dry out for re-use.'

Andrew Davidson always collects wheel turnings and scraps which are mixed and recycled, and 'the resulting pots usually fired with a plain glaze, and placed in the kiln in such a way that the passage of flames and gases gives patches of colour and varying texture.'

Marbling Leftovers

Obviously any trimmings softened down a little can be wedged lightly so the colours are marbled together for a new patchwork slab; this can then be cut across into slices, or rolled out into a long coil and sliced through. I used to mix my mille-

fiori pot-scrapings to make different greys, sometimes with the addition of a little nickel or black iron oxide.

Sedimentary Millefiori

A serendipitous event resulted in my being able to make a whole new line of ceramics. I used to leave all my pot-scrapings in a plastic bowl next to where I was working, watering this down to make the usual grey. One day I had a *plaster* mould ready to make a millefiori bowl, with the dampened cheese-cloth stretched ready inside, but absentmindedly I began putting all my scrapings into this plaster mould instead of the plastic bowl. In that instant, 'sedimentary millefiori' was born, and now I can recycle larger pieces of clay, already patterned pieces, down to the tiniest specks.

METHOD: Layers of scrapings from the metal kidney and the like are scattered into the plaster mould until it is full to the brim. Then slowly and carefully I pour on clean water. Overnight this permeates the layers of scrapings, which sink down as the water is drawn off into the thick walls of the mould.

When the residue has dried almost to leather-hard, I lift it out carefully by means of the excess cheese-cloth draped over the mould sides; then I fold the cloth around the lump, and pat it roughly into a block. Next, I compress this (like making a cream cheese) under a weight – in my case, a large Victorian flat-iron left by the cobbler who used to work in my cellar!

Once the block is leather-hard, I roll it into a thick coil and cut slices through; or I wait until just beyond leather-hard, then cut the slab through to make larger pieces with a more static patterning. These are strangely light and very strong when they are beaten with the pestle to become part of the new pot wall, rather like volcanic tufa – *every speck of colour is sharp* when the multicoloured pot wall is scraped down. I often introduce some 'patchwork millefiori pieces' into a new bowl, as I know their colouring and pattern will be a total surprise for me – and the rest of the bowl – when I open the kiln after firing. This is where I think the expression 'pot luck' really came from.

(*See* Oolitic bowls and Michele Zack's pieces using recycled coloured clays.)

6 Glazes & Surface Effects

The chemistry of glazes is fascinating. It is the question of getting the glaze to coat the ceramic body properly, in the grooves and the raised sections, to get it to sit properly on the rims and reliefs, to get it to skim down over a curved surface – the glaze will always be set in relation to the ceramic form. New glazes inspire new forms, new forms inspire new glazes, a continuous reciprocity which keeps the process alive.

Tove Anderberg

Many ceramic artists let the stain and clay speak without the need of a glaze. If the work is burnished first, it can achieve a natural appearance similar to a pebble washed smooth by the sea, and subsequent sandings with carborundum paper or finer emery papers between firings will only give a further silky smoothness to a porcelain or white earthenware. A few ceramists go even further and sand after the final firing, using power tools to obtain the correct surface feel and required appearance.

Many porcelain workers seek translucency. David Hewitt, for example, fires up once to cone 5–6 for his thrown porcelain, but to cone 6–8 if some translucency is desired. Others, such as Susan Nemeth or Anne Lightwood, fire to vitrification without a glaze, then wax their bowls.

TIP

Anne Lightwood says: 'I warm the bowls in the kiln, then spread on a thin coat of beeswax, and I polish the next day. This gives a surface like eggshell, with a sheen but not shiny. Best thing is to have a slave to do this for you – it is very boring! But as three of my assistants have gone on to Art College it can't be that bad!'

Another way to bring out the colours without a shiny finish is to use a dry glaze.

Dry Clay Glaze

Heather Graham dry glazes her thrown agate pots, firing them to 1,235°C in an electric kiln with an hour's soak. She adds small percentages of oxide to the glaze: 2 per cent copper or 1 per cent cobalt. She adds the cobalt after sieving because she 'likes the speckles'.

whiting, 45
china clay, 45
ball-clay, 10

Raw Glazing

Raw glazing is a delight. And it reduces the time between making and having fired a pot. The glaze fuses more completely and intimately with the body, seeming to allow more interaction between layers and between oxides and glaze.

Andrew Davidson

Andrew uses raw-glaze recipes from Lucie Rie, but with some additions of barium, lithium or china clay. Once Lucie had argued for the advantages of applying glaze to bone-dry pots, he has never biscuited pots since. Occasionally he has lost pots which have cracked, but, as Andrew Holden wrote, 'the process tends to weed out badly made pots.' Andrew has compared the shards of once- and twice-fired pots, and finds the union of the glaze more integral with raw-glazed work.

Pots to be raw-glazed, whether the glaze is dipped or painted on, must be dried out thoroughly before firing to 1,260 °C. (Andrew uses a gas kiln.) Also they should be brought up very slowly until the chemical water has been driven off (Lucie Rie's firings lasted over three days to make quite sure of this).

Usually a glaze veneering a stain needs to be transparent or translucent, not only to allow the colouring through, but to enhance it. Most oxides act as fluxes, reducing the melting-point of a glaze, and one oxide can produce a wide variety of colours. Also, colours used in the body will be altered by the kind of glaze applied above, depending on whether an alkaline or lead glaze is used: for example, copper oxides will tend towards blue under an alkaline glaze and green under a lead glaze.

Occasionally an artist, such as Eileen Newell, will choose to glaze only in certain areas, or to bring the colours out by firing with combustible materials. Elspeth Owen recommends reduction, 'especially localized reduction, which introduces a range of colours on one pot which is not achieved in an oxidized atmosphere.'

Reduction Glazes

Andrew Davidson, firing in his gas kiln, has discovered that changing the major flux or adding small amounts of different fluxes to the glaze base affords an endless variety of differing results. He explains that:

> Combining layers of different glazes to achieve effects, or applying just one glaze over coloured clay is both simple and satisfying. For example: copper can give orange, brown, grey and black; cobalt can give various shades of blue under a whiting-base. Iron gives tan to brown, and manganese also gives tan to brown, but different shades from iron and manganese sometimes gives a pink in combination with copper.

Tip

Adding barium enhances the pink used with a dolomite glaze over clay stained with cobalt.

Emma Vaughan recommends a barium glaze for sculpture, to bring out good colour changes in copper/cobalt/manganese – also the pleasing natural effects from yellow ochre and vanadium pentoxide.

Alison Batty talks about the excitement of using a glaze base over chrome/cobalt bodies which contain zinc oxide. These will produce brown hues in reduction, but if this glaze base has a high enough tin oxide content, then it is fairly safe to assume that you would get a beautiful pink colour. Sometimes she will place crucibles of salt, chrome and tin or copper oxide next to or near a piece … 'to create a surprise'.

Detail of brown agate bottle; oxide clay mixture plus copper and whiting dolomite glaze. Andrew Davidson (Dorset, England).

Transparent Glazes

If you are content with the glaze bringing colour out gently, then some straightforward transparent glazes can be useful. Here are four which can be used in a reduction firing:

Transparent Glaze Reduction Cone 9–10
Hans Munck Andersen

whiting, 12.5 per cent
zinc oxide, 8.8
feldspar, 68.7
flint, 10
(add iron sulphate 1.25 per cent)
Apply thinly over slips and coloured porcelain body.

Transparent Glaze Reduction 1,300 °C
Henk Wolvers

flint, 20
quartz, 30
feldspar, 50

Transparent Celadon Glaze Reduction
Naomi Lindenfeld

For cone 10–11 porcelain
whiting, 750
silica, 1,750
custer spar, 3,250
red art, 600

AND

custer spar, 440
F-4 feldspar, 180
whiting, 400
EPK, 320
silica, 640
bentonite, 40

Some people opt for convenience, using a commercial ready-mixed transparent glaze; often this is used to glaze just the inside of a vessel. Judith de Vries says, 'I don't want to spend too much time making glazes. I can do this, and did so in my early days, but having a household and family now, I don't see why I should make my own glazes.'

But each home-made glaze has a character of its own. And when an organically produced material is an important part of the whole process of your ceramics, then Danish artist, Tove Anderberg, is a good person to emulate.

Ash Glazes

Tove Anderberg

Tove Anderberg has chosen to make her own ash glazes, clothing her work organically. She is continually experimenting because, as she says:

> Matching glaze to body thickness is a difficult balancing act; I can sit searching for the right glaze for hours. The clay and glaze each have a life of their own, which has to be fathomed to be understood. Much of my work has been a long passage through the magical world of the glaze. One is close to the occult and alchemy when concentrating on the firing of glazes. When I am deeply absorbed in the process I quite forget myself, and wander around amongst the buckets, ashes and liquids like a witch, quite filthy dirty.

Tove fires in an electric kiln, and her experimentation has led to the use of willow, rowan, pine, volcanic ash – 'even human hair burnt to ash is incorporated in my glaze.' Making ash glazes from local organic ingredients (if you are lucky enough to have access to some) is a wonderful way to develop a highly personal way of creating a coating that will allow the colours to sing through the clay body where they are lodged. With ash glazes, the degree of softness of the ash determines their application.

Tove divides hers into soft, medium or hard groups, knowing that an ash can be used both as flux or a stabilizer, the coating made clearer by using hard ash, or more subdued with a light, soft ash. Ash can also be used to create structure, and Tove says, 'One of the special applications which I have discovered is to induce a localized reduction by retaining carbon particles in the glaze. I reduce the oxygen at the end of the firing, and when the charcoal burns, scattered changes of colour are produced.'

Alison Batty's Wood-ash Glaze for Cone 4 Reduction

Alison uses a wood ash over her stained body and vitreous slip (*see* Chapter 3), and the results can range from greeny-grey-blue to brown/pink. Her recipe is:
wood ash, 50
low alkaline frit, 50

Tip

Chrome, when incorporated into the body, is fugitive and will escape to contaminate the other glazes, even in the next firing, so use saggars if you don't intend to stick to the same work throughout the kiln.

Teena Gould's Ash Glaze and Barium Glaze 1,250°C Reduction

Teena tells us that:

All the glazes are layered at different thicknesses over my work: very painterly. Some I use as a really thin wash, and others are thick and applied with a slip trailer. Often I rub parts off so that they remain in the crevices. I have two favourite glazes which, in combination with the coloured clays, slips, oxides and other glazes, give me the responsive variety, particularly with the firing – I fire to 1,250°C in a small reduction gas kiln (I biscuit-fire in a larger electric kiln to 1,000°C).

Teena Gould's Ash Glaze
ash (sieved and washed), 4
potash feldspar, 4
china clay, 1
ball clay, 1
quartz, 1
(This is a good base to which to add oxides, particularly red iron or copper oxide.)

Teena Gould's Pink/Turquoise Barium
barium carbonate, 20
nepheline syenite, 40.5
potash feldspar, 37.5
china clay, 2
copper carbonate, 2

Sawdust Firing

Sue Varley sawdust-fires pinch pots, often after firing to 980°C or even stoneware temperatures. The clays she uses are equal quantities of St Thomas body, T material, crank or fireclay, all with oxides in the body (*see* Chapter 3). Extra grog, sand or fireclay may be added to create more texture, and occasionally Sue uses porcelain, liking 'its smooth quality contrasting with the rough grogged clay – though sometimes this separates at the drying stage!'

Sue Varley's Sawdust Kiln

Sue's sawdust kiln is built on a concrete slab. She rebuilds it according to need, varying it in size and shape for each firing.

Method:
After the first layer of bricks has been put down, I lay a sheet of wire-netting across the space (this prevents the bottom layer of pots from falling and maybe cracking); I fill this area with sawdust, then build the bricks up, placing the pots inside as I work.

When there are several layers of pots (each layer separated by wire-netting) I fill the whole space with sawdust, inside the pots, around and over them. I then light a fire of twigs and pieces of paper, and cover the top with an old kiln shelf.

I leave the sawdust to smoulder for twenty-four hours. I realize the pots could be fired more quickly, but I prefer to let them heat slowly.

Tips

- If you use an alkaline raku glaze on the pot, or part of the pot, and fire to 980°C in an electric kiln prior to the sawdust firing ... 'in a kind of slowed-down form of raku' ... you will get some interesting results.
- Perhaps give a wash of cobalt oxide, before re-firing to 1,260°C for more surface colour variation.
- If you paint earthenware pots with wax, sometimes over contrasting coloured clay or on a plain bisqued surface, then glaze with an opaque or clear glaze to 980°C prior to the sawdust firing, you can obtain contrasting areas of smoked grey body and crackled shiny glazed surface.

*T*hrown agate with copper clay spirals under a transparent raku glaze. Heather Graham (Norfolk, England).

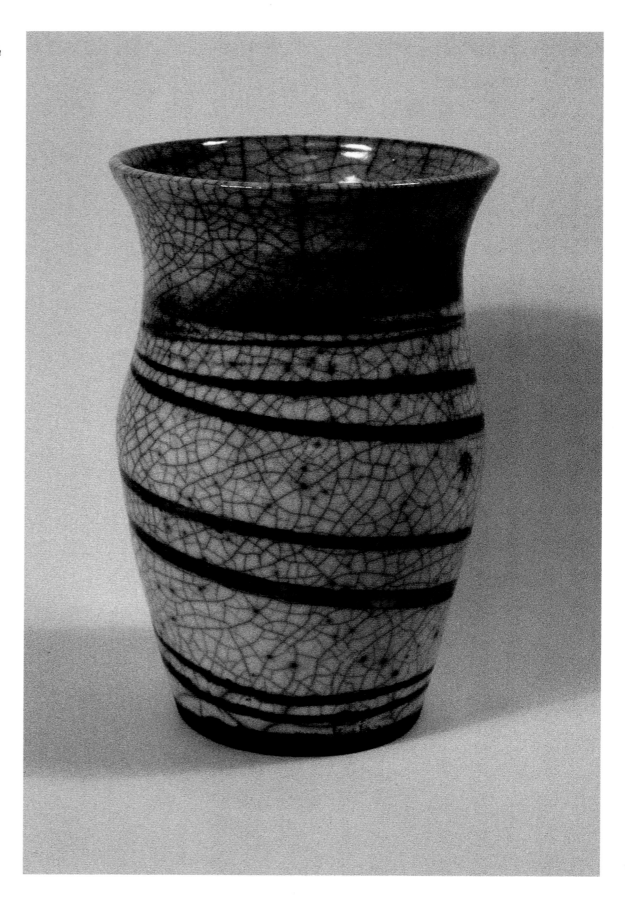

Raku Glazing

I raku-glaze all my pinch pots, and occasionally some of my more robust millefiori pieces. I usually use a soft alkaline glaze because this allows the colours to show through softly and not too shinily.

85 per cent any high alkaline frit
15 per cent ball-clay
(Add 2 per cent glaze suspender)

My pots are glazed quite thickly using a house-painting brush, then smoothed over with my fingers when dry. (Allow the glaze to get really shiny before taking the vessels from the kiln.)

Heather Graham on Raku

After recently investing in a raku kiln, Heather Graham decided to try rakuing some of her thrown agate ware. She used a clear glaze over copper bands, keeping the bands crisp (see her agate work) but not cleaning off the top layers, which glow through in varied copper tones from differing densities of this oxide, while the strong spiral bands have taken on its metallic sheen when copper in reduction is used more densely still. The natural crazing of the raku glaze makes a third layer.

There are some pleasing contrasts going on between the different surfaces and tones – all from using one oxide – and 'this may be a very exciting path to follow,' Heather says.

Jo Connell on Raku

Jo thinks that using copper oxide in the clay for raku 'gives a good deal of scope. It makes for a range of shades of greens through reds to bronze, depending on the degree of reduction.'

Salt and Soda Glazes

Jo Connell says that a salt or soda glaze over coloured clays 'creates interesting effects, breaking up the structure of the design to some extent.

Subtle colours tend to be lost, though – cobalt and iron seem to work well. Similarly, reduction firing with a feldspathic clear glaze is rather nice.'

Soda Vapour Glazing

Jack Doherty has been soda vapour glazing his work for the last seven years, using sodium bicarbonate sprayed into the kiln at cone 8, then fired to cone 10 in a propane kiln. He says:

> In the earlier work, the decoration and surface was covered with glaze which I found sometimes obliterated interesting qualities. With this way of firing, the glaze surface 'grows' from the pot, with all the surface marks exposed – whether good or bad! The soda highlights and enhances the surfaces.

Earthenware Glazes

I like to use a matt semi-transparent glaze for my millefiori work so that the colours will emerge with a diffused warmth, thus being absorbed rather than bouncing off the surface. My favourite is a lead bisilicate one, firing between 1,080–1,100 °C:

lead bisilicate, 64
china stone, 9.4
china clay, 21
whiting, 5–10

Two other good glazes to use over white earthenware or coloured slips are:

Annie Turner's matt glaze 1,140 °C
lead bisilicate, 26
borax frit, (any) 36
Cornish stone, 12
ball-clay, 4

Mary Wondrausch's clear earthenware glaze
lead sesquisilicate, 75
china clay, 18
flint, 6

All these glazes should be applied not too thick, not too thin.

Prue Seward's Clear Earthenware with Alkaline Base
(for health and safety, fire to 1,100°C)
borax frit, 40 per cent
alkaline frit, 40 per cent

wollastonite, 5 per cent
barium carbonate, 6 per cent
zinc oxide, 3 per cent

S alt-glazed vessel using iron, cobalt, ilmenite and porcelain on white stoneware clay. Jo Connell (Warwickshire, England).

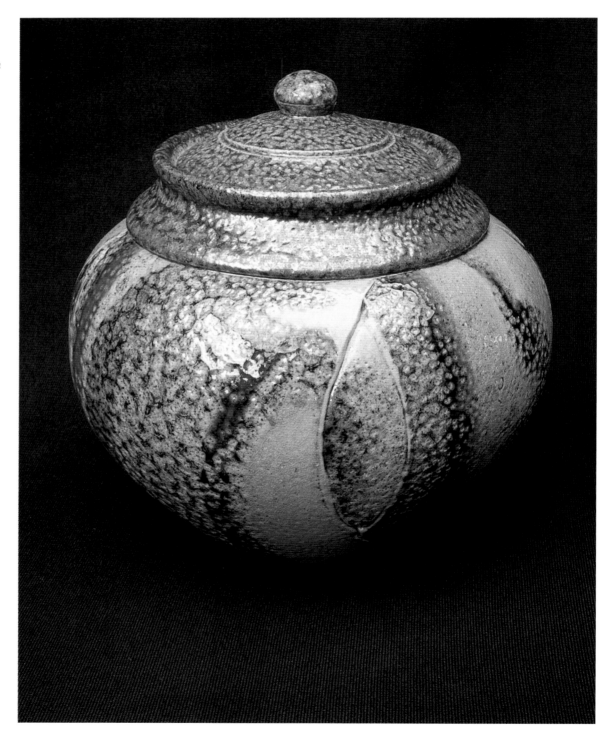

7 Throwing

Lucie Rie (1902–95)
Throwing with Spirally
Mixed Clays

A key moment in the history of modern ceramics came in early 1967 when Lucie Rie experimented by using colour right inside the body of the clay. She threw a pot from two differently stained wedged balls of clay that were 'pressed together but not mixed', as she later described. When these were drawn up on the wheel, a spiral pattern was created, the final surface of this patterning revealed neatly and clearly as the leather-hard pot was turned. Lucie was the first person to use this method in Britain.

TIP
'The spiral pattern is particularly clear if the potter uses very little water in the throwing,' was her advice.

As early as the 1950s, Lucie was encouraging colour through the top layer of her clay by inlaying sgraffito patterns. These grooves ran horizontally, or later became cross-hatched in her 'knitted' pots, made by using a slowly turning wheel, and the patterning might appear on both the inside and outside of her bowls. They were filled with such colorants as lead chromate, painted on, then sponged off.

By the time she threw her first spiral pot, Lucie was well versed in the mixing of oxides. Her

'Blue and White Spiral Vase'. Lucie Rie.

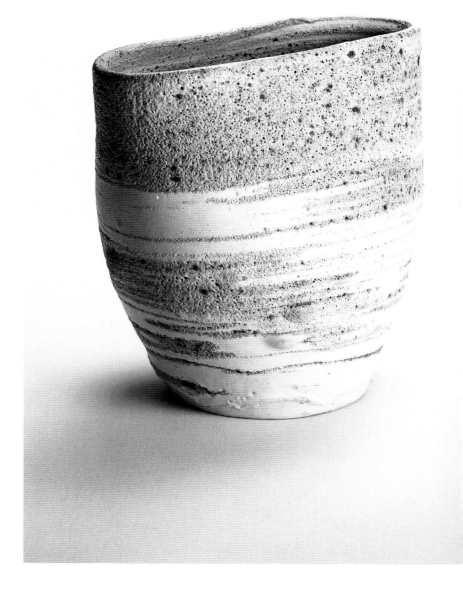

'Celestial Bowl'.
Lucie Rie.

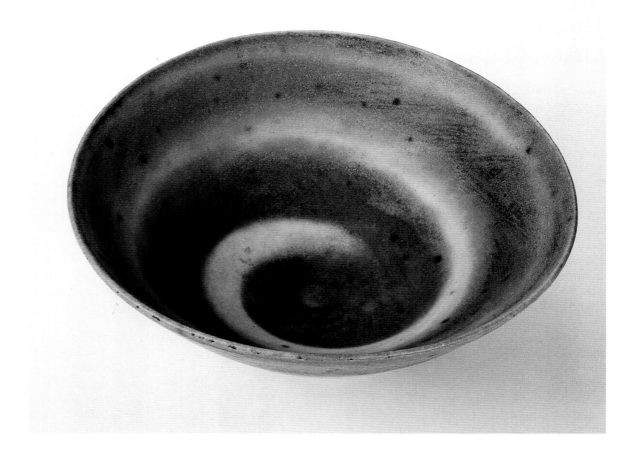

combination mix for this first spiral was manganese dioxide, 1.5; copper oxide, 0.25; cobalt 1 per cent, or iron. However, she quickly discovered that metallic oxides in the clay have the habit of affecting the expansion and contraction rate once the body is subjected to heat, and some of her early pieces cracked.

Lucie continued spiralling clays throughout her life, sometimes throwing a dark-stained clay with a darker spiral colour; sometimes forming tapered cylindrical vases with oval or inverted rims; or, in the 1980s, deep conical bowls on raised feet. A particularly beautiful example is

TIP

Add feldspar to the main clay to match the coloured clay. But how much? Lucie doesn't say. Tony Birks suggests that about 2–5 per cent should do the trick, and this would be a good tip to follow. You could adjust the amount through experimentation.

illustrated by one of her 'celestial bowls' in which the spiralled bands of colour unfurl dramatically from the pot's centre like the twin arms of an expanding galaxy.

A pale, soft glaze was painted – not dipped – onto her coloured clay pots when green, and only fired once. Through this brushwork of translucency, the darker spiralled pattern glows warmly. The combination of glaze and patterning in the body gave tremendous depth of field to Lucie's pots, automatically rendering the inside as important as the outside. And Lucie was as experimental with her glazes as she was with her oxides, often layer-painting one glaze over another: a pitted, grey-white glaze speckled with brown; a green-buff glaze with white streaks and black spots; a heavily pitted, streaked glaze; a cratered white glaze …

From the final years of her potting career in the 1990s, a stunning porcelain unglazed bowl boasts contrasting spirals of lime-green and pink covered with both a streaked and bubbled glaze.

Andrew Davidson: Thrower of Spirally Mixed Clays

The technique of colouring clay is magically satisfying. You only have to look at the number of people doing it to know that it is worth trying yourself … to try the endless variations and blends of stains and oxides.

Andrew Davidson has been working with coloured clay for three years. At the time of writing he teaches at the Bournemouth and Poole Colleges of Art and Design, and he has been elected a Fellow of the Dorset Craft Guild. Although he was influenced by Lucie Rie's colours, Hans Coper's shapes and Ian Godfrey's attention to detail, Lucie was the only one whom he met. He simply telephoned and asked for a visit – Lucie found this quite amusing, and told him when he arrived that he was 'just a bit cheeky'. But he was allowed to visit her on a number of occasions, and was given recipes to try which he is using and developing. He especially likes her spiral pottery.

His pots, vases, bottles and bowls, each group evolving from the one before, have a quiet quality, and follow Lucie's easy and effective method,

spiral bands that will always lead the eye from the base of the pot upwards, and with edges which meld softly into surrounding areas. Andrew loves 'anything worn away and smoothed by time … or things half-seen in dreams or out of the corner of the eye.' Not surprisingly he looks back to the past for his inspiration, to artefacts from ancient cultures, whether ordinary, special or ceremonial.

METHOD: Andrew uses red clays, both local and bought; and stoneware bodies with combinations of T material – though due to the ever-increasing cost of T material, he has tried out different white grogged clays, such as V material, with good results. His porcelain is based on the Bernard Leach recipe with oxides added (*see* Chapter 4): this is done by throwing out a rough slab of weighed clay, the surface of which is then dampened and the weighed amount of oxide sprinkled on top. The clay is wedged and mixed, and then left for at least a few days before being kneaded prior to use.

Andrew not only 'bangs' two lumps of differently coloured clay together as Lucie Rie did, but he will insert one cone of clay inside another; or he will slap small balls of one clay onto the surface of another ball; or he will roll out two coils of differently coloured clays, combine them loosely, and bang the lump together with a lump of plain clay. All these variations are

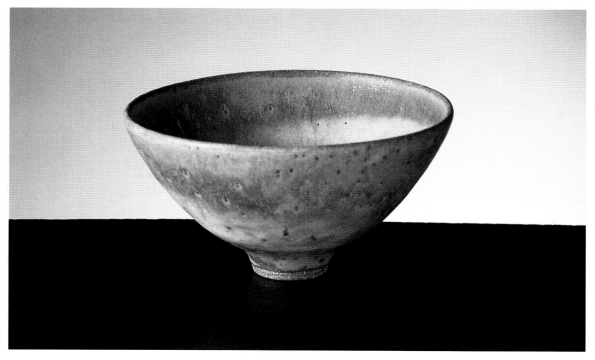

'Bowl'. Oxide clay mixtures plus copper, whiting dolomite glaze (width: 15cm/6in). Andrew Davidson (Dorset, England).

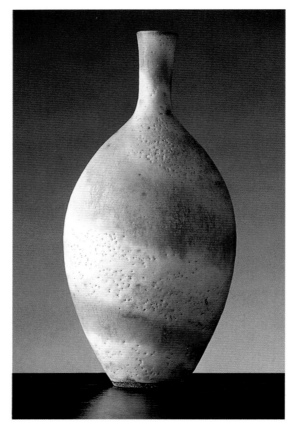

'*Oval Bottle'. T material and red clay, plus oxides, whiting glaze (height: 34cm/13.5in). Andrew Davidson (Dorset, England).*

affected by the amount of coning the clay has on the wheel to give looser or tighter spirals.

TIP

The definition of the spirals is affected by the speed of throwing.

Andrew finds that some of the best areas of colour are produced where the different clays overlap, and these often suggest new blends to try. Adding oxides to porcelain has taught him that 'less is more. The first porcelain pots I made were horrible,' he admits, 'much too dark and bloated. However, with further experiment, some very delicate colours have been produced.'

FIRING: Andrew raw-glazes his work when bone-dry to 1,260°C in a gas kiln. The particular fusion with glaze and clay body given by raw-glazing softly discloses the spiral's different intensities over areas where the coloured clay is stretched thinner or left thick. His glazes are minor variations on Lucie Rie's, and deliver the same appealing opaque warmth as her ceramics (*see* Chapter 5).

Peter Lane: Throwing Outer Spirals in Porcelain

Lord Eccles describes a good pot as having 'a quality of stillness'. I aim to reach towards that … My vessels exist as visible statements of feeling, both physical and emotional. The fact that these objects can be categorized as 'vessels', following on from centuries of similar domestic and ritualistic forms, is secondary to me.

Thirty years of teaching, as well as writing some excellent pottery books, has left Peter Lane with a feeling of urgency, that he should make the most of the little time available for him to do his own work. This has drawn him to the wheel as a rapid means of developing three-dimensional forms. He uses porcelain because it responds well to colour and is a medium which suits his perfectionist nature. He says, 'My bowls rise up and outwards from comparatively small bases, attempting to capture an elegant purity of line.'

Peter uses colour in the body only from time to time, and his particular style chosen for this method is to make bowls which have a white inner surface and a patterned outer wall because, he says, 'This technique allows me to have rather more control over the distribution of colour than one would have by wedging white and coloured bodies together beforehand.'

Peter is currently influenced by weather patterns and the search for light and colour through the constant greyness of so many English winter days! 'I can create my own illusion of bright sunshine,' he says, 'or suggest mood through soft gradations of colour and tone.'

METHOD 1: Coloured porcelain pieces are inlaid into a roughly centred lump on the wheel, then Peter centres and pulls up his patterning into a bowl or a 'closed' form. In this way, the colour appears as spiralled patterns on the outside only of a piece. To do this, Peter cuts V-shaped indents into the roughly centred clay, and inserts coloured porcelain pieces – which must be of exactly the same plastic consistency – before continuing to throw.

METHOD 2: Coloured porcelain slips of a fairly thick consistency (just short of normal plasticity) are inlaid into linear patterns drawn

through the surface. These grooves are made using metal tools that Peter has constructed specially for his method: he grinds away the two corners from the squared end of a metal strip to leave a projecting tongue, which is then bent over with pliers at right-angles to the main part of the strip. This allows him 'to draw a line quite freely around the form'. These waste-steel strips can be collected from building sites.

The lines are of even width and depth, and are drawn into the surface when the pot is leatherhard. At this point a thick slip is pressed in firmly, left slightly proud to allow for any shrinkage; the whole surface is subsequently scraped level, when 'hard' leather-hard.

Peter uses straight stain colours inlaid into Harry Fraser's Potclays 1149. 'Combinations are carefully chosen … and black is often used to act as a foil, emphasizing the brightness by direct contrast, or to make a stronger statement at the rim or at a contour change.' Occasionally he uses metallic oxides and carbonates to colour his inlays. To mix the stain more easily to more or less 15 per cent of the body, he powders the clay first.

Work made from both methods is left unglazed, but each piece is polished with silicone carbide paper after firing to 1,260–1,280°C to help towards attaining perfection.

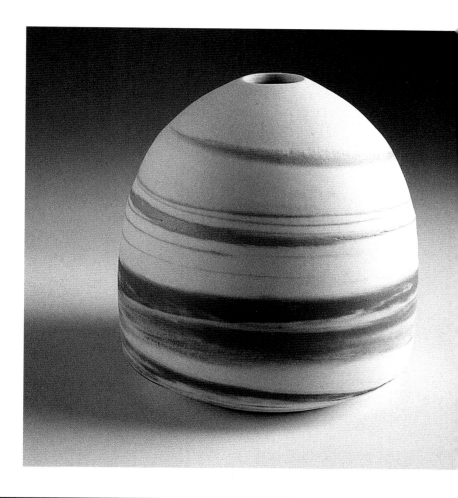

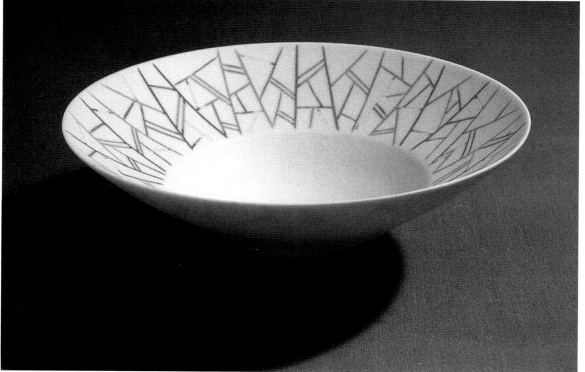

'*D*omed Pot'. *Thrown and coloured pieces of the same porcelain body were added after centring before throwing continued. Peter Lane (Hampshire, England) (above).*

'*F*ireworks'. *Incised and inlaid technique using thick coloured slips (stained from the same porcelain body) using the 'lining' tool (width: 21cm/8.3in). Peter Lane (Hampshire, England).*

David Hewitt: Thrown and Fluted Agate-ware

With normal thrown work, each repeated batch needs to look similar. Working with coloured clays is quite different. The strength of the colour may be the same, but the distribution of each piece is unique ... also one doesn't really know how it is going to look until it is turned up.

David Hewitt works in Newport, Wales. He is a thrower who, after attending a course by David Leach, fell in love with the technique of fluting the outer surfaces of vases and bowls. 'Fluting,' he says, 'is a natural thing to try with coloured clay work. The results seemed to be dramatic to me, and so it has become a regular feature of my work.'

David's background as a mechanical engineer has helped him to develop what he describes as a 'strictly practical approach to potting'. Pursuing this sort of method he has noticed that when using coloured clays, one of the variables that causes the distribution of colour in each piece is 'the moisture content of the bulk of the clay, the white part, and the smaller amount of coloured clay. As the coloured clays are prepared in 1kg batches, which may be kept for some time before use, they may vary from the bulk of white clay in this respect.'

METHOD: It is obviously important to use a smooth white clay, like Potclays porcelain 1147, for this method. David has chosen two combi-

nations of colours to go with this white base: blue and pink, and green and brown, as 'these go together well and seem to fit the current fashion in colours' (*see* Chapter 4). These colours are wedged into 1kg clay as a thin paste mixed with water until a uniform colour is achieved. The throwing procedure varies according to where he wishes the colour to show, whether both outside and inside, and also whether fluting is done:

1. **For a bowl** requiring 1kg (2.2lb) clay, 150g (5.2oz) of each colour is weighed out – say, blue and pink – with the balance of 700g (25oz) of white clay. The white clay is wedged and made into a brick shape so it can be cut into approximately three pieces. Each weighed piece of coloured clay is made into small squares and cut in two. These are then assembled like a layered cake and very lightly wedged to enable throwing (too much wedging and you obviously end up with an unsatisfactory result).

2. **For a vase** requiring colour only on the outside: 6mm (¼in) lengths of colour are extruded through a die of 6mm (¼in) diameter and cut into lengths. For a piece requiring 1kg (2.2lb) of clay, pieces are cut to 125mm (5in) long, or for a 400g or 600g (14 or 21oz) piece, 75mm (3in) long. Wedged white clay is made into a brick the same length as the coloured lengths, which are now assembled around the outside in twos and threes or fours on each side according to the weight of the piece thrown. By dropping the 'brick' on each side in turn, the coloured stripes are pressed firmly into the brick. The lump is then just coned in the hands ready for throwing;

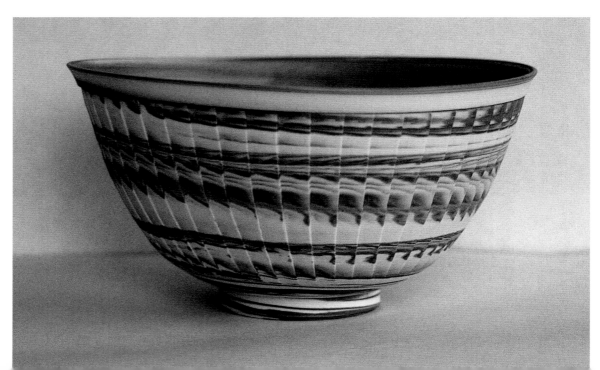

'Fluted Agate Bowl'. David Hewitt (Newport, South Wales).

this starts the spiralling effect without the need for wedging, which means that less coloured clay need be used.

Throw the pot in the normal way, and do not be concerned that not much colour is visible. When leather hard, turn up all exposed surfaces to reveal the coloured clay. 'This is the exciting stage as one sees a different pattern every time – even more exciting is to flute the outside, for as you cut into the clay, its form changes significantly. Again, each piece is different.'

FIRING: David Hewitt's agate-ware pieces are left unglazed, not only because they need only one firing (to cone 5–6, or 7–8 if some translucency is required) but because he feels that this surface seems to suit this type of ware.

> **TIP**
>
> Check each piece carefully before firing to see that no small pieces of clay have stuck to the surface during the turning up and subsequent handling … they take a lot of time to remove with a carborundum stone.

After firing, the pots are rubbed over with an emery cloth in order to give a smooth feel to the surface. The finished pieces remind one of collected layers of coloured sands.

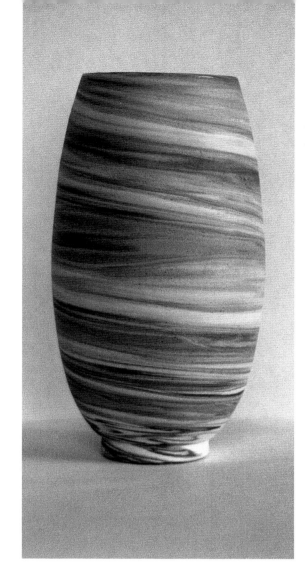

'*Vase with Outer Spiralled Colour*'. David Hewitt (Newport, South Wales).

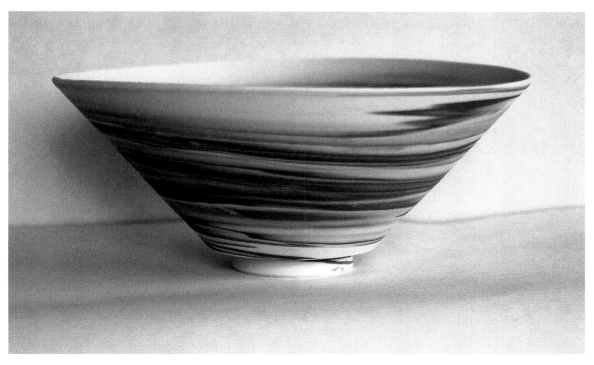

'*Agate Bowl*'. David Hewitt (Newport, South Wales).

Eva Blume: Thrown Marbled Porcelain

I am hoping that one day I will become a full-time potter.

Eva Blume always wanted to become a potter, but this was difficult since she was in full-time employment managing a residential home for people with mental health problems. Her work did not allow her to attend evening classes in ceramics, however, and when she became a locum involved in mental health projects she was able to attend some day classes. At the time of writing, she is completing a City and Guilds course in ceramics and design.

Eva became fascinated with the idea of throwing agate-ware, because her colour designs could be thrown inside the clay. She concentrated on drawing up the colour to where it could be shown off to good advantage, mainly at the rims of her bowls.

METHOD: Eva uses white Potterycraft P155, and will often combine oxides with underglaze colours mixed straight into wet clay as she likes the 'rather unpredictable mixture' (*see* Chapter 4). Cobalt oxide, if mixed in this way, produces what she describes as attractive 'small speckles'.

In her coursework, Eva has produced sets of storage jars, stacking bowls and pouring jugs. She wanted the different sets to show similarities in terms of shape, but was more experimental in the three different ways she threw her agate:

> I centred the white clay first, then added the coloured clay in such a way that the colour would remain at the rim. Next, I wedged, then layered both clays so that the patterning came out in broad bands. Finally I mixed the colours together lightly, then threw them to produce broader stripes.

The sets were completed with a Potterycraft clear stoneware glaze.

'*A*gate Pouring Jug'.
Eva Blume (London, England).

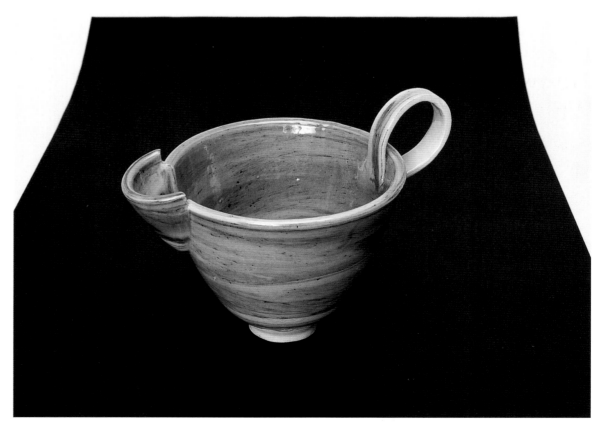

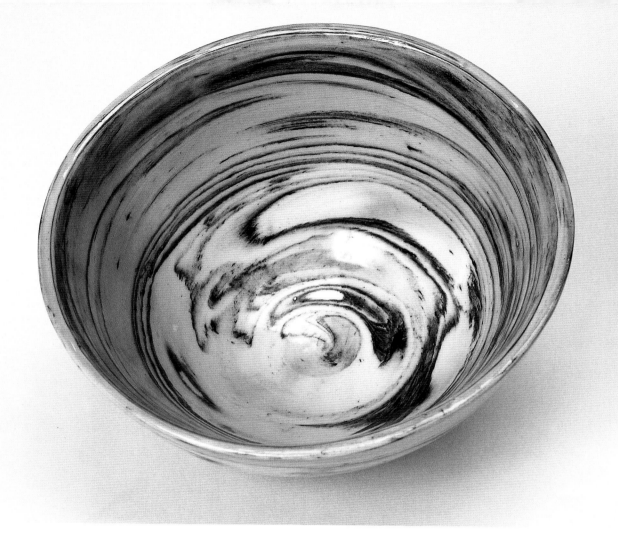

Heather Graham: Throwing with Coils of White Stoneware

A row of naked bisque-fired pots is my equivalent of the writer's blank sheet of paper.

Throwing with coloured clays provided a solution to Heather's 'blank sheet' challenge, as this technique builds decoration into the pot from the start, bands of colour being created 'which stand a very good chance of fitting the form aesthetically.' She uses grogged white stoneware, adding her oxides and preparing enough clay for several pots at a time.

TIP
When throwing two clays together, it is very important to keep both clays of the same consistency or the pot is almost impossible to throw.

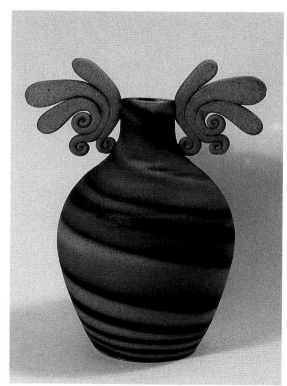

'Marbled Agate Bowl'. Eva Blume (London, England) (above).

'Thrown Agate Bottle'. Copper and cobalt spirals with coiled additions; cobalt-tinted dry clay, stoneware glaze (height: 22.9cm/9in). Heather Graham (Norfolk, England).

METHOD: Heather makes a fat sausage of body clay, about 3–4in (7½–10cm) in diameter, and then makes coils of the same length of coloured clay. These are pushed into grooves in the body clay, with care taken not to trap any air underneath. The sausage is then cut into throwing-size lengths and put onto the throwing wheel with the coloured stripes standing up vertically. Heather finds that in order to achieve simple, open spirals, it is important to throw with the minimum of pulls: 'I do not cone up and down, but start to throw as soon as the ball is centred, and I aim to reach the full height in three pulls.'

rib; however, if a softer definition is preferred, then the surface is left uncleaned.

Heather sometimes likes to add coiled features at the neck. These are made with uncoloured clay so they can be worked on long enough to get the proper finish. However, they are given a light oxide wash before glazing so that they 'belong' to the pot.

FIRING: A dry glaze is applied to her work 'to bring out the colours without a shiny finish.' (*see* Chapter 6)

It was Heather's family who inspired her to do pottery. Her mother was thoroughly intrigued by the famous 'potter throwing' interlude on BBC television back in the fifties and started taking evening classes at the local art school in Gravesend; Heather and her sister soon followed. Now both have taken early retirement from teaching, she says, 'to devote ourselves to potting'. In fact Heather has just acquired a raku kiln and has rakued some thrown work (*see* below).

TIP
If rounded forms can be pushed out from within with a throwing stick this also has the effect of widening bands at the fullest part of the pot.

Very crisp bands can be achieved on the main body of the pot by cleaning the surface with a

'Thrown Agate Bowl'. Rakued, with coppery spirals under transparent glaze (width: 17.8cm/7in). Heather Graham (Norfolk, England).

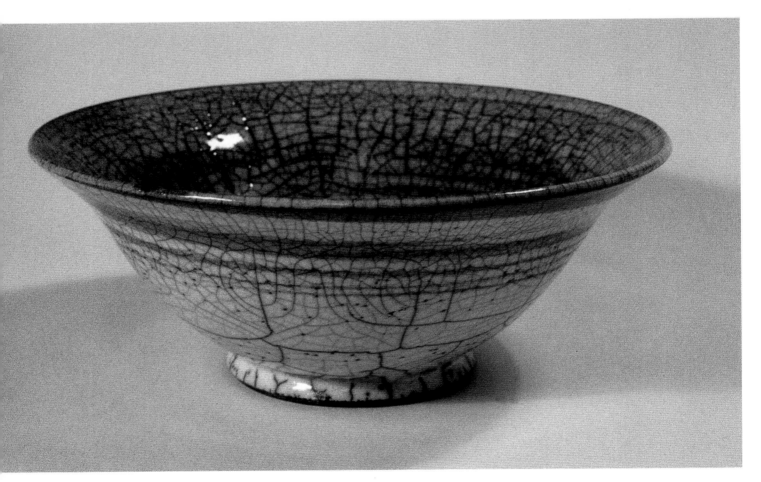

Hanna Schneider: Throwing White Stoneware and Gerstly Borate

I like the ups and downs of working in this technique.

In her workshop in Zurich, Switzerland, Hanna Schneider makes striking vessels in brightly coloured spiralled clays. She says that her 'love for clay is old', and that she learned potting with ceramists around Zurich and 'by just doing it'. But her best teachers are the Mexican potters, and Hanna has stayed in remote villages, spending time with the people and their families and 'just looking at how they handle clay'. It is easy to see the influence of Mexican shawls and the rich colours of their bright textiles in her work.

METHOD: Hanna experiments all the time with new ways and techniques to help prevent cracking between the different coloured clays. Into a white French stoneware body – T87700 Limoges – she sometimes adds grog or sand; but her new idea is to add Gerstly borate: 'As most colours fade when fired at high temperatures – namely 1,250°C – I have started to add Gerstly borate to the clay. This makes the clay watertight when fired to only 950°C, and the colours develop the brightness I am aiming for, especially the green.'

Having wedged the borate thoroughly into the clay, Hanna adds different metal compounds and stains as powder to 1kg pieces (only using commercial stains to obtain pink and yellow), then she wedges again until an even mixture is obtained. Now this treated body is left to mature for at least a month, and preferably longer.

For throwing her spiral vessels, Hanna prepares slices of clay put together 'like a sandwich, or I join coils or patches of clay, depending on how regular I want the colours on the piece.'

After throwing, Hanna leaves her pots damp for at least a week, then dries them slowly until

'Spiralled Agate Bowls' (widths: 12cm and 15cm; 4.7in and 6in). Hanna Schneider (Zurich, Switzerland).

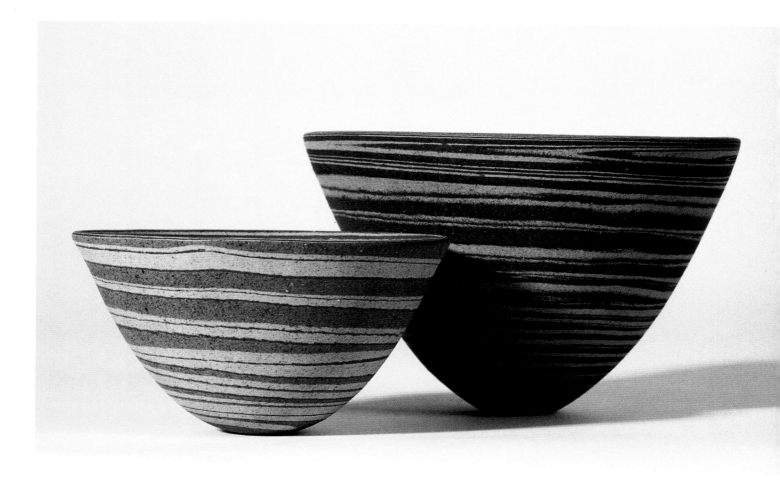

'Spiralled Agate Bowl' (width: 14cm/ 5.5in). Hanna Schneider (Zurich, Switzerland).

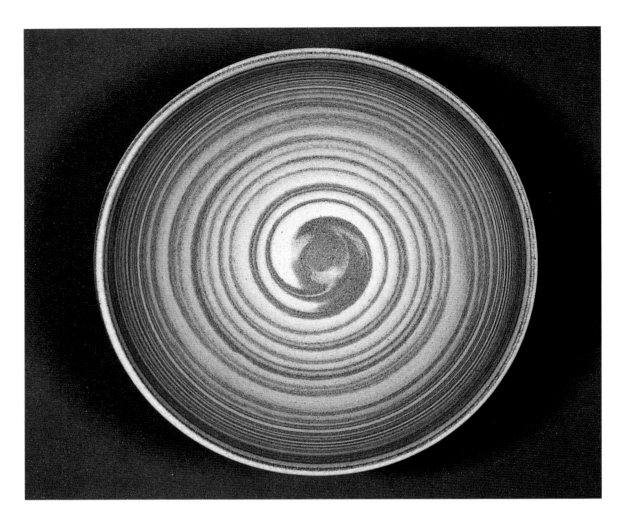

TIP

Prepare the clay the day before it is to be thrown to keep the clays the same consistency.

they are ready for trimming. Now she scrapes the whole surface, and the resulting work shows stunning bands of kaleidoscope colour which tend to keep to their pathways in neat, strong clearly defined spirals.

FIRING: The work is fired slowly in an electric kiln, not more than 50°C an hour, until 950°C then holding this temperature for thirty minutes. Fine steel wool is used to polish the surface.

Hanna also joins different strips of coloured clay to make coiled vessels (*see* Chapter 9), but says she 'enjoys the less controlled process of throwing different clays and then observing how the colours fuse and blend into the given form.'

John Wheeldon: Thrower of Black Stained Clay with Lustre

Black is the only colour with which I have ever concerned myself. It is the ideal foil for the lustre-decoration that I have used for many years.

There are some ceramic artists, like John Wheeldon and Inger Rokkjaer, who use colour in clay only as a background to throw up a good lustre, or to deepen and enrich the colour beneath a raku glaze with engobe. It plays a vital part in the appearance of their work. John Wheeldon's vessels are very smart and richly decorated – formal evening wear, rather than day wear! The black oxide mix is essential: 'Lustre can become very garish if over used, 'he explains, 'and the dark background of the black body softens and modifies this effect.' Where

this is unglazed it remains matt, and where it is beneath the patterning it gives depth, and mysterious, almost illusory effects, to the lustre above.' It is this technique which makes John's work so distinguished.

Already an excellent thrower, his work always expertly finished, John has also learned to make the lustre fit the shape so well that you cannot think of one without the other. There is a neatness and compactness to his ware, and the way the pattern is mathematically worked out over the area of decoration is similar to a beautifully embroidered tapestry cushion sitting in the middle of an antique chair. Like the chair's mellow polished wood, there is nearly always an area of black matt surrounding the lustre patterning; this has its own quality which flaunts the lustre in its care to exotic effect. To offset this, John aims to throw forms in 'tight, simple curves with crisp edges', and the rims are important in conveying the texture and feel of the clay in the finished piece. Not unnaturally, John is inspired by 'long-buried things and corroded stuff … Neolithic, Bronze Age, Iron Age, and lately, Roman work'.

METHOD: John Wheeldon's 'Big Black' is: iron 2; manganese 2; copper 1; and cobalt 1, mixed into ball-clay and china clay. Because this mix is made purely from natural metallic oxides, it has character and tone; but he says 'the resulting body is not very plastic to throw, owing to quite large quantities of grog – however, I put up with this as I like its textural qualities' (*see* Chapter 3).

FIRING: After turning and firing to 950°C, the pots are glazed only in the areas that will be

Lustred black clay dish with 'rubber stamp' decoration. (width: 33cm/13in). John Wheeldon (Derbyshire, England).

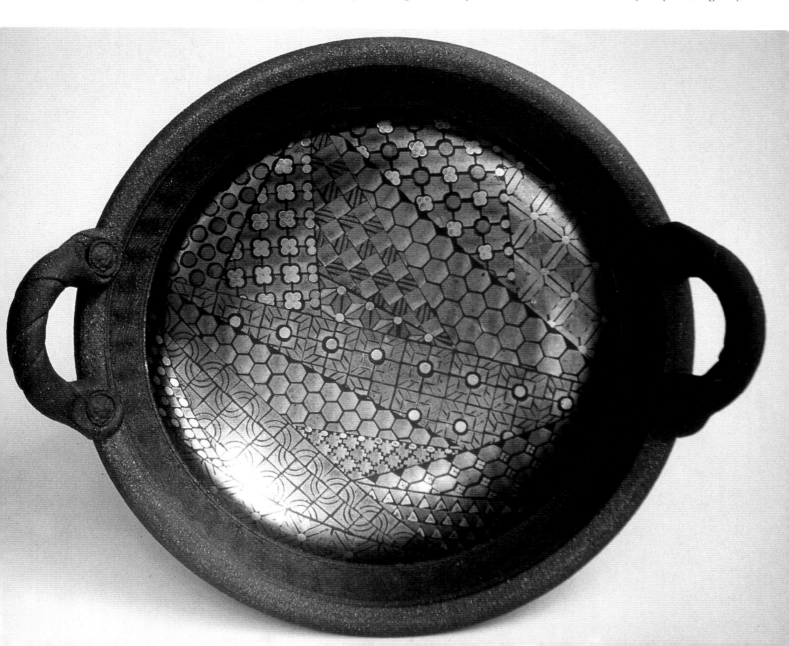

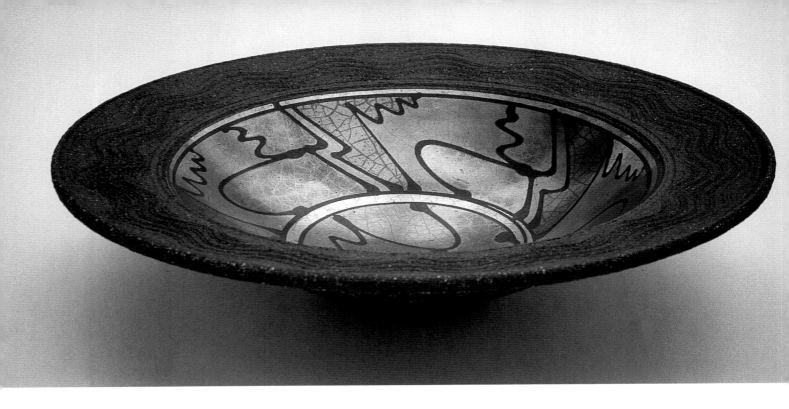

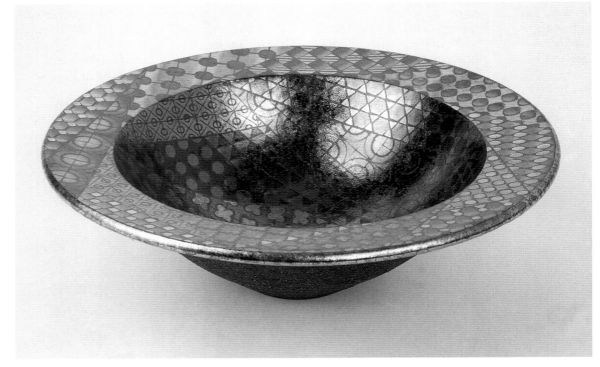

Lustred black clay dish with latex resist decoration. John Wheeldon (Derbyshire, England) (above).

Large black lustred dish with 'rubber stamp' decoration (width: 33cm/13in). John Wheeldon (Derbyshire, England).

lustred later: a simple transparent glaze in oxidation must present a good surface for the lustre. John explains why this is important:

> The lustre is applied onto the fired glaze and then re-fired to a lower temperature – and it takes on the shine, mattness or otherwise of the glaze. I like to aim for a point somewhere between high shine and matt, and preferably with a slight texture or sugaryness, as this imparts a glitter to the lustre. I fire quickly to 1,220°C over seven hours, including a one-hour soak. The lustre is applied using rubber stamps, latex resists and brushing, and they are ordinary commercial chemical lustres bought locally. The lustre firing is to 720°C.

Tove Anderberg:
Throwing and Altering

I regard my work as bodies and my glazes as skin, and my continuing efforts are to reach such a harmony of expression that they fuse together naturally as a single element … but the irrational element of chance in ceramics is so significant that I am also grateful when a firing succeeds.

Tove Anderberg is from Denmark. She lives alone in the north of the country in the middle of the forest where it is dark, and it is this nature of darkness and light that is paramount in her work. She walks for long parts of the day and also the night, 'finding my way, and observing life, light – nature'; but she says that inspiration comes from her reactions to nature *inside herself*, and not from using nature directly. However, the darkness of the night is always inherent in the background colours of her pots. She creates interest by inlaying a mixture of contrasting clay and colour into the walls of her pieces – but it is her home-made ash glazes that add the light.

METHOD: Tove Anderberg used to use Bornholm piping clay – the only stoneware clay to be found in Denmark – but after a visit to England

where she saw a Lucie Rie exhibition, and where she met the ninety-year old Bernard Leach with whom she talked about 'the poetry in life and in art', Tove returned to Denmark happier and more optimistic. She exchanged her dark stoneware for porcelain, and removed some of the clay content from her glazes so that they gave more colour, transparency and depth. As she explains: 'Happiness in work arrives both from finding new ways as well as learning from earlier experience.'

All Tove's dark pots are thrown, but then the walls are pressed out using a wooden 'shape' until they are very thin. Next the pots are dried for about an hour in a temperature of 20°C. At this stage she cuts a pattern through the thin porcelain walls of her bowls, using a sharp knife. A mix of stoneware clay containing 25 per cent fire-brick stained with iron oxide is inlaid into the holes of the cut pattern, allowing it to stand proud of the surface. 'It all looks very messy at this point, as the mix has to be well inlaid' she explains – but once the pot is dried leather hard, the patterning can be scraped down to leave a clean surface. Tove carries out this operation using a very special 'old shaver knife made from bone and steel' which she found in the market.

FIRING: After a bisque firing of 1,000°C, the bowl is glazed with a dark matt glaze. It is in the

'Pattern' from the Black Pot Series. Tove Anderberg (Sulstead, Denmark).

second firing of 1,200°C that the fire-brick patterning – which has a lower melting point than that of the glaze – becomes rougher and darker than its surrounding porcelain. Tove Anderberg likes the contrasts produced in this way – between the delicate porcelain and these rougher intrusions, and in the tension created between the shiny effect of the pattern and the overall matt surface of the glaze on the rest of the pot.

With all her pieces having such thin, delicate walls, 'almost at break point', Tove was confronted with finding a suitable glaze that would make sense of such a thin body. Thus her experimentation with ash glazes began (*see* Chapter 6), and so she found the answer to the kind of glaze she wanted, by once again looking at nature:

> In the fine crown petals of flowers I saw gloss, depth and structure on even the finest, most fragile of bowl shapes – for instance, on the small, downy flower of the cowbell. And I translated its form to silky-finished, downy surfaces and colour tones in layers of different glazes. I have glazes with up to seven layers of finely nuanced colours.

Tove's works reflect strongly her place in the forest and everything around her: they are indeed true reflections, as well as being a celebration of nature in harmony with her own existence.

Jack Doherty: Thrower Using Mixed Agated Clays and Soda Vapour

This soda vapour firing process has become central to the way in which I think about the surface; the soda highlights and enhances the surface in a way which I feel is special.

Jack Doherty was born in Northern Ireland, but he and his wife moved from County Down and at the time of writing their studio is in a converted cider barn next to their cottage on the edge of the Forest of Dean. Here, the forest inspires his colours.

Jack draws the maximum qualities from the stains he uses in the clay body through to the surface of his work by the particular way in which he uses soda vapour: this exposes all the surface marks, 'whether good or bad'. It is this chosen range of colours and way of firing which, I think, give his work its warm, autumnal atmosphere, redolent of the way spent leaves are shiny when they first fall from the tree, then go matt after carpeting the ground for a while. Jack captures both effects in his ceramics, for one of the essential features of his soda/salt firing method is the relationship between silica and alumina in the mix of bodies he uses at one time. 'For in practice,' he says, 'clays which are high in silica produce shiny surfaces, while those which are high in alumina are matt! This has opened up interesting possibilities – having shiny colours and matt colours on the same piece.'

METHOD: Recent pots have been made from a mixture of china clay, ball-clay and porcelain, and this has produced a range of colour from pale yellow and gold through to russet and orange. The results are attractive and match the form handsomely. These experiments were based, he says, 'on the "classic" salt glaze potter's slip recipes – typically china clay 50, ball-clay, 50 – though these colours are, of course, specific to either soda or salt firing.'

Jack usually has around fifteen pre-mixed coloured clays in his studio (*see* Chapters 3 and 4). He uses combinations of coloured and textured clays which he draws up to build 'collages' on the surface of partly thrown forms, using ideas from drawings he has made. Then he uses the wheel to unify both elements. For example, he often alters

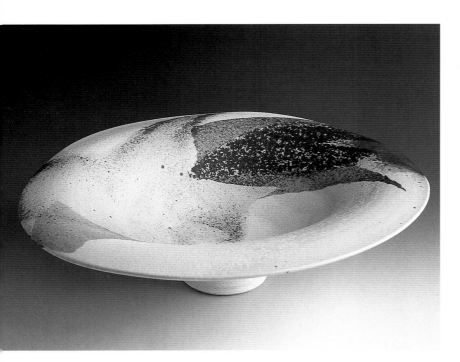

Wide bowl, copper and ilmenite; soda-fired (width: 40cm/15.7in). Jack Doherty (Herefordshire, England).

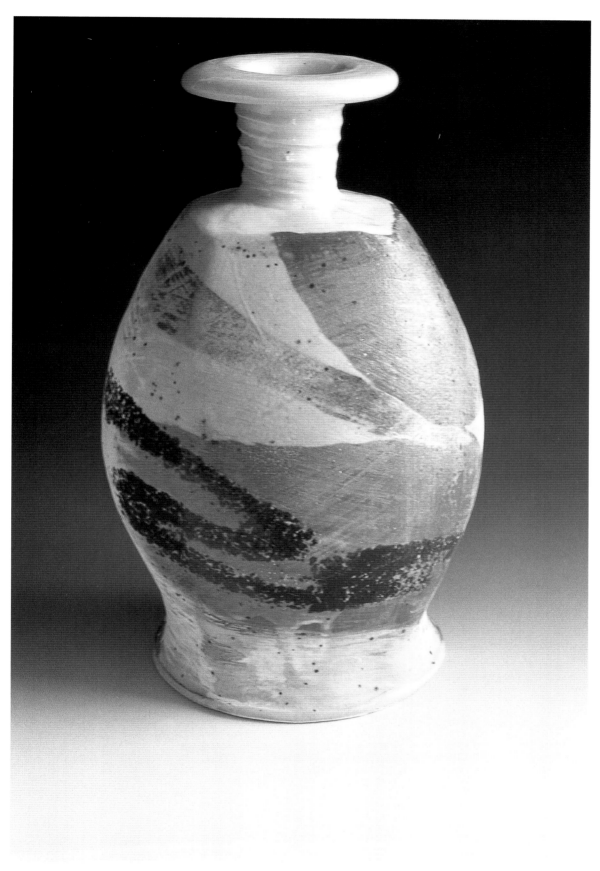

*L*arge bottle, thrown
and altered; soda-fired
(height: 38cm/15in).
Jack Doherty
(Herefordshire,
England).

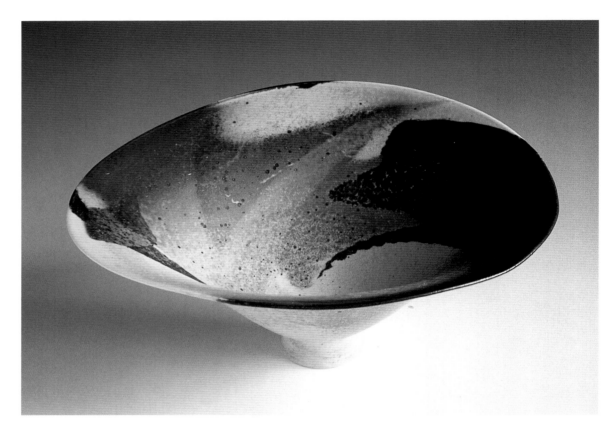

Oval bowl with black interior (width: 30cm/11.8in). Jack Doherty (Herefordshire, England).

work by cutting and squeezing while the clay is still soft and in a state where he has maximum control; in this way he can emphasize 'interesting relationships between form and decoration'.

FIRING: Jack Doherty's fascination with colour and surface clay continues with each firing. It is an on-going experiment because something is always being tested for future use, so, like a growing patchwork, each firing – to cone 10, using his soda vapour method (*see* Chapter 6) – leads to further possibilities and excitements, enriching and adding to discoveries already made.

In a way, this has been the pattern of Jack Doherty's life, which is multifarious: he advises, lectures and gives workshops, all of which lead on to further activities, and his involvement, and dedication to the ceramic world is nothing short of total. It all started when he joined the Kilkenny Design Workshops, sponsored by the Irish Government. He then helped the Arts Council of Northern Ireland advise on the provision of funding for the crafts in Ulster; later he was elected chair of the Craft Potters Association; and became a director of Contemporary Ceramics and of *Ceramic Review* … together with countless other commitments.

Inger Rokkjaer: Thrown and Rakued Mixed Clays

If you can bake a good loaf you can also feel what needs to go into your clay, slip or glaze.

Inger Rokkjaer colours her ceramics in layers, both in the body and in the slip, and finally in the glaze. Further pittings and crackles come from a raku firing to impart richness of surface. Her pots are perfect in their gentle warm colouring, almost as if they were wrapped in several blankets of shade one after the other, yet all of them adding to the final warmth when colour glows through like a heat-haze arising from the blankets. There is usually an area of pure white on her pieces to offset and contrast with colour; if it doesn't show on the surface, then it is in the form of a slip under the stained glaze and therefore transformed. All Inger's pieces are lovable and instantly desirable. They also embody the kind of qualities that are most beautiful about a piece by the poet Koetsu. They are stunningly simple;

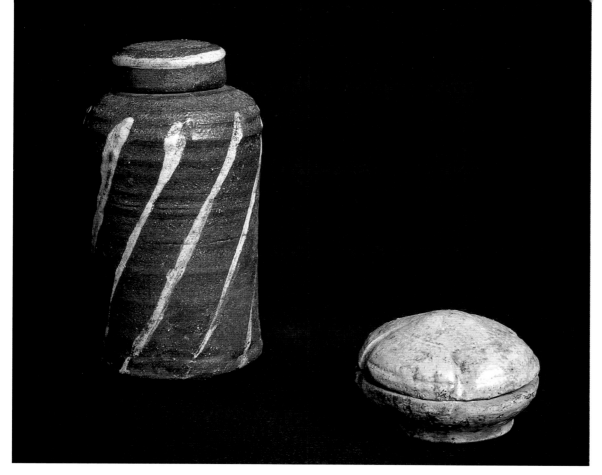

*T*wo rakued jars.
Inger Rokkjaer
(Hadsten, Denmark).

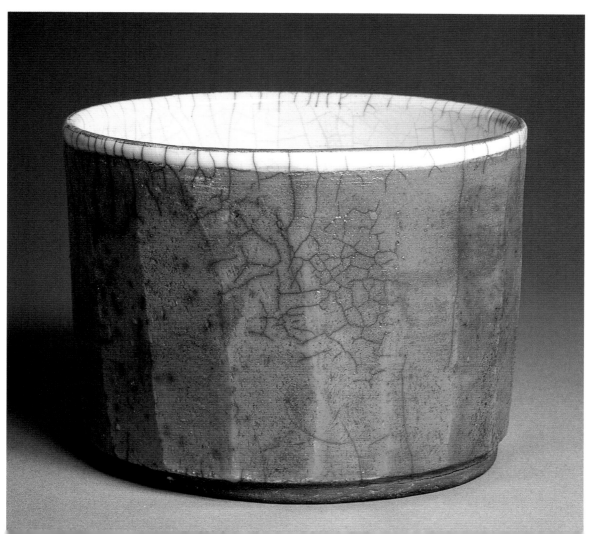

*R*aku bowl. Inger
Rokkjaer (Hadsten,
Denmark).

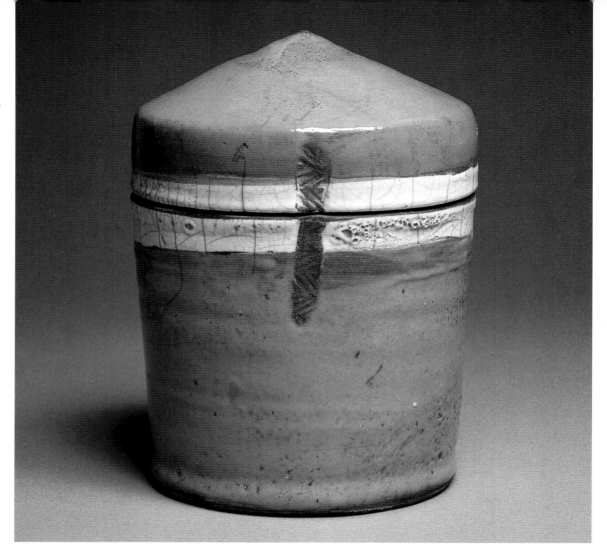

*R*ed-lidded jar. Inger
Rokkjaer (Hadsten,
Denmark).

poetically inspiring; and they have complete-
ness in themselves.

One of the main influences on Inger's way of
working is Japanese ceramics. As in the Japanese
tradition, her pots appear to be the result of an
inner reflection – although Inger admits that she
works 'rather unreflectedly, impulsive-like', the
effect, no doubt, of her other major influence:
mediaeval potters.

Inger is an experienced artist and has experi-
mented for thirty years with raku. She has tried
all the various oxides, though now she mostly
adds them to her slips: 'I've tried so many
things,' she says, 'but I keep reverting to the sim-
plest effects and techniques possible, both in
the firing and in the materials.' However, she is
interested in things which have an impact on
the glaze that covers her work, and adds ingre-
dients to her clay body as if she were cooking:
'such as coffee grounds, and various finely-
ground vegetation … spruce, pine or birch nee-
dles or leaves.'

METHOD: Inger's garden holds a special
bounty. She reveals that there is 'a brooklet con-
taining very fine red ochre which I use in my
clay.' But if she is making black pots, Inger adds
manganese to the clay to intensify the black
colour. For her yellow pots, she adds yellow
ochre, not only to the clay but to the glaze as
well. She loves white, and uses this as a slip over
the coloured clay or under a simple transparent
glaze; or the inside may be white, while on the
outside there is a powerful covering of one of her
glowing orangey-pinky-yellows.

Inger is a natural, and her vessels are always
visually effective: they always look 'right'. But
she follows no hard and fast rules: 'I always work
slightly "haphazardly", and am not much of a
theorist,' she admits. But she thinks it is a 'bril-
liant idea' to collect everyone's information
together.

There is a Danish author, Paul la Cour, whom
Inger considers expresses her approach to raku:
'What I love in a work of art is not its perfection,
which is deceptive, but its pulsating life.'

8 Pinching

Paulus Berensohn:
A Tribute

Many of the people in this book, myself included, were first inspired to use colour in the clay body after reading Paulus Berensohn's pioneering book on pinch pots, *Finding One's Way With Clay*. Elspeth Owen (*see* below) pays tribute to him, and Judith de Vries goes so far as to say that 'this book became my "bible". I made a lot of pinch pots, and I tried a great many different tests with all kinds of oxides and carbonates, which flowed naturally with the growing of the pot.'

In view of his importance I was keen on finding out what he thinks today. It took a long time to locate him, but then he was happy to talk, telling me that he 'still does claywork – mostly with kids – and makes pinch pots, but in a more ritualistic manner, returning them unfired into the earth.' As Paulus is, in his words, 'a passionate deep ecologist' as well as 'a professional fairy godfather' to everybody, these seem adequate reasons for there being no actual pot of his to show here. However, his spiritual leadership and the results of his inspiration feature throughout this book. His own book has now been republished in a special twenty-fifth anniversary edition.

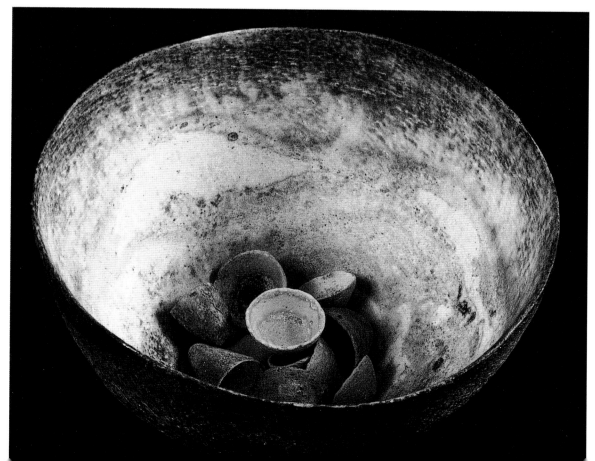

'*Treasure*'. *Iron and vanadium oxide in white slip over dark body (width: 50.8cm/20in). Elspeth Owen (Cambridge, England).*

Elspeth Owen: Pinch Pots with Slips and White Earthenware

'Jar'. Chrome oxide exterior; cobalt and nickel interior (height: 30cm/12in). Elspeth Owen (Cambridge, England).

I work at low temperatures – below 1,000°C and without glaze – so all the colour comes from the fire's effect on the clay body ... Without realizing it, the work undergoes slow shifts of emphasis and accumulates into a history of experiment.

Elspeth Owen has been working nearer to the surface of her vessels, and, like Inger Rokkjaer,

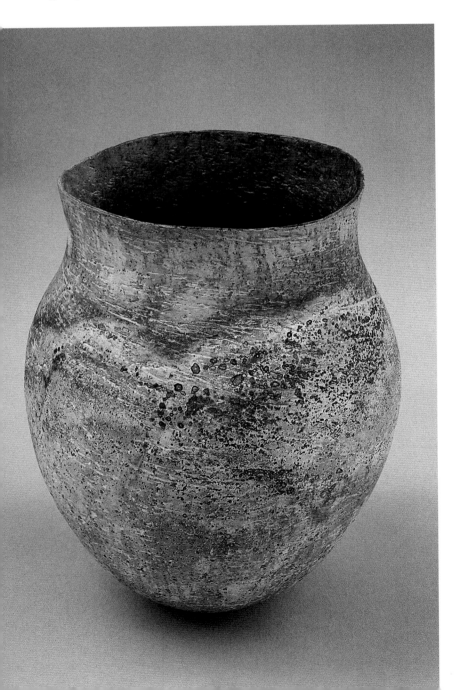

has been putting a thin layer of white slip over coloured bodies to find that the colours come through 'in unpredictable ways'. Elspeth is primarily excited about the fire's interaction with her work, enjoying the spontaneous and magical way in which the flames illustrate the surface with their own designs, using the colorants as a palette, and leaving their markings sealed within the clay's surface.

She feeds her fire interesting food to keep it excited, packing in such organic matter as seaweed, salt and dung which interacts selectively with the oxides in the body. The fired pieces remind one of the sea, the earth and the landscape, eroded through history and time.

Elspeth works on her pieces in a gentle way that shows patience and an unhurried approach. We can imagine her comfortably seated, settling down to a good 'pinch', and this attitude shows that she is a master of her profession: each form is pushed to its limits, each curve warmly echoes the capabilities of her cupped hands or the sweep of a scraper. The results are an individual statement of love and commitment to creativity.

METHOD: 'Like many cooks,' she says, 'I judge quantities of oxide by eye. Inspired by *Finding One's Way with Clay*, I make a hollow in the wet clay, and add the oxides by the spoonful and then moisten them and stir in the hollow. Then I wedge the clay, sometimes thoroughly, sometimes streakily' (*see* Chapter 3).

Adding colour into the body is, for Elspeth, part of a process of integrating form and surface as far as possible. She admits, however, that 'gradually shoulders and hands have grown tired of all the wedging' and that she has 'started to add oxides to a porcelain slip which is painted onto the surface of a pot composed of white clay. Because the oxides are basically all in a white body I have found a palette of stronger, clearer colour, especially blues, greens and purples. I also use, in slip form, clays that have their own strong colour for reds, browns and oranges.' Elspeth has discovered that this shift of keeping the colouring nearer to the surface has added a richness of texture, especially because she can 'reveal the body underneath to varying degrees and thus give a sense of layering, of wear and tear on the surface.'

It is this 'eroded' quality that gives Elspeth Owen's work its ageless feeling. But the forms also reflect the kind of vessel shapes found in tombs, placed there as treasured possessions to

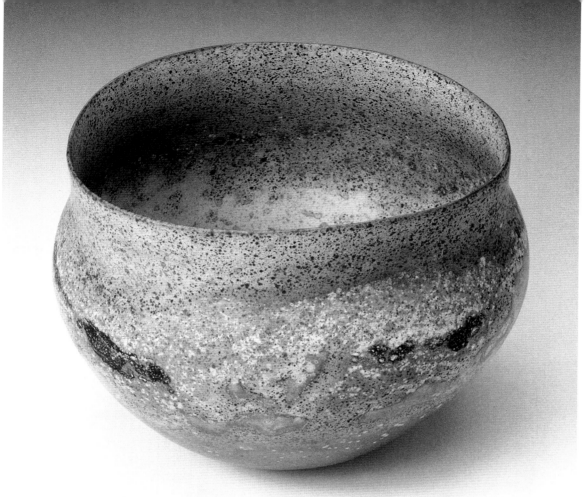

'*B*owl'. *Cobalt chrome and vanadium in porcelain body (height: 12.7cm/5in). Elspeth Owen (Cambridge, England).*

accompany the spirit into the next world. Both qualities put Elspeth's work at the modern end of an age-old ceramic tradition. I became even more convinced of this recently when, in my local Aylesbury museum, I chanced upon a pot of Elspeth's called 'Treasure', tightly wrapped in tissue paper, there being no room to put all the work on show. I was given permission to look at it, and found that there seemed to be lots of little parcels inside also wrapped in tissue. An exquisite bowl was revealed, thin, tight-skinned and deeply colour-marked by fire, and the small parcels turned out to be a host of tiny pinch pots of various oxided hues – the 'treasure' inside the mother pot.

Elspeth confesses that her most recent pots 'have been in a white clay with the colour markings created in the fire alone … with no addition of oxides!' However, she is quick to add that, though she 'likes the clarity of colour which adding oxides to iron-free clay gives, there is something mechanical about the painting-on process which I do not enjoy as much as the actual shaping of forms. Perhaps I'll go back to adding the oxides into this new white clay I've found, and see where that leads … '

Jane Waller: Pinched Raku Using T Material, Porcelain and Stoneware

I have been putting colour inside the clay body of my raku pots since the seventies. I find that the colours glow warmly through in a much gentler, less brash way than when applied to the surface.

Raku, for me, is a summer activity, to be carried out cross-legged either in the secret roof garden of our house in Waterloo, or more recently, at our cottage in Buckinghamshire. Millefiori work is for winter and indoors. My inspiration comes from sketches produced in every type of museum, whether at home or abroad.

METHOD: Oxides are mixed into the clay using the 'well' method (*see* Chapter 3). I choose warm pinks, blues, greys and greens. As I am wedging in the colour and making the clay warmer and more plastic, it puts me in the

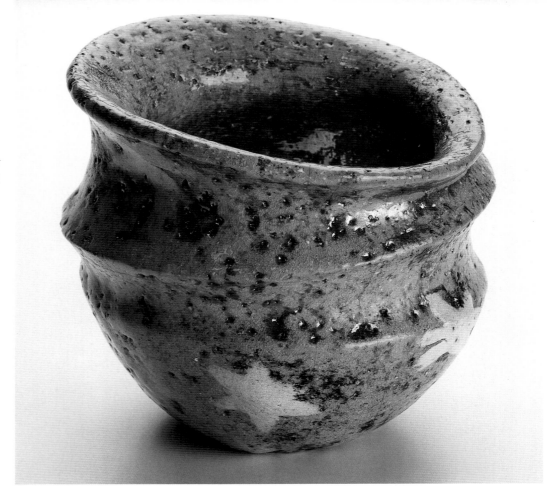

'*B*lue sky, White Stars'. Potclays 1154 raku body and T material; cobalt carbonate and traces of copper and black nickel oxide. (13 × 13cm/5¼ × 5¼in). Jane Waller (Buckinghamshire, England).

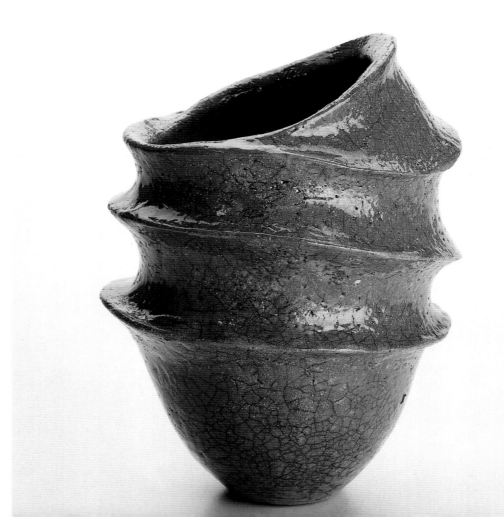

'*C*arinated Vase'. Stoneware and T material with yellow ochre and some iron spangles; alkaline frit glaze (19 × 14cm/7½ × 5½in). Jane Waller (Buckinghamshire, England).

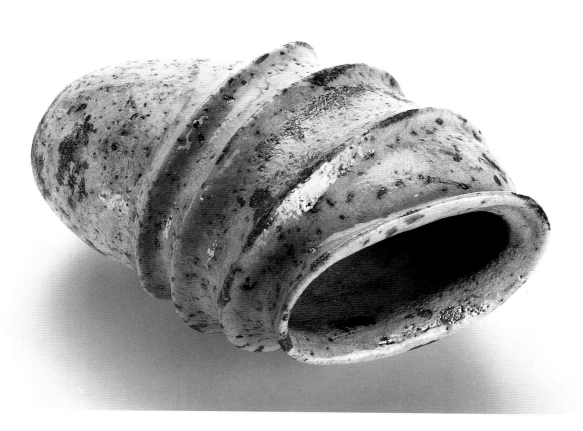

'Incremental Pot'.
Potclays 1154 raku body
and T material; traces
of oxides and fired with
tin and alkaline frit (20
× 15cm/8 × 6in). Jane
Waller (Buckingham-
shire, England).

'Shrugging Pot'.
T material and
stoneware with traces of
cobalt oxide, black
nickel oxide and iron
chromate; raku-fired
with high alkaline frit
(15 × 11cm/6 × 4½in).
Jane Waller
(Buckinghamshire,
England) (below).

mood to plunge my thumb down to make the first hole and form the base. In fact it is rare that I actually 'pinch' the clay: I usually draw it upwards in tiny strokes, changing the emphasis from inside to outsides. But I make sure always to do a complete circuit, so that there is continuity in the surface lines and curves, whatever the direction they take. Then the pot is rested on its rim, which is kept moist until the base is thoroughly finished and dried enough to support the pot.

I work on three pots at a time in different stages of dryness; this allows me to look at the form again, and to reassess the contours of the pot. A wilful change of direction always has to achieve balance with the rest of the pot. I have been making carinated pots and simple bowls and vases for a long time now, trying to keep a tautness to the profile without slackness inside the curves. Scraping and thinning begins as soon as the clay will take it. Sometimes I cheat and keep an extra piece of the initial lump of clay (newly plastic and damp) to add on further up the carinated pots, but the bowls are always made from a single piece. I try to introduce movement into the carinated pots as I do in my millefiori.

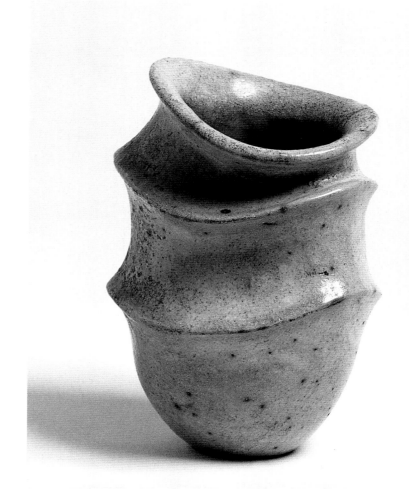

I scrape away throughout the process, always removing more clay by using my set of much worn, bendy metal kidneys, or sections of metal kidney, ideal for getting into difficult areas.

FIRING: Dried pots are bisqued to 1,000°C, then a transparent glaze – usually a high alkaline frit glaze – is painted on fairly thickly. Sometimes 2 per cent tin is added in order to create an opaque tone, or if I want an effect of pink over chrome, or mother of pearl. In the raku firing I allow the pot to soak until the surface is really glistening. I also reduce the pot right down in the sawdust for about twenty minutes before taking it out to be quenched in water. (I was once given some 'harpsichord sawdust' by some instrument makers at the London College of Furniture, and nothing has ever worked as well as this!) A long reduction often produces a silvery gleam with cobalt, especially when slightly overloaded, or a possible pinky tint with copper.

Sue Varley: Pinched St Thomas Body and T Material

I like the fact that the result is unknown and is created as I pinch out the clay – some work, some don't.

Sue Varley makes her 'landscape bowls' by pinching them from a single ball of stained clay, whilst referring to drawings she has made when visiting the Brecon area of Wales: 'Here the weather constantly changes the appearance of the landscape, especially as clouds move across, altering the view dramatically. It is these fleeting moments in time which I attempt to capture.'

Sue first became interested in colouring the clay body when she made a study of an agate

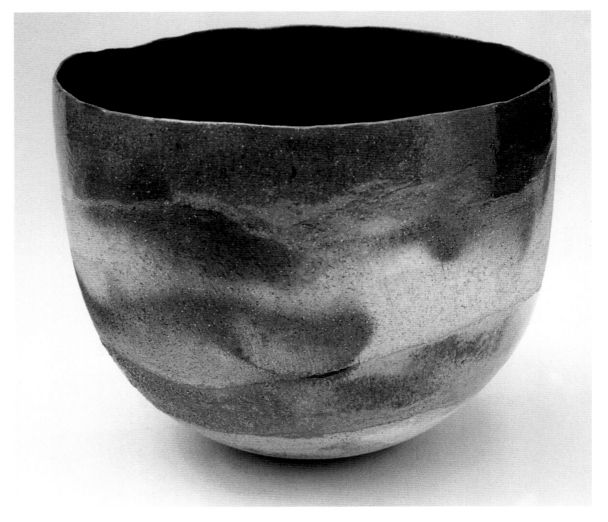

'Landscape Bowl' from Landscape Bowls series. Pinched out of one piece of coloured clays; part-glazed and fired to 960°C in an electric kiln, then part-reduced in a sawdust kiln. Sue Varley (Middlesex, England).

Staffordshire dog at the Bath Academy, where she was taught by James Tower. Later, looking at bluey-grey pebbles with bandings of colour, she made a pebble form herself, loving the unity of design and colour. In her subsequent teaching posts she allowed selected students to experiment with colour in clay (though on grounds both of cost and safety, she no longer does this.)

METHOD: Sue pinches out a group of three or four pots at one time, each group being a variation on one study. She uses a combination of 50 per cent T material and 50 per cent St Thomas body, stained with oxides – mainly manganese, rutile, red iron, nickel, chromium oxides and cobalt carbonate (*see* Chapter 4). Although Sue now lives in Middlesex, she still bases most of her designs on her Brecon drawing and painting and the 'fleeting moments' of memory. First she divides each colour into three or four smaller

pieces, one for each pot, slicing off a piece for her test tile; then she makes a block from four or five balls of these coloured clays sandwiched together.

Pots are opened out with the thumb or a stick, then pinched up from the base; this is kept rounded, and Sue holds it in her hand or lap until it has dried enough to support the weight of the pot. The other pots which are not being worked on are wrapped in fine polythene and left either upside down or standing in a bowl or jug. Taking great care not to let cracks appear, the piece she is working on is pinched and stretched outwards until it is as thin as possible. When dried to leather hard, the vessel is scraped inside and outside, 'until it is as fine and light as possible. It must feel balanced and 'right' to pick up – but it must stand well, too.

FIRING: At this stage, Sue may burnish areas of the pots before they are dried completely and

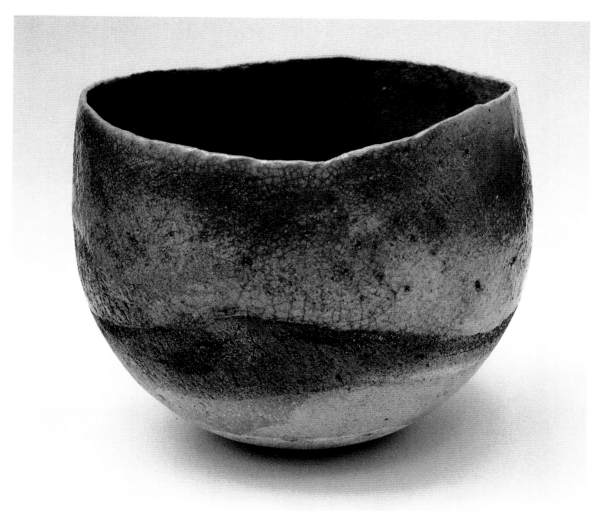

'*L*andscape Bowl'. (see *preceding caption*). Sue Varley (*Middlesex, England*).

'Landscape Bowl'.
(see *caption page 62*).
Sue Varley (Middlesex, England).

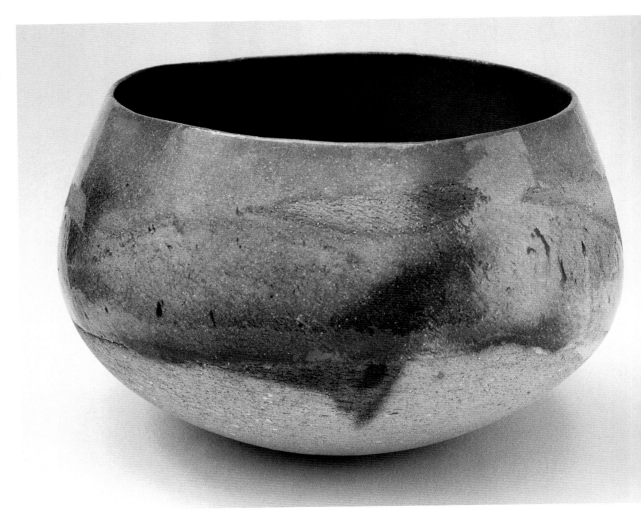

bisque-fired to 960°C in an electric kiln. Now some areas are waxed out, and certain parts glazed with a low-firing alkaline raku glaze 'depending,' she says, 'on which colours I wish to be dominant – or I may want the sky section to remain lighter in tone.' Recently she has started to use a white crackle glaze (Potterycraft's P2599), refiring to 960°C.

Finally, Sue reduces her work in a sawdust kiln when 'obviously a great deal of colour will be lost … but the pots change from a pale, almost pastel-coloured pot to one that is darkened. By using sawdust, ranging from very fine to wood chippings or layers of newspaper, and then by putting the pots in upside down or part-filling with sawdust, there is a certain amount that I can control and plan.'

The smoky surfaces of her vessels are rich and mellow, and strongly evoke the Welsh landscape in all its variety.

9 Coiling

Hans Munck Andersen: Neriage Coiled in the Mould

I wish the bowls to be delicate as an eggshell or a seashell. Everything in movement is captured in them: grass under water, the bird's flight, the winds soaring over summer fields.

Hans Munck Andersen works in his studio-farmhouse on the north-eastern corner of Born-holm Island, Denmark, with his wife and fellow artist, Gerd Hiort Petersen. Local kaolin has been a help to all the sixty potters who dot the island, but it was seeing the marbled claywork of Jean Gaugin, a sculptor working in the forties and fifties at the Bing and Grondahl porcelain works, which inspired Hans Munck Andersen to develop a technique that would allow him 'to combine rolls of coloured clays, yet maintain a measure of control over the final pattern'

Hans was influenced by glass beads and vases from the Roman era, by Minoan pots, and by glass from the Art Nouveau period; but it is nature and the changing seasons around him on the island that show through most clearly in his work.

METHOD: Hans has a basic slip to which he adds his colorants: nepheline syenite 29.2; ball-clay 15.8; bentonite 2.0; kaolin 16.2; flint 36.8. To this he adds standard additions of black iron oxide and commercial stains.

Stained porcelain rolls, with coloured pat-terning in them like a necklace or multi-coloured ribbon, are twisted and pressed into a plaster mould comprising four pieces – three side-pieces keyed into a separate base. Further extensions can be added to the initial mould for taller pots.

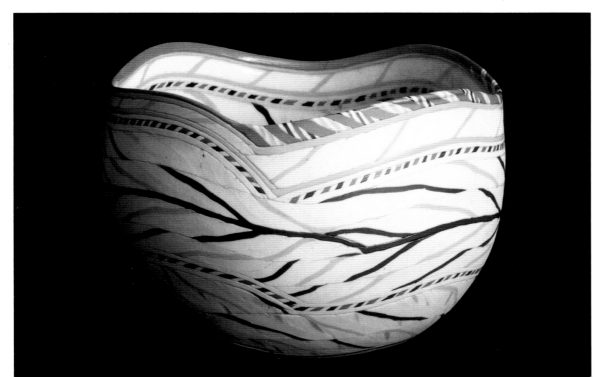

'Quadrangle Autumn'. Neriage technique in porcelain. Hans Munck Andersen (Gudhjem, Denmark). (Collection: Danish Museum of Decorative Arts, Copenhagen.)

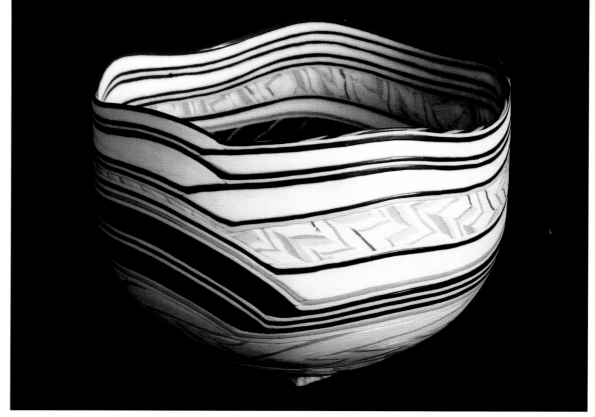

'*P*entagonal Blue'.
Neriage technique in
porcelain. Hans Munck
Andersen (Gudhjem,
Denmark). (Collection:
The Oslo Museum of
Applied Art.)

Hans begins work by coiling a flat piece in the fashion of a crocheted mat, joining the coils well. This will make up the first section of the pot, bedded down into the base of the mould and pressed flat with the ball of his thumb to subsequent coils above.

As the bowl 'grows', there is room for what Hans calls 'divergences within the patterns and principles of growth': these reflect the kind of accidental deviations and variations found in nature, and it means that Hans may suddenly change his patterning, introducing a new set of flattened coils of a different colour and design; they will nevertheless keep their coiled identities, adding to the feeling of movement and growth around the form. Thus maybe the rim will be wavy, like a flowerhead or the waves on the sea.

Once the work has dried sufficiently to take from the mould, Hans leaves the piece supported inside its base-mould while he refines the surface with a razor blade.

FIRING: When the pieces are dried and biscuited, Hans treats the surface with emery paper, then coats the interior with a clear or coloured transparent glaze (*see* Chapter 6). Firing is (cone 9) reduction between 800°C and 1,280°C, then oxidation to 1,300°C. Each piece is supported on the kiln shelf, sitting in an individual, perforated, coiled clay support filled with ceramic fibre or sand.

Hanna Schneider: Coiled Neriage White Stoneware

The variety, the textures, and particularly the colours prompted me to work with coloured clays. I love joining different colours into a pattern.

Hanna builds her pots using coloured clays – not in coils, but in flatter strips. She fashions vessels that are brightly banded and have a clear, cool look about them. The width of each strip depends upon the kind of pattern she needs for the banding proportions to look right. She does not have a precise method for her hand-building: variations always depend upon the nature of the pot.

METHOD: Hanna prepares a mix of white firing T87700 Limoges French body, adding 20 per cent Gerstley borate to render her work watertight when bisque-fired to 950°C. To 1kg (2.2lb) of the above she adds her metal compounds (*see* Chapter 4).

TIP
Always take care to wedge each coloured clay to be coiled together to the same consistency before use.

Each strip is joined by a slip made from one of the two clay bodies being put together. Once formed, the pots are left moist for a week, then dried very slowly; it takes about four weeks for them to become leather hard. Then the pieces are scraped with a metal kidney to reveal an even, clean patterning. Another two weeks will pass before the pot is dry (depending on its size). Fine steel-wool is used for the final surface finish.

FIRING: Most colours fade at high temperatures, and it is to avoid this that Hanna has added Gerstley borate, which she says 'allows the colours to develop fully at 950°C'.

Hanna Schneider also enjoys 'the less controlled process of throwing' (*see* Chapter 7).

Jennifer Lee: Coiled White Stoneware

Having discovered that oxides from various sources produce different results in the firing, I buy them from Britain, the USA and from Japan. I am constantly experimenting with pigments and exploring their possibilities ... using rust from iron pipes ... raw materials found in Arizona in the ground or in 'rock shops' ...

Jennifer is a careful, thoughtful potter originating from Aberdeenshire, in Scotland. Her pieces are made with infinite dedication and are distilled to perfection. We were at college together, and Jennifer was always a social person delighting in other people's company; but if one minute she was chatting and laughing, the next she'd be bending over her pot, totally absorbed in coiling, scraping and honing, oblivious to all around, her mind concentrated like a magnifying glass on a specific area a fraction of a centimetre wide.

Since those college days her work has matured to become more self-assured, more refined, and finer in form. Her vessels spring upwards from a

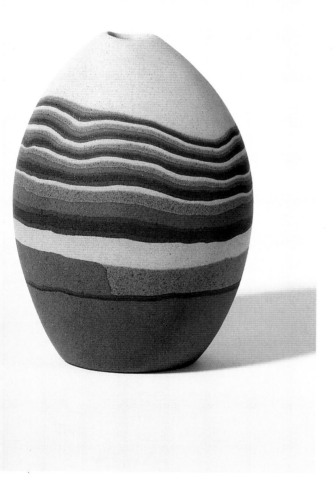

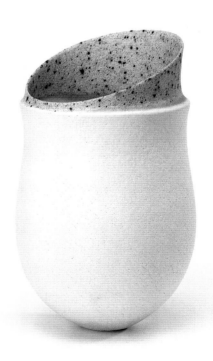

'Vase' (height: 16cm/6.3in). Hanna Schneider (Zurich, Switzerland) (left).

Pale pot, speckled emerging rim; hand-built, coloured stoneware (23.5 × 13.5cm/9.3 × 5.3in). Jennifer Lee (London, England) (right).

Dark peat pot, coned rim; hand-built, coloured stoneware (22.6 × 12.5cm/9 × 5in). Jennifer Lee (London, England) (left).

Dark pot (left), speckles, blue rim (17.2 × 12.1cm/6.8 × 4.8in); speckled dark pot, blue rim (29.8 × 18cm/11.6 × 7in); both hand-built, coloured stoneware. Jennifer Lee (London, England) (right).

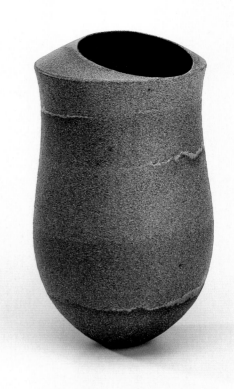

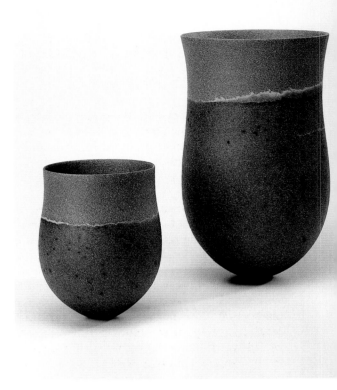

base that begins pinched, rather than coiled, so that she has complete control over the direction of silhouette, the base a good springboard from which the pot can dive upwards into a line that is taut and full of energy. But her shapes are not too rigid, or too tight, or too set: they are essentially female forms, the curved lines swelling upwards into the pot's belly in an organic, lively way.

Jennifer is a master of balance and controlled space: her pieces always stand well, and they achieve that timeless quality, which is always a good thing to aim for. Also her pots seem to hold a certain inner energy, constantly pushing outwards, stretching the vessel's surface skin – in a word there are no 'slack' areas to be found.

METHOD: Jennifer derives her inspiration from her life, her family and from travelling. As she travels about she picks up ideas – as well as raw oxides – from different places and cultures, and as a result her pots display a lively universality (*see* Chapters 3 to 5). 'I always buy oxides when I travel … cobalt from New York, copper from Kyoto … as they have subtle variations in texture or colour.' She uses T material, a stoneware body with a gritty content that gives strength and prevents shrinkage; it also gives variety to a vessel surface by altering texture.

Her coils are not always added round in section – sometimes the bands are flattened into larger

pieces which help to create direction change or alteration in form. As one band of colour is pinched with finger and thumb or smoothed over with a wooden or bamboo tool, the joins are softened and one tone will meld softly into another in a fusion of colour and clay. The reaction of the oxides in firing will intensify these bands or areas of colour, and they may give a speckling 'surprise' where the oxides, although mixed well into the clay, are not necessarily sieved.

Shape is intensified by scraping with a metal kidney, usually both inside and out, once the rim is reached and the pot firmed up. It is important to Jennifer that her pot walls are even throughout to make the weight feel right, so all unnecessary clay is taken away. The surface skin is also compacted further by burnishing with an agate pebble.

FIRING: A single firing without a glaze brings the pots very slowly to 1,230°C, then a soaking for one or two hours allows the colours in the clay to mature. Nowadays Jennifer's palette is not so muted and can, for example, display intense blues. Her characteristic colours range through whites and ivories to olives, blues and bluey-greys.

One of Jennifer Lee's pots can take between one and four weeks to complete. And by always referring to test tiles, sketches and previous pots, her work becomes an on-going evolution that is a delight to follow.

Christine Jones: Coiled White Earthenware

I have always been a hand-builder, and work entirely by eye and touch. I do, however, make preliminary sketches of the forms, but ultimately work directly with the clay, allowing the form to evolve through the working process.

Christine Jones lives and works in Swansea, South Wales, amongst a moving mass of maritime town, sea and changing coastal climate. However, her work reflects none of these, but searches for an internal peacefulness and quiet. Her pieces are usually bowl forms and incurving vases, and they are coiled from coloured clays that would normally make the work zing. However, these don't, because the way she combines opaque colouring within the clay body allows them to remain powerfully cool and remote, as if they existed in a universe of their own. Their maker, too, is a silent person and leaves her work to speak for itself.

At first glance, the simplicity of form looks like a precisely turned pot made on a wheel; but look again, and you see that her work goes beyond the wheel, for it leaves behind no evidence of how it is made: the surface has been pared down to a deeper, more precise level, and the form excavated to a purity of volume and line. Christine's pieces end up showing us a solidity, a fluidity and a presence that need no additions – except, perhaps, more of their own kind. Grouping them together, is a different experience from when other pots are assembled as a family where one member leans towards another, consolidating through harmony, and stronger in combination; in Christine's work, one pot is not dependent on others to make a 'pretty' showing – it is as if single, wholly independent units have come to stand quietly next to one another, their only common link being their maker.

METHOD: Christine's pots are coiled from a pinched base, neatly and precisely, using Potclays studio white earthenware strengthened with fine silica sand, which helps to unify surface and texture. She also uses Y material. Her colour stains or stain/oxide mixes (also Potclays) are in strengths of between 4–10 per cent, depending on the tone required.

Christine's monochrome dark and paler midtones – such as cobalt, coral, yellow, soft whites, or occasionally black – allow the light to be dif-

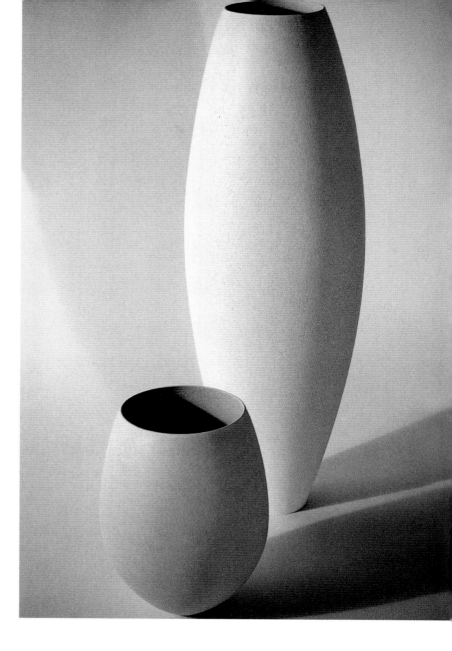

fused rather than bounced off the surface. To my mind the pots appear to suck surrounding light into themselves, their shadows stretching away from the shapes where light has not touched, or hiding darkly inside the volume of the interiors.

The pots are scraped and scraped as Christine coils, always paring away to get down to that essential form. These are so precise and curved and taut that they end up entering the world of engineering, geometry and maths.

FIRING: The pots are fired only once, to 1,100°C, with a short fifteen-minute soak, and are left unglazed, allowing the slightly burnished and very slightly textured surface to stand simple and pure. They belie the work that goes into their construction, and the fact that Christine adds only two or three coils a day.

Coiled vessel forms: white stoneware. Christine Jones (Swansea, South Wales).

Coiled vessel forms: white stoneware. Christine Jones (Swansea, South Wales).

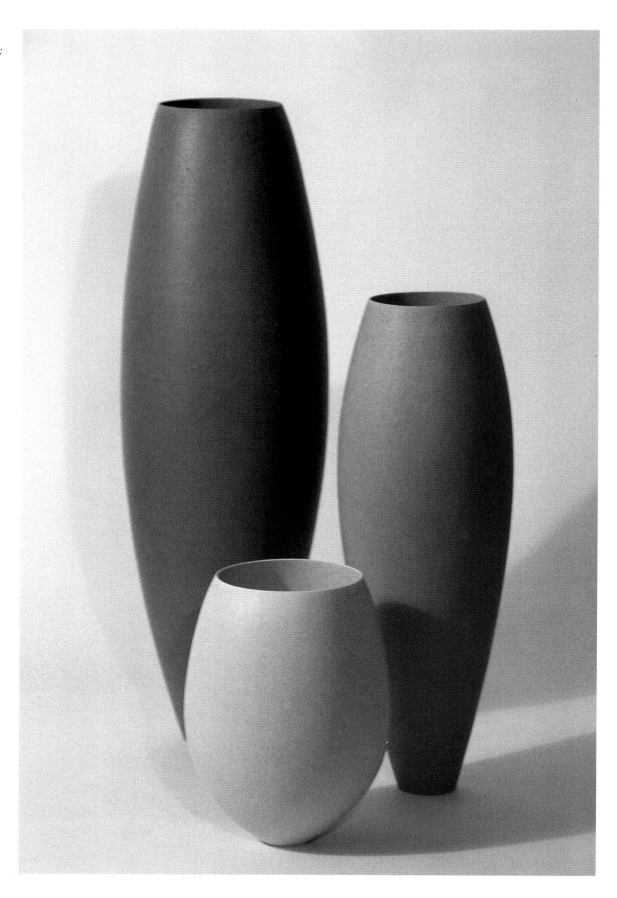

10 A Rainbow of Techniques: From Agate to Millefiori

Novices tend to be confused by the great variety of names given to the different methods of using colour in the clay body. This can make it difficult to decide which techniques to try. Some techniques are known by more than one name; some differ only in minor detail; others can be used in combination; a few have been freshly invented. In the end it is usually the maker who decides on one particular name for his or her chosen method, and this is what I have observed for the following part of the book.

When you begin to describe some of the methods that follow, you can immediately see the confusion: coloured pieces can be made either by butting thin rolls of different colours next to one another, or putting all kinds of cut forms from different coloured slabs next to or overlapping each other, or by inlaying coloured pieces into a background blanket of a plain or coloured clay. Patterns can go 'all the way through' your vessel walls, or various 'sweetie-like' or 'sushi-like' patterns can be made up as blocks first, and can then be elongated, rolled or stretched in some way to make the patterns smaller and smaller. It can go on forever. Here are therefore a few suggestions to try out:

1. Rolls, triangles or squares and so on of one colour, put with slabs of another around them.

2. Spirals made from two or more colours on top of one another.
3. Striped motifs made from layers pushed together, cut, rolled, joined and so on.
4. Blocks of colour made by simply pushing damp rolls, slabs or other patterns together to make 'earth formations' to cut through.
5. Recycled pieces pushed together or made by sedimentary millefiori (*see* Chapter 5).
6. Two or more colours just marbled together and cut through.
7. Using a small extruder (I have a small extruder with about a 3mm (½in) barrel and

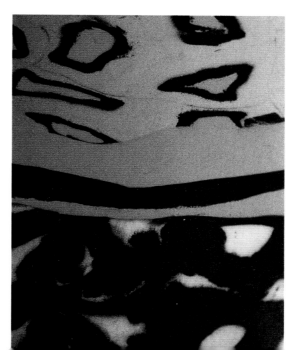

*D*etail of laminated Parion bowl. Linda Caswell (Tranwsfynydd Gwynedd, North Wales).

10cm (4in) long), I extrude different 'worms' of shape through these, depending on which dye I place in the end. If you dry these extrusions a little, you can cover them in very damp blankets; wait until the dampness evens out, then cut through.

There are countless variations and possible ways, and any artist can easily invent a method and give it a new name: in fact I have just made up two new ones:

8. Take a plaster mould and lay cheesecloth in it. Pour in a bowl of wet slip, coloured or plain. Into this throw left-overs, bits of pattern, or new made-up pieces of pattern, and allow to dry until you can lift it from the mould in its cloth, to compress or roll out. Then further, possibly weird patterns can be cut through and made from these. I think I will name this method 'Mortadella'.
9. Of course you could just damp down a complete failed pot – if, for instance, it has cracked during drying – until it is damp enough to bash together (to get the air out), form into a block, or roll out so thin that it looks as though it is being sucked into a 'black hole'. Then you could have fun slicing your old pot through to incorporate into a new one! This method could be called 'Total reclaim'.

Thomas Hoadley: Porcelain Nerikomi

My initial attraction to the nerikomi technique came from its organic union of pattern and structure; the two are one and the same. Nature abounds with this sort of union and, as a result, offers endless inspiration for pattern-making.

Thomas Hoadley is a studio potter who lives with his wife Stephanie and their two children in western Massachusetts, in a house which he helped to design. As well as using coloured porcelain for his nerikomi method, Thomas has a line of porcelain jewellery using the same technique. His delightful patchwork decorations remind one of early Japanese woodblock prints. (Thomas was, in fact, introduced to the art of nerikomi while in graduate school by a Japanese potter who gave weekend demonstrations.) The stages of this work are slow, but ultimately rewarding, and his advice to others is to be patient.

TIP

Be patient. Dry the work very slowly. Don't cut corners, and follow your intuition.

Coloured porcelain bowl (height: 19cm/ 7.5in). Thomas Hoadley (Massachusetts, USA).

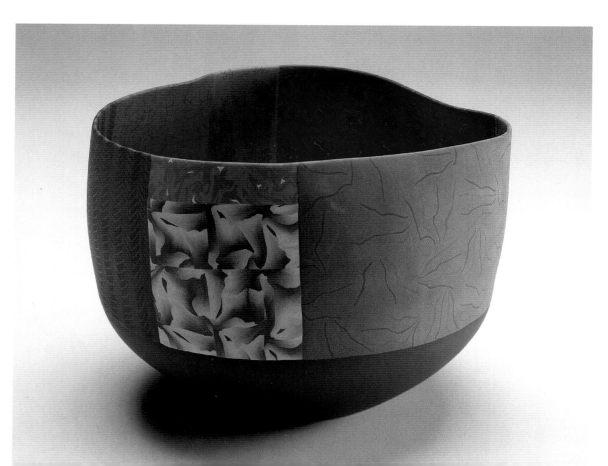

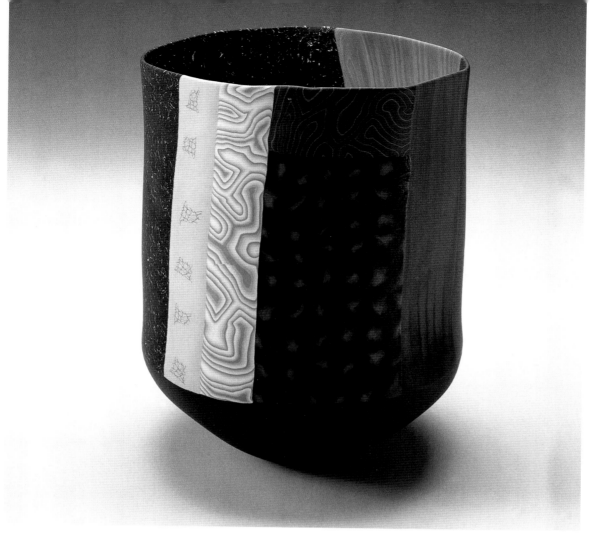

Coloured porcelain vase (height 25.4cm/10in). Thomas Hoadley (Massachusetts, USA).

Thomas spends part of his time making abstract paintings using unconventional materials, and his ceramic work is also 'an investigation and attempt to unify solutions to various visual problems' – only this time he sees the vessel as 'an abstract sculptural form with its many associations, both literal and metaphoric … and how pattern and colour as abstract elements can create various feelings or impressions.' He is exact in the positioning of each area of colour that penetrates the vessel's surface, and in fact it is good to put oneself at direct eye level to one of his pots and turn it slowly round to appreciate how the pattern relates to the form when seen in profile.

Often he will accentuate an area with a bulge or depression, or allow a bolder area of patterning to rise above the rest of the rim. Visual movement is created by the juxtapositioning of pattern differences, with each one, if you like, 'doing its own thing' yet confined to its own boundaries. Thomas likes the play of implied visual depth against the 'flat' modulating surface of the pot, versus the real depth that is present in the interior space. His vessels are optimistic, uplifting and for pure enjoyment.

METHOD: Weighed colorants (in 2–8 per cent range) are mixed with a little water to a paste and wedged into small batches of a cone 6 porcelain. Then his '10lb loaves' of stacked layering are created: the very plasticity of the clay is altered when these blocks are manipulated, and the straight parallel lines in the stacking become undulating or are perhaps made to taper down to a hair's breadth. 'I think of my patterns as being a collaboration between my imposed structure and the clay's wise alteration of that structure,' Thomas says.

When the slices off the block are cut through, some fascinating cross-sectioned patternings are produced. Thomas will lay down these pieces (carefully wrapped in plastic) for future use, in the same manner that one might keep slices of wedding cake or choice scraps of material for a patchwork quilt. He has used them, he say, 'up to a year later'. It comes as no surprise to find that fabric design and graphic design of all sorts

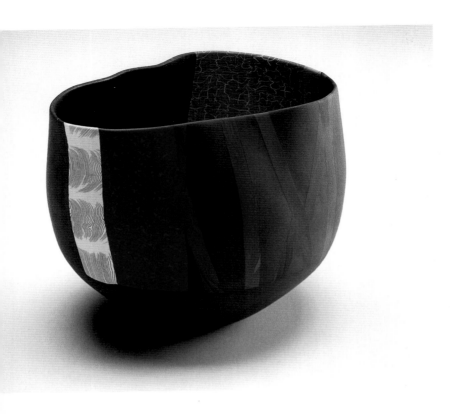

Coloured porcelain bowl (height: 15.2cm/6in). Thomas Hoadley (Massachusetts, USA).

Prue Seward: Laminated Porcelain or White Earthenware

The pottery world is cut-throat, and when you are older you can please yourself and don't have that pressure to 'get on'.

Prudence Seward is a 'natural' at ceramics. She started life as a printmaker, then won the Rome Scholarship at the Royal College of Art for Engraving. This led to a career as an illustrator, then as a museum conservationist. But Prue wanted 'something three-dimensional' – and besides, she 'needed some tiles for the kitchen'. Ceramics fitted the bill, and so she decided to become a potter.

It was only in the last three months of her pottery course that Prue was allowed to stop throwing and given access to a huge stain cupboard – and to a competent technician who gave her a list of stain percentages to use. But she wanted something bright, and stains and porcelain were the obvious thing, and to Prue's way of thinking, 'much purer than using underglaze colour'.

Prue's subsequent pieces have obviously been influenced by her colour-printing, and they show a brave, extrovert and freely expressive style: the enjoyment in their making is evident in their design. Prue likes the idea of constructing special, one-off pieces, the sort that take very much longer than throwing. She also quickly discovered that 'making both colour and form together is a very satisfying combination'. She draws collages of things she wants to make, and her ideas come from 'visiting museums and galleries often – and I love "looking around"'.

METHOD: Half a litre of John Leach porcelain from Potclays is formed into a thickish cream slip (*see* Chapter 4). Three separate portions of this are mixed with three stains, the proportions of stain to slip being about 15 per cent. These are poured onto plaster bats to remove excess water – and 'Isn't it interesting,' Prue notes, 'that black slip, for some reason, will lift off from the plaster bat without any difficulty at all!' When dry enough, the coloured slips are rolled out into a sandwich of different coloured clays, and are then cut and combined into patterns.

Prudence works a bit like a dressmaker: sometimes black slip, for example, is spread onto a plaster bat covered with newsprint, then cut like

serve as visual stimulation to him, as well as rocks, shells and flowers.

Formerly, Thomas used moulds for his forms, but then, he says, 'limited by the small number of shapes for which I had moulds, I was prompted to experiment with free-form shapes.' This decision has pushed his work forwards to greater freedom of form and flexibility of design.

He begins with a simple biscuit-draped mould which will form the base of the pot, and when this is leather hard, he will place it on a bat with clay supports. From this base, pieces of patterned wall are joined, using slip and scoring to knit them together one or two sections at a time. The completed form is paddled into shape, then scraped inside and out with a metal rib to clean the patterning. But to get his eggshell-smooth surface, Thomas Hoadley sands down his pot (inside a booth) once it is bone dry. This is followed by wet and dry sanding both after bisque-firing and the final high-firing, to cone 6 in an electric kiln unglazed.

Thomas Hoadley's pieces become even more precious when he applies an area of gold leaf as a final touch – though this is not fired on and can be scratched, thus betraying its superficial nature. More often he will give his work a coating of mineral oil which will sink into the surface to deepen the colouring, and so make this more pleasing.

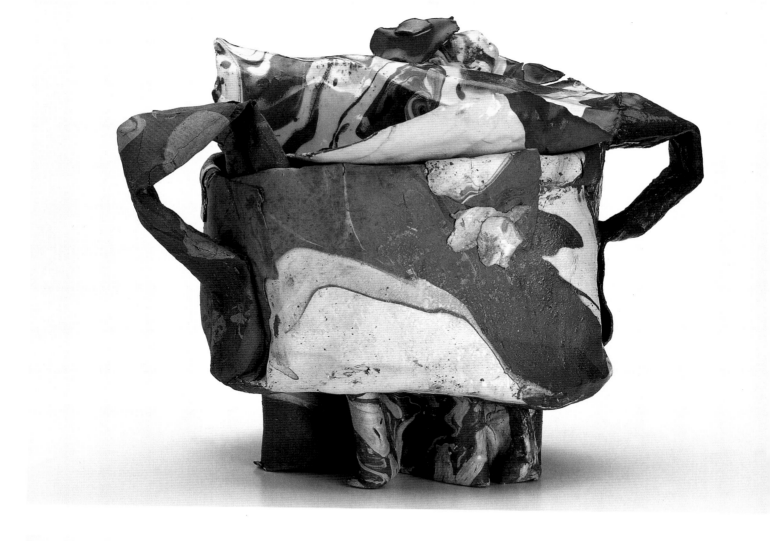

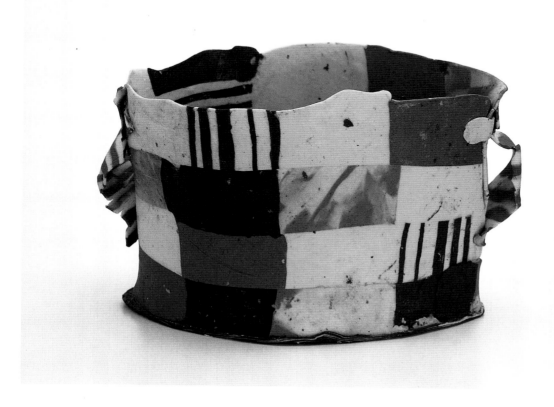

*E*arthenware cup with two handles and cover, hand-built, earthenware clay (white), stained with underglaze blue and yellow and red earthenware (15 × 22 × 12cm/6 × 8.7 × 4.7in). Prudence Seward (London, England) (above).

*O*val cup with two handles, hand-built. Stained porcelain body, cornflower blue, canary yellow and black stains (9 × 12 × 8cm/3.5 × 5 × 3in). Prudence Seward (London, England) (left).

> **TIP**
>
> Leave the rolled patterns to mature in a damp cloth plus the plastic cover for about three days.

a dress pattern when semi-dry, and assembled, often using newspaper as a central support. After the patterns are formed into the imagined object, the whole piece is wrapped in plastic and left to dry slowly so that the edges of the coloured clays 'knit' together properly.

FIRING: Only when completely dry are the pieces bisqued, then refired to stoneware 1,280°C, either without any glaze or, if earthenware is used, maybe a transparent glaze is brushed on and spattered in certain areas. (*see* Chapter 6) and fired to 1,100°C. 'The kiln does the rest of the work,' says Prue, 'by distorting the surface as well as burning out the newspaper supports.'

Each piece is lovingly treated in an individual way. For her 'earthenware cup with two handles and cover,' for example, Prue felt that she wanted the handles 'to look like folded paper', so the clay sheet was folded round two sausages of paper. Clear earthenware glaze was brushed on the cover, the interior and one of the handles, leaving the rest matt.

Prudence Seward's work is fresh and lively, colourful and well designed. Her pieces have such a familiarity about them, and such charm that I look forward to these qualities being incorporated again and again in every future piece.

'Tulip Vase'. Oxided Potterycrafts' stoneware (yellow ochre, chromium oxide, lead antimony and black iron oxide) with strapped rim. Fired unglazed and waxed (21.6 × 21cm/8½ × 8¼in). Jane Waller (Buckinghamshire, England).

Jane Waller: Pestled White Earthenware Millefiori

Sometimes I inspire myself with a kaleidoscope, at other times I look at fractals or stare down a microscope at sections of things gleaned from nature. I like to push my method to its limits, using not only combinations of stains and oxides, but different clay bodies, recycled millefiori pieces, and clays of different 'wetness'. All are ultimately unified with the use of a pestle and cheesecloth.

'Millefiori' is what I call the method I invented while studying in the Department of Ceramics and Glass at the Royal College of Art. During my time there, as the only person working within both areas, I occasionally crossed the boundaries between the two disciplines. When glass-blowing, for example, I often used colouring agents borrowed from ceramics. For my pots I adapted the technique of millefiori, a term long used in glass-blowing.

METHOD: Patterned layers are formed into large blacks which are rolled or beaten to stretch the internal pattern thinner and finer, thus altering their design. (This is akin to two glass-blowers drawing out a millefiori-patterned cane between them, then sawing slices through like Brighton Rock.) I use a pestle and cheesecloth (butter-muslin) to join the pieces together and expand the design, creating at this point a type of mosaic with the pattern going right through.

A deflocculant-free, powdered white earthenware clay is chosen, both to show colour well and because the lower firing temperature preserves colour brightness. But I will mix different clays together, unifying them with a good proportion of 10–20 per cent of powdered molochite. My soft, powdery fresco colours and powdered clay are weighed dry, then mixed using an industrial electric mixer. (*see* Chapters 3 and 4). My patterns are created directly inside a plaster mould. These moulds I first sculpt 'solid' in clay, hone down until well finished and smooth, then cast with fairly thick plaster walls – thick, because the mould has to bear the force of a pestle beating the fractal patterns together. (A thicker mould also absorbs more moisture and lets this out slowly, thus helping the drying process.)

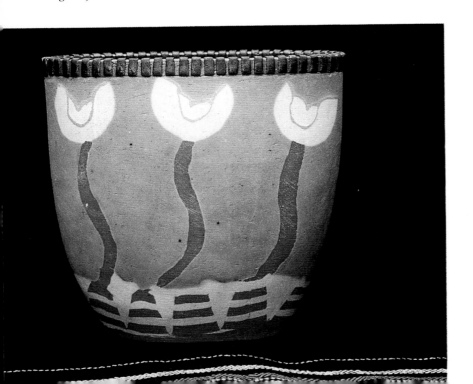

A layer of cheesecloth is dampened, then stretched into the mould. A pattern is assembled, then altered and moved with different-shaped pestles while the mould is turned on a banding wheel. No slip is used; it is done purely from pressure, which also compresses the clay and makes it strong.

TIP

Cheesecloth takes up moisture from the clay while it is being joined. It also allows the pattern to move against the plaster walls without areas sticking.

A cheesecloth-covered pestle helps take up unwanted moisture, absorbing more from the wetter clay … because sometimes I work dangerously, using harder, drier millefiori pieces next to those which are soft. I enjoy movement in my patterning: that is to say, I want the pestle to move patterns in the soft clay, but I want 'straight lines' and less movement to be permitted in the hard. The success of this method relies on exceptionally slow drying between the muslin cloth, which seems to 'even out' the process well. The movement of my patterns is reminiscent of how the earth's crust itself is formed: from severe

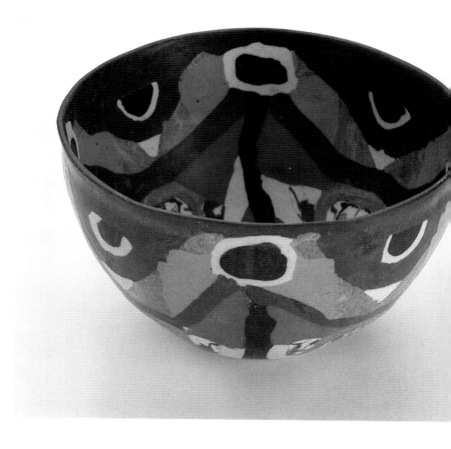

'*K*aleidoscope Bowl'. Oxided Potterycraft, Dutch 'fingerling clay' using black stain. Fired unglazed and waxed (8.3 × 14.6cm/3¼ × 5¾in). Jane Waller (Buckinghamshire, England) (above).

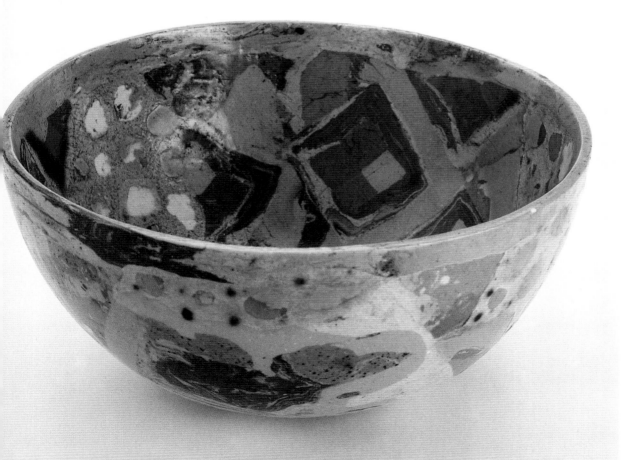

'*C*onglomerate Bowl'. Oxided Potterycraft, St Thomas body and porcelain with 10 per cent molochite. Fired to 1,100°C. Jane Waller (Buckinghamshire, England).

changes in rock structures set next to one another because of intrusions; faults, and volcanic activity; and pressure from the layering of sedimentary rocks (and sometimes my pots seem to take almost as long to make!)

The day after the pattern is pestled, the clay will have dried enough for me to peel off the cloth (which now bears the imprint of the work, like the Turin shroud) and to push in with a rubber kidney any pieces that are not quite pestled together on the underside. Back in the cloth-lined mould goes the piece until just drier than leather hard. The piece is then scraped and pressed further, using a whole 'team' of different metal kidneys, many worn on both sides until the edges have become razor sharp. Finally a good, clean pattern – now in the form of a three-dimensional mosaic – is revealed, and the rim and thickness of form attended to. No piece of colouring is wasted (*see* Chapter 5).

There now follows much tedious waiting until the piece (rewrapped in cheesecloth) is completely dry, and hopefully not cracked. (This happens inside a 'tent' of polythene, which takes up moisture so that it trickles down the tent without touching the piece.) Then it is bisque-fired to 1,120°C

FIRING: I don't like light to bounce off a shiny glaze, but prefer my colours to receive diffused light to give depth of field to the pot's surface. So either I use a very matt transparent glaze and refire to 1,100°C, or I beeswax and turpentine the pieces, taking each still warm from the residual heat of my octagonal electric kiln. The beeswax comes from my father's beehive, and the smell fills my studio.

'Shield Bug'. Coloured porcelain. Clare Rutter (Chester, England).

Clare Rutter: Porcelain Millefiori Inlay

It has taken a lot of time and mishaps to get where I am with porcelain, but I found the more problems it gave me, the more I was determined to solve them. I found myself saying, 'If this works, it will look wonderful!'

Clare Rutter's patterning is strong and bold, and reminds one of African textiles and animal markings – in fact she can relate a good African porcelain tale that she has read: 'I discovered in this book that the Swahili people believed that porcelain absorbed evil spirits, and it was therefore kept in a room where important events took place, such as marriages and births. It was believed that if a porcelain piece broke, it had absorbed the evil, therefore protecting the family.'

Clare's philosophy is just as sensible. She knows that her chosen method of working with porcelain is one that requires 'patience, and a sense of humour to put up with the breakages'. She measures her ingredients carefully so that one colour can be made again and again, and has ended up with numerous tests using underglaze colours and body/glaze stains, varying the percentage of colorant added. She wanted 'a palette of colours which had a smooth surface – not one produced by oxides which act as a flux, resulting in clay movement and surface bubbling'.

METHOD: Coils of one colour are rolled out, then covered with a thin layer of another colour; the coil is sliced and reassembled. As many thin layers of colour can be added to the coil as required, in a method similar to that of making millefiori glass. But first Clare's designs are painted on paper: a copy is made of this, and the resulting pattern is cut up into pieces to be used as templates for the appropriate coloured clays, always keeping the original painting as a guide. 'It is like doing a jig-saw,' Clare says. 'I reassemble these pieces of patterned clay and then join them in a mould to produce the desired forms.'

At first Clare was taught to roll out her clay sheets between oiled layers of plastic, but she found that when she was joining several layers of very thin clay together, the oil acted as a repellent to a thorough knitting, with the result that many pieces cracked as they dried. She tried

'*K*aty Blue'.
Coloured porcelain.
Clare Rutter (Chester,
England).

'*M*ay Fly 1'.
Coloured porcelain.
Clare Rutter (Chester,
England).

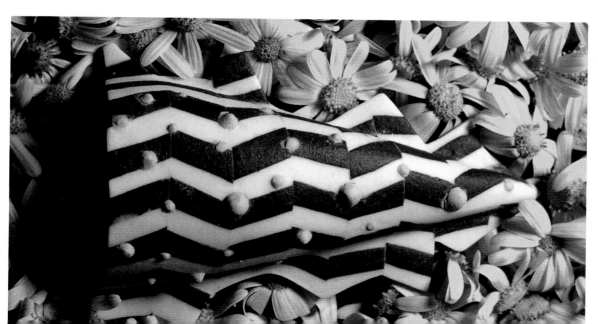

'*T*rap'. Coloured
porcelain. Clare Rutter
(Chester, England).

different ways, and at last came up with the following solution: to use two pieces of glazed cotton, as thin layers could be rolled out, leaving only very little surface texture.

Clare produces her equal thickness by rolling out between card runners. Furthermore, doing it this way also has the advantage that if sections of patterned clay are re-rolled between damp cloths and thinner card runners, the sections of patterned clay have stronger joins.

Once leather hard, the shape is removed from the mould, and any cracks in the outer surface are filled with the corresponding coloured slips. Her bisque-fired pieces are sanded down to remove any smudges, resulting in a smooth surface and a well defined design. 'I wear a mask to do this,' Clare states, 'and use a damp cloth to remove excess dust from the surface of each piece before firing.'

FIRING: Presenting the pieces so scrupulously clean produces a sparkling-clear pattern after firing to 1,230°C. Much experimentation has been carried out by Clare, who is well aware that porcelain is 'one of the most temperamental clays to use'. She had many problems with warping in her second firings, especially with the shallower platter forms. She tried supporting these in the kiln with silica/silver sand, and this 'worked well, but it retained the heat and took a long time to cool'. Eventually she found a solution, and this may be of help to others:

A cradle of kiln fibre is made first, then a layer of kiln paper (used mainly by glass artists) is placed on top to produce a smooth surface to receive the piece. Gloves, goggles and a mask must be worn to do this, and Clare warns: 'Though this makes you look ridiculous, it saves a lot of pain from the fibres.'

Clare feels that the technical knowledge she has gained has left her with a vast area of application where there will always be new forms to be produced. Nowadays her work is fuelled by fictional worlds inspired by marine life and insects, both supplying an abundance of tough, bright colouring, pattern and form. Her pieces 'explore the ritual and ceremonial events of these worlds, and in particular the similarities between the rituals of the insects and those of humans … such as the offering of gifts from the males to the females to gain "favours" …'

'*L*unar' (detail). Dorothy Feibleman (London, England).

Dorothy Feibleman: Laminated Porcelain

My thought processes are similar to looking at a computer-generated image that can be turned around and inside out and altered in my head. When I saw the process on a computer for the first time, it wasn't strange for me, because I have always thought that way. My mind does this most of the time (in the background) when I look at objects and when I am thinking about making things.

Dorothy Feibleman spent much of her youth staring at artefacts and pots treasured at her grandmother's home in Indiana, USA. These were brought back by her grandfather, who was an amateur painter and archaeologist travelling and working throughout the Far East and South America. Whenever she visited her grandparents, Dorothy handled and examined these objects, or looked at his photos of indigenous South Americans. She spent nearly every Saturday at the local children's museum among indigenous crafts from all over the world. When you see one of her detailed laminated bowls, it is as if your eyes are pressed against a glass case gazing in with the same intense curiosity, because they have captured that tribal essence from her youth. Their shapes remind you of the way a feather curves tightly from its spine, their mirror-imaged sides seem to unfurl. They may spread open further and, on a butterfly's wings, take off in an exotic flurry of pattern.

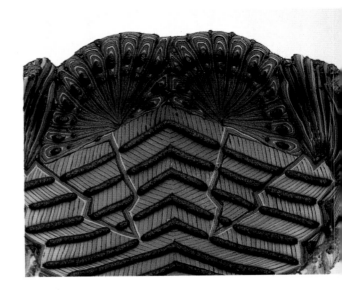

Dorothy is very interested in tools and their usage, and she makes some of them herself. She has dental tools, drills, tumblers, grinders knives and surgical scalpels; she uses wood slats, jigs and moulds. She doesn't consciously draw reference from other potters, but transfers methods and tools from other fields such as musical instrument-making, metalsmithing, building, and so on. She has studied joinery formally, and jewellery-making informally. She has become a true master in the skills of bending, curving and joining her laminated forms into neat little masterpieces, until these sing with energy and life. 'I value good workmanship,' she says, 'and I work carefully to achieve this.'

METHOD: Dorothy Feibleman uses white porcelain and her own white parian to obtain two translucencies and textures of white on white. She usually stains her colours with between 16 and 20 per cent, but can always work down from a higher percentage. She rolls out varying dimensions, thicknesses and colours of coils and slabs using wooden slats as

depth gauges. These elements are combined in various configurations, using slips to accentuate or eliminate attention to the join, depending upon the elements. These are cut into modules and assembled flat on a tightly woven cloth. The cloth is primed with slip which is scraped off so it impregnates the cloth. That way, the texture and absorption of the cloth is lessened.

Each join has slip in between, and is compressed; in some cases just water and compression are adequate. Every time a new element is added, it is compressed with the others in the process Dorothy calls lamination, and she says, 'I can become totally absorbed for hours, and am quite unaware of time.'

Contrasting colour blankets can be sliced into stripes or joined into geometric patterns from other blankets of colour, and made into new rolled slabs (making sure to wipe excess slip from each side with a rib). From these, she cuts shapes by eye or by using templates, like a tailor cutting cloth. She assembles them on a thin, tightly woven cotton cloth, cleans up the surface with a kidney, compresses it with a rolling pin,

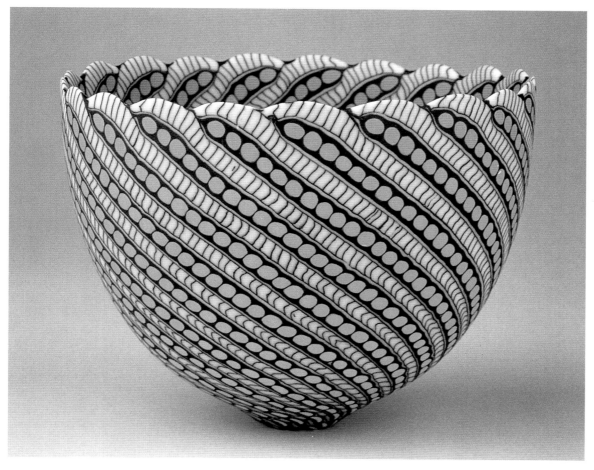

'Pink to Yellow Fading Spiral' (13 × 15cm/5 × 6in). Dorothy Feibleman (London, England).

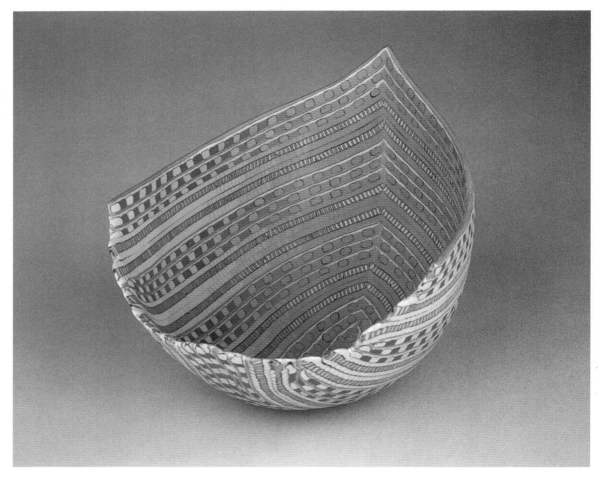

'Asymmetrical Fading Pink to Yellow' (20 × 16 × 11 cm/8 × 6.3 × 4.3in). *Dorothy Feibleman (London, England). (Museum of Contemporary Ceramic Art, Shigaraki, Japan.)*

then turns it over onto a clean area of cloth and repeats this process. Sometimes these elements are assembled in a shape a bit like a fan: the two ends of the fan are painted with slip, compressed together and put in a bisque mould, compressed with a roller, then taken out and placed on a wheel and thrown closed upside down (*see* 'Pink Spiral'). They are then put back in the mould and compressed once more with the roller.

When the piece is the right stiffness so that it won't deform greatly, Dorothy takes it from the mould and wraps it in thin plastic, returning it to the mould; this is when any alterations to form take place (*see* illustrations above). Like a cheese it is then left for a month, turning it occasionally. (These are the spiral pieces. Others are made with normal slab methods and pressed into bisque or wooden moulds.) 'The whole process is done carefully,' she says, 'but it looks like being in the middle of a tornado while it is happening. The surface of the work can look quite messy, but it doesn't matter as the design is structural and it is always underneath the

mess. It is best to ignore the drying piece for as long as possible and wait to see what is under the smears.' When finally dry, the pieces are refined with steel wool in varying gauges.

FIRING: Dorothy's intricate pieces are fired in saggars or moulds, with silica sand supporting the work. During the firing, Dorothy is aware that the overloaded colorants and different clay bodies used together have a bearing on the form. Unless left intentionally textured, most vessels are smoothed between firings with silicone carbide and also diamond paper to create the standard of finish that she requires:

I subject my pieces to several firings in order to change texture and shape; thus I can end up with a totally different piece from the one I started with … I enjoy knowing that my pieces 'grow' in the kiln, and it is always surprising and exciting opening it up … I keep changing how I work in small ways – the only absolute is making sure the joins are good within the patterns.

Judith De Vries: Laminated Porcelain

In the process of working I sometimes think: 'Why not leave the slab like it is , it already looks complete, why make it into a vessel?' But then it feels as if the material of clay invites me to form it.

Judith de Vries likes the fact that her vessels are decorative, and not meant to be used: 'I think the vessel with the rim as a border from inside to outside is an exciting vehicle for expressing ideas.' She lives next to the zoo in Amsterdam, and when she walks there with her six-year-old son, she is intrigued to find patterns she has made in her studio recur in the skins of animals – while she herself is inspired by the designs, the patterns and the colours of the fishes and the birds. Perhaps they borrow ideas mutually, for Judith thinks that 'sometimes it feels like getting a glimpse of the mystery of nature.'

METHOD: Judith uses Limoges porcelain TM10, because it matures at a low temperature (between 1,200 and 1,260°C), and also because it offers a

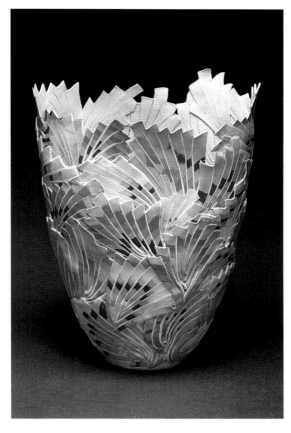

'The Four Seasons – Spring'. Judith de Vries (Amsterdam, Holland).

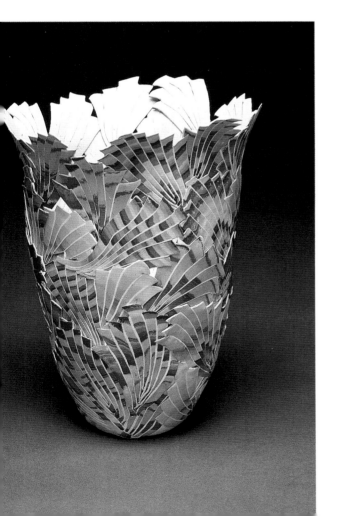

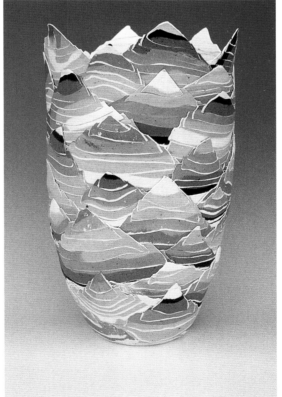

'The Four Seasons – Autumn'. Judith de Vries (Amsterdam, Holland) (far left).

'The Four Seasons – Winter'. Judith de Vries (Amsterdam, Holland) (left).

'The Four Seasons – Summer'. Judith de Vries (Amsterdam, Holland).

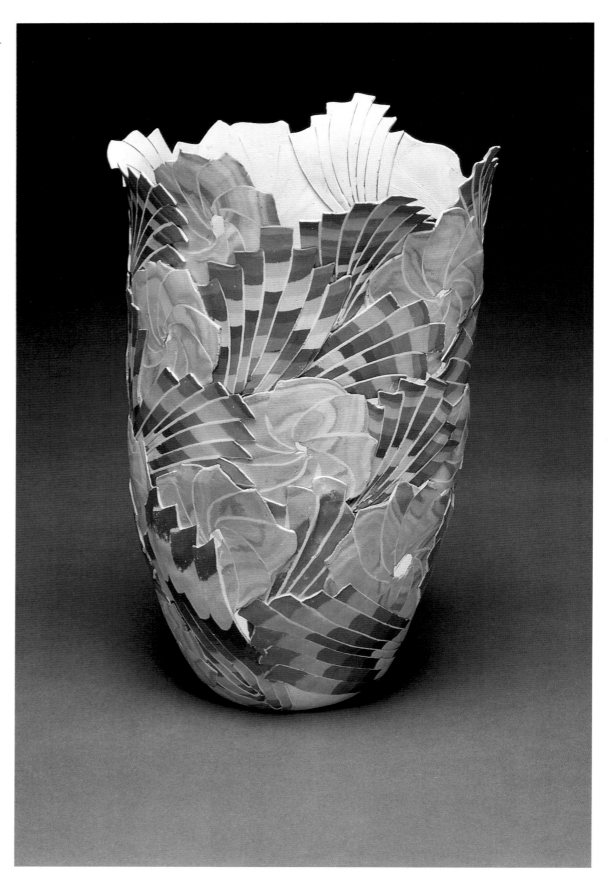

clean white body to show her colours brightly. Into this she mixes 1–10 per cent commercial body and glaze stains – with possibly 1–10 per cent iron oxide, or cobalt oxide, which gives blue already in a quantity of $^{1}/_{20}$ per cent. All colorants are ground or sieved to ensure an even blending.

Judith has chosen lamination, as this method gives her more freedom, both in form and composition. She experiments with layering coloured pieces one on top of another, then wire-cutting them through into thin slabs to expose striped layers. These she rolls out again, to reassemble in different ways, often on a white slab of the same porcelain body. She employs a kind of stacking with these patchwork pieces, building them up inside her self-made plaster bowl moulds, spiralling them in much the same way that the whorls of a flower might grow. This patterning always leads the eye from base to crown, so that you think you are witnessing one of those wonderful delayed shots of an opening flower from a nature programme on television.

Using a backing slab means that the patterning doesn't always go right through the piece, and white from the background shows as very thin lines between the strokes of pattern in front. Likewise, colours from the front show like the thin veins of a flower petal on the reverse of the slab, that is, on the inside of the pot. Of course, this means also that as the patterns are stacked one on top of the other, some of the design must be hidden away inside. Since she discovered this effect, Judith will often reverse different patterns before rerolling them, bringing variety to both surfaces.

Judith's favourite time is when her lovely pieces have dried slowly to leather hard, and she can scrape them with a metal kidney, rendering the patterns sharp and clean. Her least favourite time is a stage further on, when the porcelain has dried: she chooses this time to rub away with very fine steel-wool all surface marks made by the scraping. As she explains, 'This process requires total concentration and *great* caution, because the piece is very fragile in its dry state, especially when it is thin; it's more like 'tender stroking'. Many people prefer sanding the piece when it is bisque-fired. It is a safer way, but I hate working with sandpaper – it's such a dry, dusty job, so I'd rather take the risk, and I must say, I cope quite well!'

FIRING: Judith de Vries bisque-fires her pieces in an electric kiln to 1,000°C, then glazes just the inside with a ready-made transparent porcelain glaze, firing to 1,220°C. Once her vessels emerge from the kiln, she burnishes the outside with wet and dry paper to obtain a softly smooth surface.

Working in her technique in porcelain requires great patience and endurance; 'and even then,' Judith says, 'there is no guarantee of success. With my fourteen years of experience, still one in four of the pieces has small cracks or deformation that cannot be tolerated.' This makes the ones that get through very special indeed.

(Judith also creates woven sculpted pieces: *see* Chapter 11.)

Curtis Benzle: Millefiori and Laminated Porcelain

If pure white porcelain whispered a special beauty, coloured porcelain could shout it.

Curtis Benzle's involvement in coloured clay has been, in his words, 'an evolution – an exploration of technique in search of a means to unlock an ideal beauty.' This is found, he says 'in the natural interaction of two essential elements: light and clay. The ideal is when light is filtered through space; the means to do this is controlled by the artist.' He qualifies this by stating that, 'whether this space is occupied by an object or atmosphere is conceptually irrelevant. The relevance of objects in all this for me rests solely in that I am a craftsperson – a maker of things.'

Curtis's workshop is situated just north of Columbus, Ohio, in the USA. There he fashions vessels that are delicate and unashamedly pretty – yet they go beyond mere prettiness to reach a purity and beauty which make one think of the line from Keats' *Ode to a Grecian Urn* … 'beauty is truth, truth beauty'. Peaceful tranquillity and joy in life are what Curtis patiently and methodically embroiders into his visual imagery. And quality found in his own work, is what he seeks from his pupils whenever he teaches in the many institutions which have been fortunate to use him as an instructor; for Curtis is kind and generous in nature.

Although his relationship with Suzan Benzle has now ended, her presence has been involved in Curtis's work from the very beginning, inherent in

the way he was first inspired prior to his actual collaboration with her. He says: 'A favourite image of mine was her newly dyed silk fabric hanging to dry in the wind. Like porcelain in its ability to transmit light, how much more vibrant the coloured fabric was than its earlier white, and unaffected counterpart. The addition of colour, in a figurative way, makes light more visible.'

Curtis's vessels appear as little gems if you put them in the window. They remind me of the traditional stained glass done by my sister Lyn Clayden, and my mother, Barbara Batt: in the same way that a church window appears to trap a more scintillating colour than that found in the real world around, so do his pieces – and they have that same quality of light filtering through coloured glass which activates movement within pattern. The fine differences of the porcelain's thickness enhance luminosity, too, and one is not surprised to discover that Curtis finds inspiration from 'an early morning mist that partially obscures the distant meadows – a swirling eddy capable of concealing fish behind nothing more dense than a shadow – or an eggshell-thin porcelain bowl, light enough in weight and appearance to float away on a breeze.'

This delicacy is the result of a very special porcelain which Curtis developed during the late seventies and which, when fired to cone 7, acquires a vitreous nature not unlike glass … 'and harder than most stone'.

METHOD: Curtis chooses porcelain both for its initial whiteness and for its being a 'tactile material that will enhance translucency and incorporate the vitality of colour'; this occurs because his glass-like material contains only 25 per cent clay. Once patterns have been formed, using both oxides and stains, Curtis draws upon a variety of methods 'some new to me at their inception, such as being inspired by millefiori, adapted from the Murano glass technique.' (Like myself, Curtis also did a short graduate study in glass in the seventies and fell under the spell of millefiori.)

Curtis does use more common methods, including slip painting and inlay; however, his trademark is his mosaic patterns pieced side by side in their moulds. He works by stacking multiple layers of thin, inlaid patterning, and these have to be very fine or it would result in a certain opacity which would dull the light's progress through their walls, and luminosity is always of paramount importance.

The variation in the quantity and quality of light through his vessels makes these fresh and exhilarating, and Curtis must be credited with 'forever piping songs forever new'. Curtis asks himself:

What lies ahead? What new technique will give voice to the still silent images within my mind? My exploration of coloured clay began with an ideal of beauty. That still remains; elusive and seductive. My pursuit of this vision has grown to include others – most exceptionally Suzan Benzle – and has now contracted again to a similar quest. But it has never ended, nor do I expect it to as long as there remains yet one more way to caress colour and porcelain into speaking of ideas too complex for words alone.

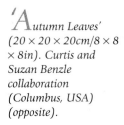

'*F*ree Flight'. Wall sconce (23 × 43 × 15cm/9 × 17 × 6in). Curtis Benzle (Columbus, USA).

'*A*utumn Leaves' (20 × 20 × 20cm/8 × 8 × 8in). Curtis and Suzan Benzle collaboration (Columbus, USA) (opposite).

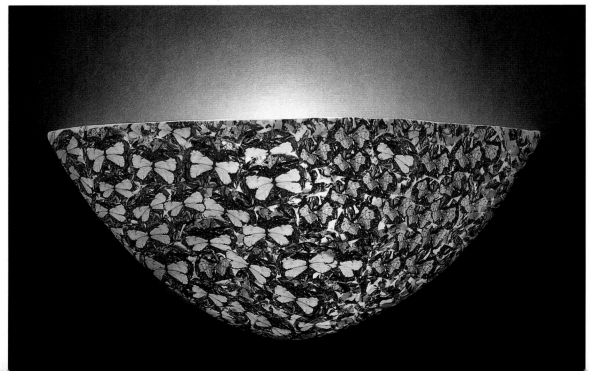

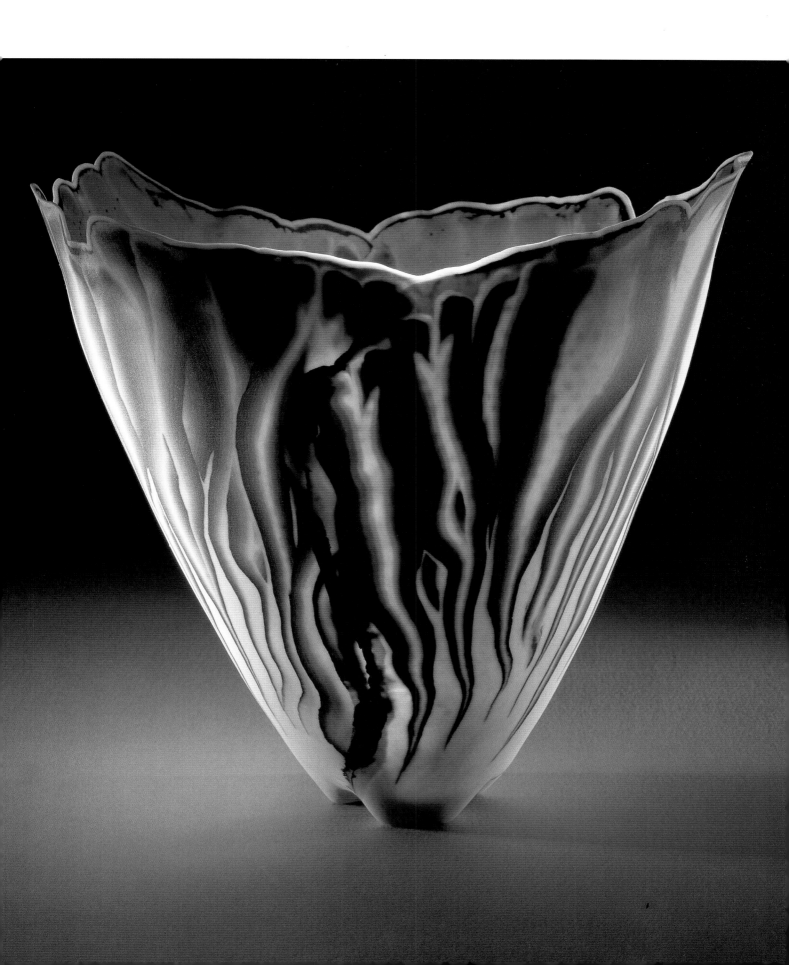

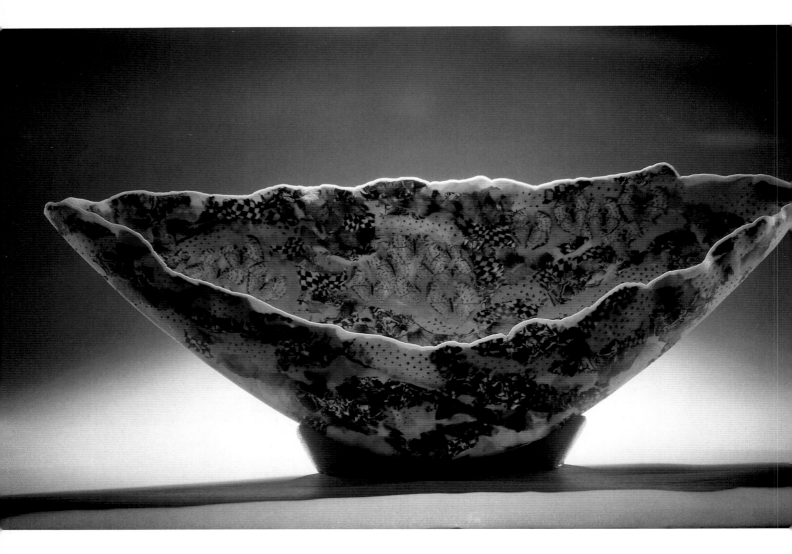

'M*oments in Time'*
(20 × 46 × 10cm/8 ×
18 × 4in). Curtis
Benzle (Columbus,
USA).

Henk Wolvers: Slabbed Porcelain Lamination

I think in porcelain.

It is open to question whether the Dutch artist, Henk Wolvers, is a painter, sculptor or potter, because he combines all three disciplines effortlessly. He brings strength of form and the bold statement of a sculptor to his work, as well as a painter's excitement with colour and an understanding of spatial relationships; and he has a potter's enjoyment in handling porcelain. His special gift lies in his ability to meld these disciplines so that one does not dominate the others.

Henk is not timid in his approach: sometimes he marches whole armies of pieces together – a fearless family in uniform, but with subtle differences, which remind you of the Chinese

terracotta army excavated from the tomb; only Henk's work is very much alive. Above all, he knows what he wants; there is nothing tentative about his ideas. Like all good artists, Henk thinks of the whole as he works on a part, so that his pieces are cohesive in shape, style and design.

METHOD: Henk's ideas are kept in a sketchbook, opened when he is ready to make the piece he has thought about. His studio is like a prepared canvas, primed for colourful approaches, the walls, shelving and workspace as pristine and white as the porcelain he uses – a Limoges porcelain 1,350°C.

Porcelain is a difficult clay to manipulate, which is why Henk's intimacy with, and respect for the material tell him to go with, rather than against its natural inclinations. He knows from experience when it becomes optimally flexible and malleable, and exactly when to lift, bend

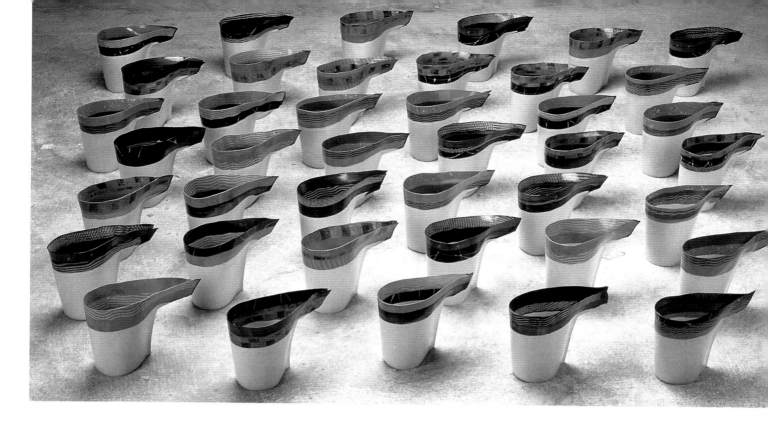

and manoeuvre the slabs together. It is important to be definite, as any indecisive movement will be immediately reflected in the walls when the slabs are squeezed together. Slabbing allows Henk large areas of picture plane upon which to work, with additional layers of engobes and paint-marks.

First Henk makes up his patterns, wedging in all kinds of stains and stain mixtures in strengths from 5–10 per cent, and rolling these together until he has made up a patchwork of coloured patterned slabs. He also paints on a pure porcelain engobe, or will add further layers of coloured slips but always on the flat slab before any assembling takes place. His colour palette and patterning reflect his optimistic mood, and he enjoys the fact that his method gives decoration to both inner and outer surfaces like a 3D set.

Henk's pieces show symmetry and balance, and it is important to him that they stand well and behave in relation to the ground and space around. This is often helped by the way in which he builds an interesting wrap-around flange on the rim, making it an apex of strength, rather than just leaving it as a natural square, round or ellipse.

FIRING: Henk fires his work in a gas kiln reduction to 1,300°C. Sometimes he will apply a clear transparent glaze (mostly inside) through which his painting and patterns will gleam (*see* Chapter 6).

*H*enk Wolvers (Hertogenbosch, Holland) (above).

*H*enk Wolvers (Hertogenbosch, Holland). (40 × 17 × 8cm/16 × 7 × 3in).

Henk Wolvers (Hertogenbosch, Holland). (36 × 18cm/14 × 7in).

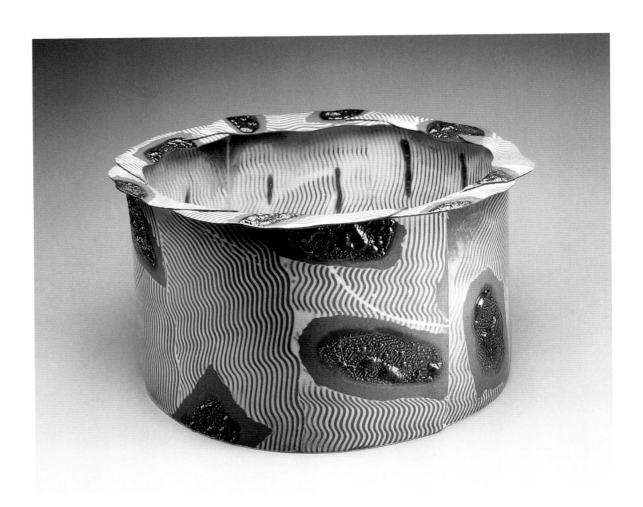

Henk Wolvers (Hertogenbosch, Holland). (40 × 20cm/16 × 8in).

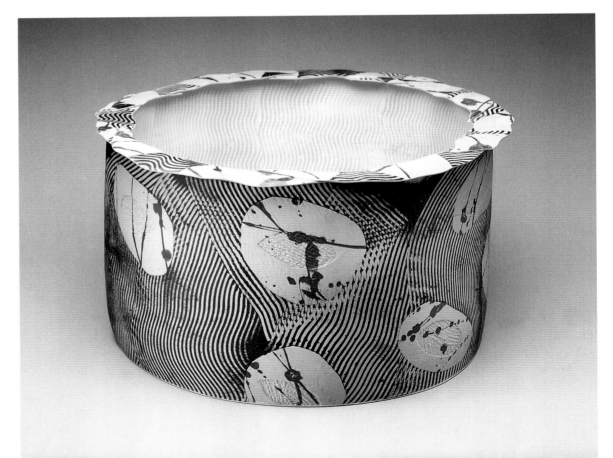

Naomi Lindenfeld: Laminated and Carved Porcelain

I like to work with patterns that are a connection to the natural world, fluid in movement and rhythm, a visual effect that I find quiet, yet stimulating.

Naomi Lindenfeld was first introduced to working with clay at the age of fourteen, so she knows what she is about! She has been living in rural Vermont, USA, since 1981, and participates in many craftworking organizations. She is fully involved in the ceramic scene in the north-east.

Her work looks freshly made, her patterned forms deftly folded, and they reflect her love of dance. Once prepared, her patterned sheets of clay are manipulated into forms with graceful spontaneity. When assembling flat sheets of clay she feels it is important that the folding is never done fussily, but in one bold sweep to allow the work to keep its crisp and clean appearance. She 'paddles' the corners to keep the outline soft, and some of her pieces have a carved edge which she sponges, giving them a smooth, fluid feel; this creates an illusion of waves spilling over the edge of the piece. The overall design flows like the effect of oil on water.

METHOD: Naomi stains her porcelain using Mason's tremendous colour range, but she also uses a few oxides. These are layered into a block (*see* Chapter 4), and a slice is then taken from this block and rolled out against a blanket of white porcelain. Naomi explains that she does this because: 'the backing strengthens and

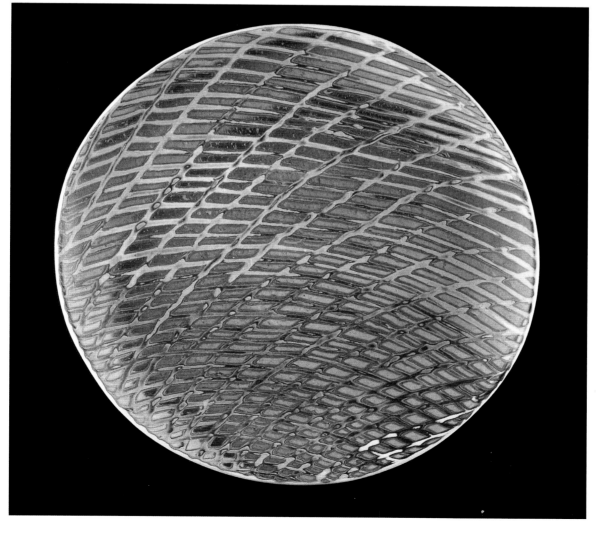

'*P*latter' (width: 30cm/12in). Naomi Lindenfeld (Vermont, USA).

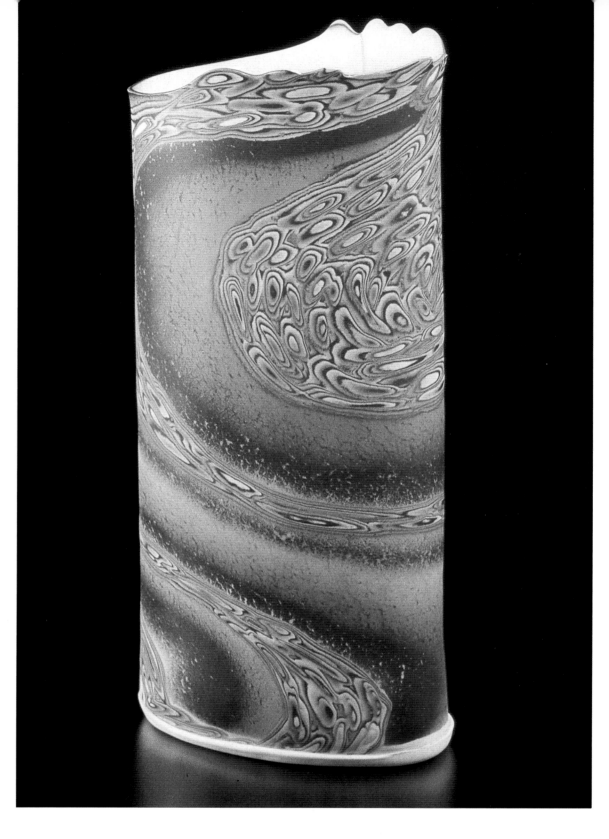

'*O*val Vase with Carved Edge'. Naomi Lindenfeld (Vermont, USA).

binds the coloured clays together, and as a result there is less cracking and warping'. Cross-sections taken from the layered block reveal rings of colour, and these suggest the direction to take each time the piece is rolled, carved into, and re-rolled.

The carving part of the process is important. Naomi uses a fine carving tool to cut through multi-dimensional planes before rolling them flat again, and the resulting designs create imagery reminiscent of galactic orbs, fish scales and flowing currents – anything characterized

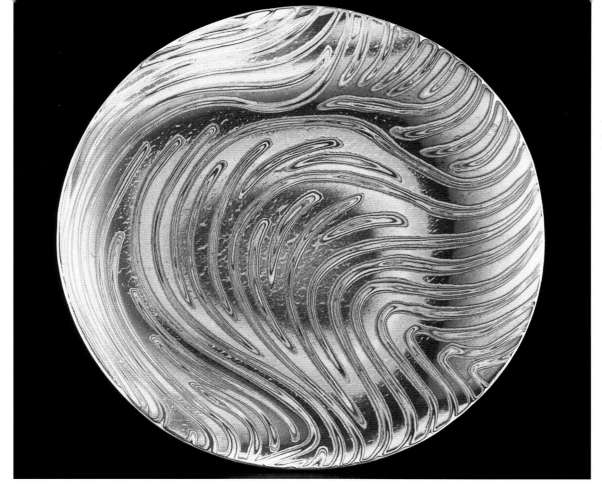

by liquid motion. Finally a flat blanket of dancing swirls is created, which will, as far as possible, involve a feeling of immediacy. Naomi says that she tries to 'contrast densely patterned areas with a background of softly blended colours. When the patterned blanket is assembled into its finished shape, the seams are allowed to be visible, giving the forms a freshly put-together look.'

FIRING: Although Naomi coats the inside of many of her pieces with a celadon glaze, she prefers to keep her work unglazed on the outside. She chooses to work with porcelain for its smooth, matt surface, for clear, vibrant colours and its sensual feel. She also insists on her work being usable: 'The work is fired to 2,400°C, cone 10–11, in a gas kiln,' she explains, 'and is therefore quite durable and washable. They are also safe to use in dishwashers and microwaves, and they are lead free.'

Naomi has to meet the demands of a large clientèle, while at the same time attempting to keep the individuality of each piece alive. 'But,' she says, 'the unexplored potential in coloured clays always leads me forward into new discoveries.'

Anne Lightwood: Inlaid Coloured Porcelain Using Hump Moulds

Anne Lightwood is a hard-working, prolific potter from Scotland. When her 'Largo Pottery' burnt down in 1984, she moved to St Andrews in Fife and set up another. She was a founder member and fellow of the Scottish Potters' Association, and is now on the management committee of the Association for Applied Arts in Scotland; she also teaches and lectures, and with the help of studio assistants, manages to run a studio, too. This produces so much work that very often it is sold straight from the kiln, sometimes prompting people to comment on how warm the pieces are!

METHOD: Anne Lightwood uses an original technique which she has researched and developed: her bowls are made on cloth and rolled out flat with a rolling pin, and put onto hump moulds. Blocks of coloured clay are assembled like liquorice allsorts or a stick of rock (*see* Chapters 3 and 4); these are sliced through, and the

'Waves Bowl'. Inlaid coloured porcelain. Anne Lightwood (Fife, Scotland).

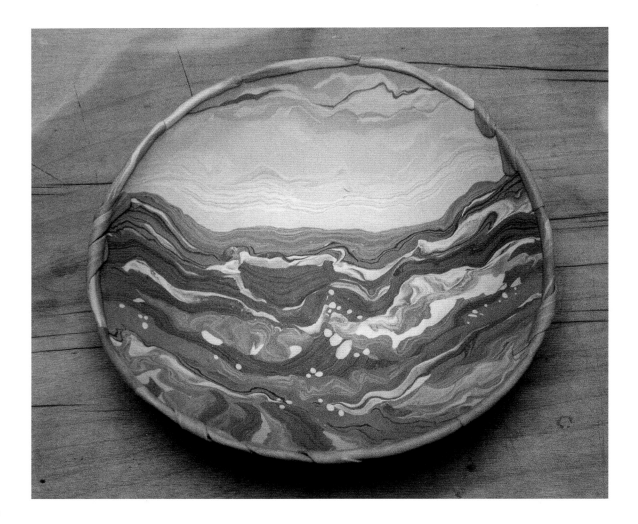

pieces arranged to build up patterns which evoke the colour and landscape of the sea that surrounds her. The direction of rolling will alter the design so that the rhythm and movement of the sea may seem to be captured within. The cloth is turned with care and the rolling kept even, so the shape remains roughly circular.

At various stages, shapes can be cut out and others inserted like a patchwork; overlaps are allowed. The thinner the inlaid clay pieces are, the more precise the pattern will remain. Once the design is complete, the whole thing (on its cloth) is flipped over a hump mould and gently pressed into position. Then the cloth is peeled back and the surface smoothed with a rubber kidney, both to compress the pattern and to remove the texture of the cloth imprint.

The footing and any edging around the rim is added while the bowl is still on the hump mould. 'I often use twisted coils for this,' Anne says, 'or sometimes small wrapped pieces of different coloured clay, depending on the size and

TIP

Take care that the clay blanket is not too soft or the edges of the inlay will blur.

width of the piece. Catenary shapes are strongest and keep the best shape.'

Each clay bowl has to be lifted from the mould within a few minutes, and Anne is still amazed at how quickly a floppy pancake on the cloth can stiffen to a thin bowl capable of standing on its own. Furthermore, if left too long the clay will be difficult to release because it shrinks; longer still and the piece will crack. Anne has found that pieces up to 12in (30cm) will stand on their own straightaway; larger pieces will usually be supported within another bowl until the rim no longer falls back or cracks. Likewise smaller pieces dry very fast, whereas larger ones with more attachments will take over a week or so. All work must be dried evenly.

FIRING: A single firing is made in an electric kiln, going from cold to 1,240°C in about eight hours overnight. The controller is set so the kiln takes five hours to reach 600°C, then goes on full until it reaches 1,240°C with no soak. The final stage is to wet and dry the bowls with carborundum paper, and to wax the surface (*see* Chapter 6).

Using a Hump Mould

Anne's largest hump mould is 43cm (17in) in diameter (kiln-shelf size) and her smallest, 7.5cm (3in) for 'tinies'. She uses hump moulds 'to keep the inside of the porcelain as sharp and as smooth as possible.' She also has this advice:

> Moulds from thrown porcelain or fine stoneware, turned and burnished and fired to about 1,100°C, are far more practical than plaster since they don't chip or crack if used with care; and releasing the porcelain is much easier. Also, a small piece of clay on a large mould will give a very shallow dish – though be careful it isn't *too* shallow or the pieces will slump. And a large piece will drape over a smaller, deeper mould giving a fluted base. These can look very attractive, but they are difficult to polish and may crack in the folds.

Probably to prevent this happening, Anne Lightwood has begun to use paper clay for her work (*see* Chapter 11).

Linda Caswell: Marbled Slabbed Hump-moulded Porcelain

A chance viewing of *Reef Watch* on television found me hurriedly scribbling in my sketchpad (not something I am often taken to doing) to capture the patterns and colours of the fish. It fired my imagination, and using coloured clay enabled me to recreate and enlarge on my sketches.

Linda Caswell makes very fragile bowls from fine, marbled, slabbed porcelain or sometimes parian porcelain, to give stronger colours used 'neat' or in combination. She is hard-working and busy; at the time of writing she has just moved house and country and although she now gets pine needles through the roof when the wind blows, she has the compensation of wonderful views in North Wales. She also makes mobiles, buttons and jewellery which are tumbled in a stone polisher, and this gives a very nice finish: 'if only I could put the bowls in, too!', she sighs.

Linda loves what she calls the 'controlled randomness' of using marbled clay:

> No two sheets of clay will ever be exactly the same: colour density, juxtaposition of colour and pattern, even the similarity or difference of the patterns on each side of the sheet of clay vary every time. Sheets of clay that seem strongly marbled when making can turn out to have a

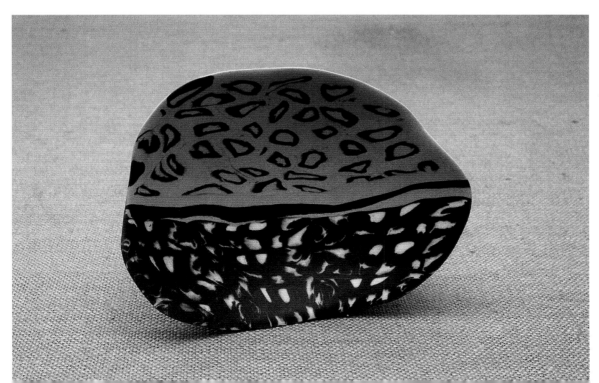

'*Bowl*'. Stained and laminated parian, unglazed, polished at bisque and after final firing. Linda Caswell (Tranwsfynydd Gwynedd, North Wales).

'Bowl'. Black, brown-and-white marbled porcelain, unglazed, polished after firing. Linda Caswell (Tranwsfynydd, Gwynedd, North Wales).

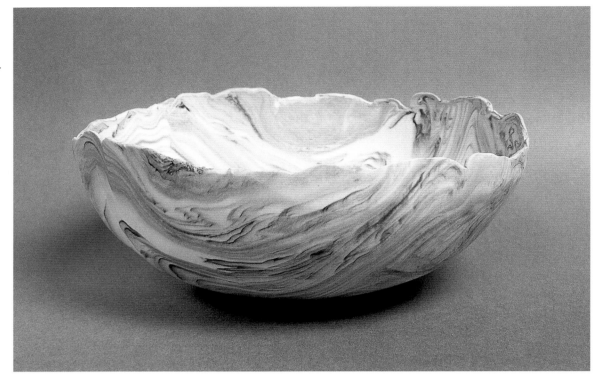

'Bowl'. Stained and laminated parian, unglazed, polished at bisque and after final firing. Linda Caswell (Tranwsfynydd, Gwynedd, North Wales) (below).

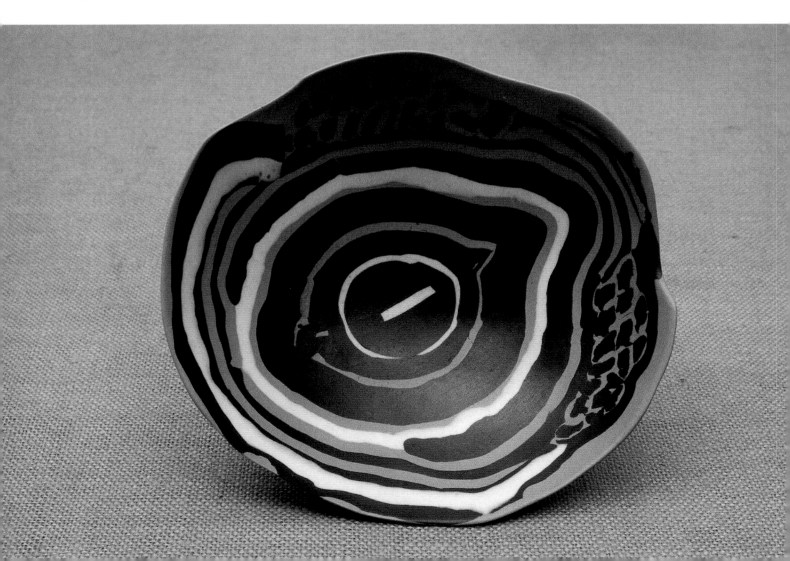

misty quality, and sheets which don't show much marking can be wonderfully marbled when fired; every piece is an adventure.

METHOD: Using Valentine's P2 porcelain for these, and colouring them with her favourite white, black and brown stains (*see* Chapter 4), Linda Caswell makes up patterned sandwiches. First she cuts a block of plain porcelain, about 18cm (7in) cubed, straight from the bag. She roughly wire-cuts this into slices, each of which will vary from 2–3cm (¾–1in) thick. She peels off the first slice of the plain porcelain and puts it on the bench, then lays over it very thin slivers from a small block of her coloured porcelains (using an adapted cheese-slicer), sandwiching plain and coloured slices and so on. The block is then wedged, cut in half, and one half is banged down on the other; this is followed by a little gentle kneading to introduce a twist – though not too much or the marbling will be lost altogether. The marbled clay is stored until it is needed; then it is sliced with a wire harp, sometimes just one piece being taken to work with, sometimes several. Next these are rolled between two sheets of newspaper.

TIP

If rolling out clay hurts your hands, invest in a Roderveld Jumbo Junior and an IKEA Sten bench which is very stable.

By carefully rolling with her Jumbo Junior, by thinning the sheet only slightly each time, and by using new newspaper, and turning it round, Linda is able to manipulate the way the marbling moves. Then she cuts out a circle from the rolled sheet and drapes it over a hump mould (or a balloon), and beats and coaxes it into shape.

FIRING: The dried bowls are once-fired to 1,220°C in an electric kiln, then wet-sanded with very fine 1,000 grade 'wet-and-dry' sandpaper to create an eggshell quality.

I enjoy working with very thin sheets of clay, and the fineness I can achieve. However, they rarely come out of the kiln the same shape they went in because the thinness of the porcelain and the stresses caused by the marbling can dramatically change the form. Opening the kiln after firing is always exciting – and sometimes a little disappointing: why is it always the best marble patterns which distort most?

Syl Macro: Textured Inlaid Stoneware

Living in the Pennines I'm surrounded by sweeping hills and moors, with colour changes you just wouldn't believe. Put almost any combination of colours together and it is suggestive of this landscape at some time of the day or year. I see landscape made up of individual areas of colour and texture – some natural, some man-made – apparently randomly juxtaposed to form a whole.

Syl Macro does not use her textured materials in any cosy way; she gets them to work for her so they reflect the strong winds blowing in the trees or great sections cut through the earth beneath her. And texture is probably the most important aspect of Syl's work; the colour merely fills the interstices of the imprint left by the material, and makes it solid once again.

METHOD: Syl uses Potclays powdered white stoneware 1145 or their powdered buff stoneware 1119, or a 50/50 mix … 'It depends on whether pale, delicate colour or more earthy

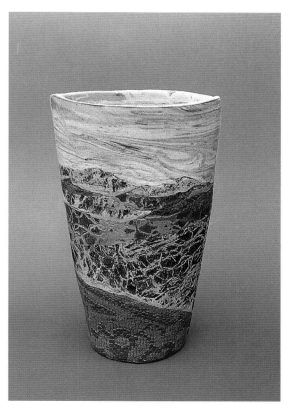

'Landscape Vase'. Textured stoneware inlay. Syl Macro (Cumbria, England).

colour is desired.' To this she will mix 10 per cent molochite and between 5–10 per cent of coloured stain (*see* Chapter 4).

TIP

For larger pieces, try kneading together an equal amount of Potclays Y material with the coloured clay.

Rolled out sheets of coloured clay (usually about 500g (1lb) at a time) are imprinted using a variety of objects. Net, lace, old dishcloths, bits of old agricultural sack, unravelled rope – even dead plants – are pressed into the clay which is then coated with a contrasted coloured slip. With these textured pieces, Syl recreates part of a north Pennine landscape. 'One of my favourite textures,' she confides, 'is achieved using a crochet-work dressing-table set made by my mum – I'm sure she wouldn't have minded, being an artist herself!'

Other clay is marbled by pressing together several different coloured sheets, lightly kneaded, then wiring them through the centre – this will give some Pennine sky effects, as if they were hidden inside the clay all the time and only needed revealing. Still working flat, the pieces of textured clay are cut to shape and butted together, lightly rolled, then flipped over to enable the reverse side to be finished. The assemblage is then placed face down into moulds and allowed to firm

Slow, even drying is essential for the work, for this is when cracks may happen.

FIRING: Cracking may also occur in the firing, because this is only done once – straight up to 1,235°C – 'to give a hard, more earthy feel to the pieces.'

Usually Syl makes elliptical vase forms, bowls and wall pieces, as these shapes are easily mould-formed, and lend themselves to landscape design. She is a strong and persistent potter, because, as she says, the feeling she gets when she opens the kiln 'to discover that a piece you spent hours on has a huge split in it or is distorted, makes you more determined than ever to try again to get it right.' Currently she is planning to do some experimentation with paper clay, to see if this will overcome any of these problems.

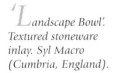

'Landscape Bowl'. Textured stoneware inlay. Syl Macro (Cumbria, England).

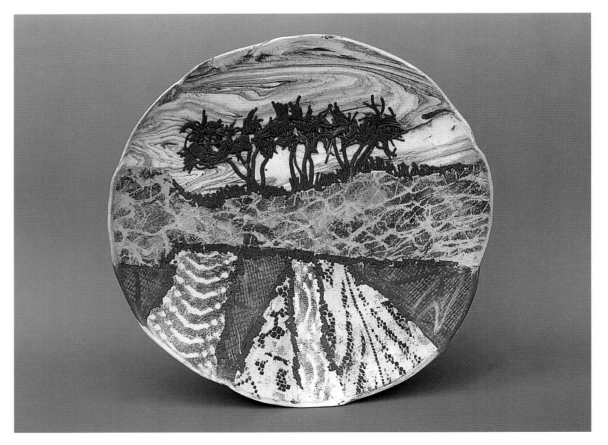

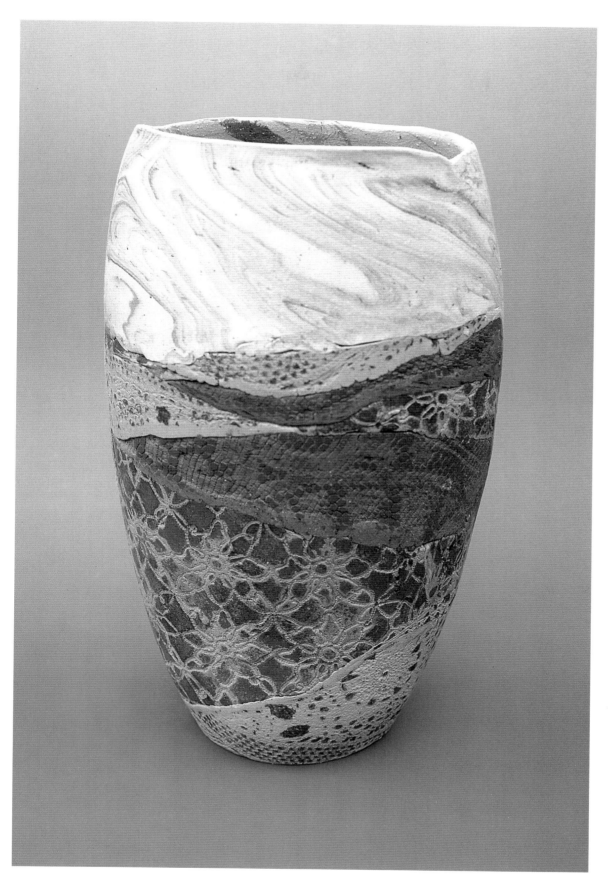

'Landscape Vase'.
Textured stoneware
inlay. Syl Macro
(Cumbria, England).

Jo Connell: Appliquéd Inlaid Moulded White Stoneware

Inevitably some of the best results arrive by accident and it is hard to repeat such things. What seems to matter most is the 'balance' between the colours – a thin streak of a contrasting or strong colour is often impressive, but it is a difficult thing to control.

Jo Connell divides her time between teaching and making her own cheerful and smart ceramics; her enormous Georgian house in Warwickshire has a large bake-house which she uses as her studio. The house is situated on a Roman site, and so Jo can boast of having had three archaeological digs in the garden. 'Coloured clay is important in archaeology, too,' she says. 'The region is famous for its motaria (mixing bowls) made from pipe clay and its "greyware" made of red clay fired in reduction.'

METHOD: Jo Connell uses white stoneware because, she says, 'it is important to use a clay which "appears" white in the wet state so that the colours can be seen – usually, but not always, they are remarkably representative of the fired colour.' She will not use buff as she says it is difficult to see what you are working with, 'rather like painting by numbers'. Instead, she uses this clay as a slabbed background into which she rolls her appliqué, building up a picture which can be quite figurative. Her darker floral or abstract motifs rolled into these lighter blankets of buff or white stoneware create bold and distinctive designs.

Jo uses various mixes of stains and oxides (*see* Chapters 3 and 4). 'I work on the basis of using what bodystains I have (some ancient discontinued ones), and buying only what is strictly necessary to broaden the palette.' She uses several rolling pins, 'setting one aside as it becomes wet or sticky'. Some of her appliqué is rolled very thinly indeed, and there is often distortion when it is rolled over other pieces of the patchwork, though this can be minimized if wished. If the clay is too wet, she sandwiches it between two cloths – but she warns that it will dry out quickly so it is essential to work fast. Often Jo rolls so thinly that the coloured layers become stretched 'almost to transparency, and a kind of optical mixing occurs. But these can be rolled

*U*nglazed stoneware vessel (width: 10cm/4in). Jo Connell (Warwickshire, England).

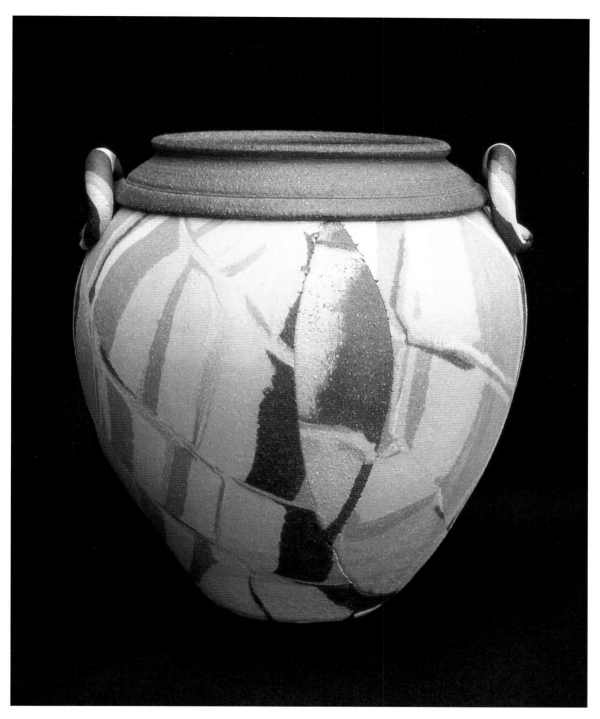

Unglazed stoneware vessel (width: 38cm/15in). Jo Connell (Warwickshire, England).

onto a thicker slabbed background of any colour and re-rolled so that the pattern becomes very diffused.'

Once prepared, the appliqué slabs are lifted into one- or two-piece plaster moulds. When the moulded pieces are dry enough to be joined, Jo does not try to disguise the seams that disturb her patterns, but leaves them as part of the form.

> **TIP**
>
> If you want to roll thinly, use a section of a broom handle.

Next she adds a thrown or hand-built section, a coiled rim or a handle perhaps.

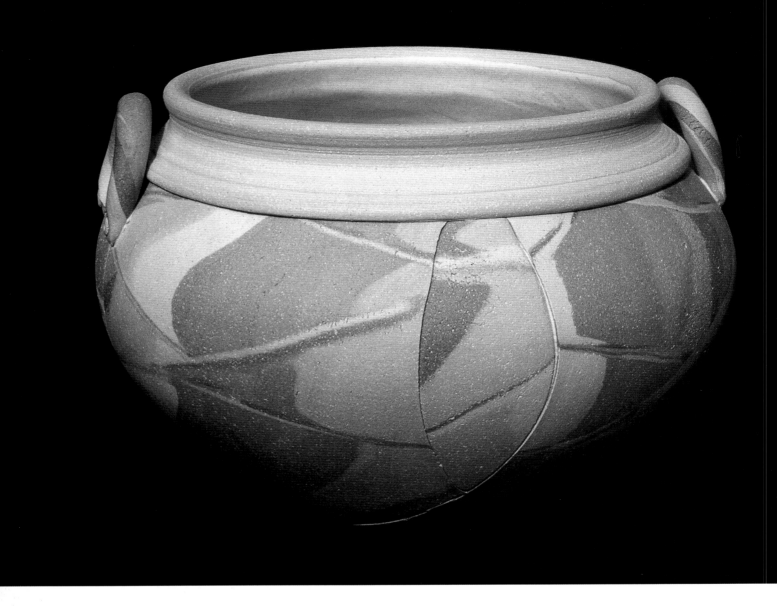

*U*nglazed stoneware
vessel (width:
20cm/8in). Jo Connell
(Warwickshire,
England).

Jo's earlier pieces drew on historical examples
of surface pattern, such as Art Deco textiles and
wallpapers, but nowadays she prefers to be more
impressionistic and creates abstracted asymmet-
ric designs. These she makes by rolling coils of
clay into a loosely striped, strata-like pattern,
kept crisp and sharp by using relatively stiff clay
and rolling carefully in the same direction.

FIRING: Although it makes a welcome change
to use glaze occasionally, Jo usually glazes only
the insides to make her pieces watertight. 'I have
always preferred a clay surface to a glazed one,
as it seems to allow so much scope for texture.
A clear glaze would certainly brighten colours
further, but I find it too harsh.' She also finds
that an oxidizing atmosphere of 1,250°C
'brings out the colours to their richest.' (*See*
Chapter 6.)

Mignon Woodfield: Slabbed and Carved White Earthenware Inlay

I especially like to make jugs intended to be
crammed with flowers.

Mignon Woodfield lives in a farmhouse in Blag-
don outside Bristol with her philosopher hus-
band and two little girls. She is surrounded by
fields of wild flowers, and all her work reflects
this environment. Mignon trained as an illus-
trator, and then worked as a decorator for Ken
Clark in Covent Garden, and this, too, has obvi-
ously influenced her work. It was Ken who

encouraged her to take up ceramics and to go to art college. She loves drawing and painting, and says that she would like her pots to become 'more painterly, making the surfaces rich and impressionistic while keeping the forms simple'. I think, in fact, that she has already achieved this.

METHOD: Mignon's jugs are slab-built using Potclays LT25 white earthenware clay which is dried out and stained, usually 'with 10 per cent colour, and sometimes a concoction of colours – especially greens'. A slab is rolled out, and strips are rolled into it creating a chaotic background of colour 'as in a flowerbed'. Next, two slabs are rolled together, making the pot's inner surface one solid colour. Now the jug or bowl is assembled.

When hardened a little, petal or flower shapes can be carved out quite freely, and these are quick and easy to pull out owing to the double skin. Next, the spaces are filled with clay and left to dry very slowly to leather hard. Finally the surface is scraped clear with a metal kidney and smoothed over with wire-wool. The jug handles are made from coloured coils.

FIRING: The dried jugs are bisqued to 1,100°C – and still the decoration continues, because

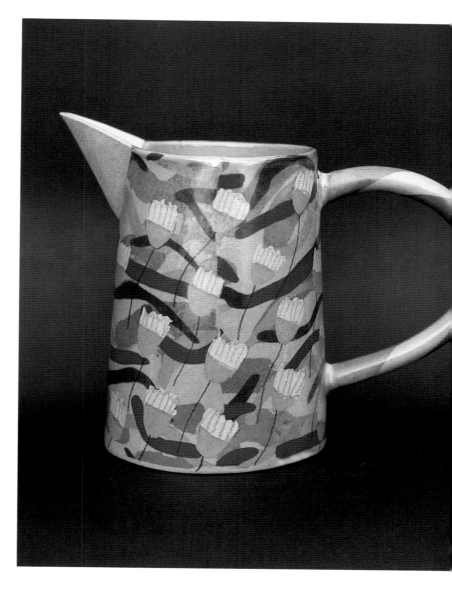

Jug (20cm/8in). White earthenware, carved, inlaid, drawn and painted; then fired with a matt glaze. Mignon Woodfield (Bristol, England).

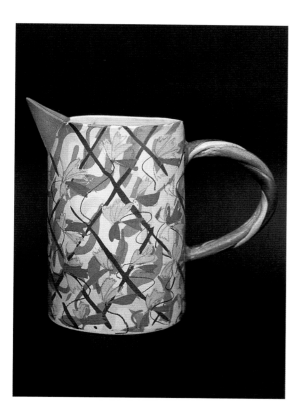

Mignon draws and paints on the surface with underglaze colours and ceramic pencils. The insides are covered with a clear commercial glaze so that the jugs can be used, while the outer surface is treated with a Dora Billington matt glaze. This must be sprayed very thinly before being fired slowly to 1,100°C; this is done in Mignon's Cromartie top-loading kiln.

Although Mignon's technique is very laborious, the finished product is always fresh, colourful and spontaneous – and that is the idea.

Jug (20cm/8in). White earthenware, carved, inlaid, drawn and painted; then fired with a matt glaze. Mignon Woodfield (Bristol, England).

Jug (15cm/6in). White earthenware, carved, inlaid, drawn and painted; then fired with a matt glaze. Mignon Woodfield (Bristol, England).

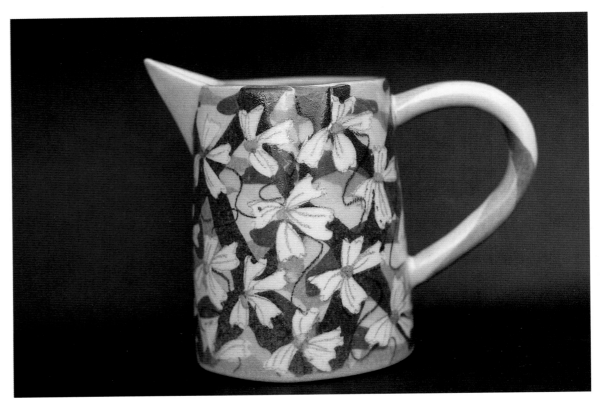

'A–Z' teapot. Lucy Howard (London, England).

Lucy Howard: Collaged Inlay in White Earthenware

I love working with gaudy, contrasting colours and bold pattern. I delight in choosing colours that work well together – as I do in my surroundings at home.

Lucy Howard's biggest influence is her small two-year-old daughter, Billie, whom I met dressed in brightly patterned clothes in a sunny yellow room with a happy Teletubbies' poster behind her. All Lucy's ceramics reflect a child-like pleasure, and fun-motifs pattern most of her pieces. Lucy means you to enjoy her work – and yet their 'easy' outward appearance belies the length of time it takes to make them … 'In many ways,' she says, 'this is an incredibly fiddly and frustrating way of working, and I wish I were more free when I work with clay – but when the results are good I know *why* I do it the way I do, and I love it.'

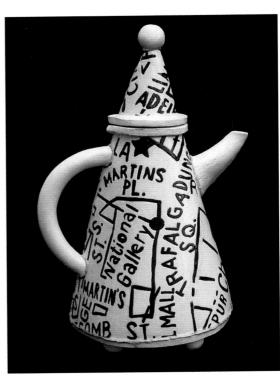

METHOD: Using lots of newspaper and pieces of clean canvas, Lucy first constructs her work as a flat picture in much the way a child would arrange felt patterns. All the work is decorated 'at the soft stage' before components can be assembled. On a rolled-out slab of white earthenware,

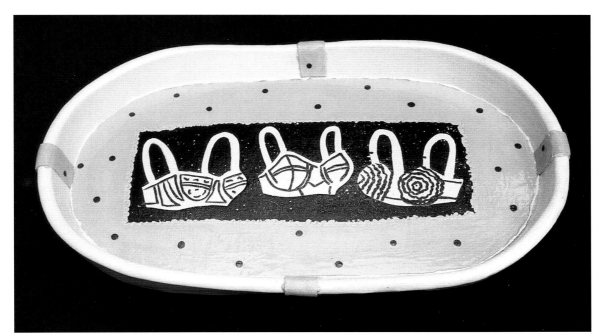

slightly grogged, Lucy creates a cheerful background of coloured slip, thickly painted. She mixes this colour using measurements again taken up in child-like proportions of 'half a jam-jar of slip to two heaped dessertspoonfuls of stain (mixed with water first, then sieved) … My

methods of mixing are *not* scientific', she sighs.

Sometimes Lucy uses newspaper cut-outs as resist at this stage, where later an inlay may be inserted. The clay for the inlay is weighed in a similar way: one golf-ball piece of clay to one heaped teaspoonful of stain (mixed with water

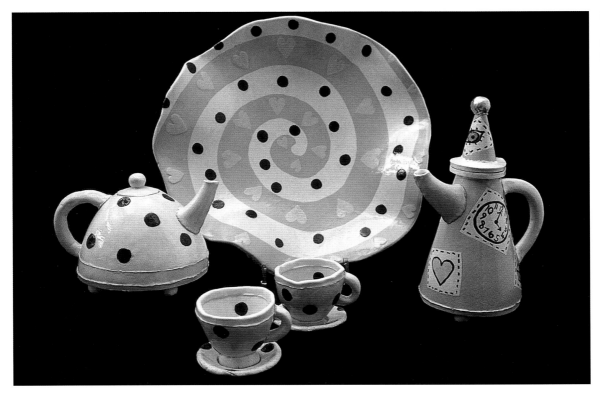

Tea-set. Lucy Howard (London, England).

*C*utlery drainers.
Lucy Howard (London, England).

first). Her colour schemes work together in much the same way as she decorates her home, and she chooses W.G. Ball stains 'for strong, bright, man-made, synthetic-looking colours.'

Now Lucy is ready to dress her slab with blocks of pattern. Small amounts of coloured clay are rolled between sheets of newspaper to make the motifs. Next she spreads clean canvas over the positioned inlay, then gently rolls them into her slip-covered background in distinctly defined blocks. Using canvas in this way smooths ridges, prevents colour-smudging, and leaves a slight all-over texture.

Although the coloured clay should be well bedded into the background slab so that it 'sticks', it should still have a slightly raised edge and not merge completely.

Pattern pieces are often cut out of the 'fabric' by Lucy and reassembled using card-markers; these are joined with contrasting coloured slips which she uses as a feature, 'This 'squidgy glue', she says, 'is important to emphasize the seams … I often feel like a seamstress, not a potter! I have never been able to draw, and have used collage and photography as a means of visual exploration. I think I also do this in clay.'

For Lucy Howard's particular method, the consistency of the clay is important; although

the surface must be allowed to become almost dry in order for the inlay to be accepted without smudging, the slab itself must *not* dry out, as it will not then be possible to curve and bend the slabs into their final forms.

FIRING: Lucy uses a clear glaze over her work, not only to bring out the colours, but so that the pieces can be *used* – though she confesses to being 'probably the most unadventurous potter ever when it comes to glazes.' She is forever making excuses … 'The signs, symbols and patterns inlaid are to amuse myself,' she admits. 'My decoration all sounds very domestic, trivial and whimsical – and it is.' But her motifs are glorious statements of 'motherhood' … three bras dance across a platter, and a spiral pattern in the middle of a wobbly plate looks like a child's spinning top, or part of a children's tea-party. Lucy has even made an A to Z teapot on which you can read 'Trafalgar Square' and 'The National Gallery' – everything is for enjoyment.

But Lucy Howard was brought up in India, and so the brightness and patterning all fall into place … 'India is always somewhere in my subconscious,' she explains, 'and this is my way of seeing things.'

Sabina Teuteberg: Press-moulded Inlay

When decorating, I take into account the function of the piece. I have in mind the user, and also the pleasure which should go with any such piece. The decoration should allow the user to rediscover the object continuously, to interact with it.

Striking patterns cover a set of Sabina Teuteberg tableware: her work is optically as well as functionally satisfying. Strips of graphic colour appear to float, Matisse-like, over, or through, or into her plates above a creamy-white background of snow; or they are white patterns

'Bowls'. Jiggered and jollied. Sabina Teuteberg (London, England).

'Plate'. Jiggered and jollied. Sabina Teuteberg (London, England).

hovering in a black Alpine sky. Sabina has that gift of being able to fill the complete picture plane of her ware: that is, the black and white areas are balanced spatially, like the YinYan symbol or a good piece of Mimbres pottery; they have no gaps or empty spaces in between.

Sabina is Swiss, born in Basel. Near her home in Switzerland there is an industrial village where she is allowed to experiment in one of the many ceramic factories. She also lives and has a studio in England, bringing a Swiss sensibility

and precision to her work here, as well as making a generous contribution to everyday life. For Sabina is that rare being, an industrial potter, one who can make a set of tableware in which each piece is individual but is also an integral part of the whole. Her colours are cool, her forms are comfortable to use, her approach is practical but tinged with fun. Underneath every piece is her signature, crayoned and fired in, to signify that the piece has individual importance and is made by her.

METHOD: Sabina uses a combination of three parts white earthenware to one part white stoneware. Her patterning is first made flat, as a decorated clay slab onto which thin 2mm strips are carefully laid, coloured with underglaze or bodystains of 5–12 per cent (*see* Chapter 3). She works in a very organized way; her decoration is direct and composed with great flare, and it always looks fresh. Once a pattern has been designed, Sabina rolls it in. This stretches and softens the pattern edges as well as integrating them completely into the base slab. Next, if the piece is to be round, it is flipped over a hand-built plaster hump mould. Then the industrial precision of 'jigger and jollying' takes over, smoothing and rounding the rim; this strengthens and smartens up the piece, as well as conforming it as part of a set. The process also cuts the pattern short – which one feels might otherwise go on for ever – and wraps it around the rim in a pleasing manner. The compression of clay pushes the pattern even further into the blanket. It is a method which Sabina says 'combines the freedom of expression with a controlled way of finishing the product.'

TIP

To get an even, very thin layer of coloured clay, extruding is the best method.

FIRING: The application of a shiny, industrial, lead-free glaze helps to seal the pattern in as well as producing a clean, smooth, dish-washer-proof surface. Pieces are bisque-fired to 960°C, then glazed to a hard-wearing vitrification point of 1,140–1,160°C.

Because Sabina works in confetti strips which have light and shade, her decorations often throw up shadows that pull the patterns intriguingly forwards or backwards into the surface plane. This special feature of hers, combined with an ability to integrate her spatial pattern to form, places her work far beyond the heavy hand-made mug or brown, hand-thrown tea-set. Nor are they too pretty or fussy. They look modern, light, attractive, usable and, above all, highly individual pieces that belong to a set … one which anyone would want to involve in their everyday life.

(Sabina Teuteberg also makes sculptural forms. *See* Chapter 11.)

Susan Nemeth: Press-moulded Porcelain Inlay

I consider finding suitable combinations of colours in a piece to be more important than the colours themselves. I like variation, but the colours seem to change more depending on what colours are next to them than by small variations in density … I like the idea that design influences can come from anywhere and can flow round and round in circles like patterns … there is no order, as influences come around again years later and different versions are made.

Susan Nemeth's work is very stylish, its patterning stamped with a happy personality. Her pieces are beautifully crafted, and as well finished as the eighteenth-century porcelain she so admires. The things which have influenced her flow from one idea to the next, and almost constitute a cyclical diary of her practical life. For instance, the layering idea started from seeing all the peeling wallpaper inside the derelict houses which surrounded her at Wolverhampton College. Then she was inspired by the 'figurative and free drawings covered with pattern' introduced by the people with learning difficulties whom she was teaching. This led into her subsequent excitement with Matisse collages in which she 'cut shapes from sheets of coloured clays or white clays covered in coloured slips, and rolled these into backgrounds of further coloured clays and slips.'

In 1990 Susan won the Inax Design prize and was invited to work in Japan. 'There,' she says, 'I could indulge in as much stain as I wanted without worrying about the cost!' In Japan she soon found food and cookery motifs invading her work, and began to inlay 'sushi' or 'crabs with lotus root'. 'Mackerel with lemons' soon followed, and at this period in her life the playful, over-bright cookbooks of the 1960s, which took in the element of light and shadow, also entered her series of work. Now she produces tea-sets to order, and these may have 1960s tableware and bits of furniture 'floating about all over them'. However, her pieces never have the feeling of being too crowded, Susan preferring to use 'a tiny motif here or a detail there.'

METHOD: Susan loves experimenting and has many colour tests, although she says that she

'Tea-set'. Inlaid porcelain stained with bodystains. Susan Nemeth (London, England) (above).

'Ochre Bowl'. Inlaid porcelain stained with bodystains. Susan Nemeth (London, England).

'Sushi Plate'. Inlaid porcelain stained with bodystains, press-moulded. Susan Nemeth (London, England).

measures haphazardly using a teaspoon. She mixes the stains or uses them singly, and will incorporate underglaze as well as bodystains in her work. Favourite colours are mostly from Sneyd Oxides, and she buys them by the kilo: sky blue, Flanders, amulet green, yellow, orange, brown. These are augmented by the high temperature red from Potclays, and Potters Connection pink.

Tip

Potters Connection will match any colour for you!

Susan works her designs into flat slabs which are themselves usually of coloured porcelain. She builds up a collage of many layers of further stained porcelain clays and slips which are rolled together and stretched into pattern as they are inlaid. It is this stretching of the collage that both neatens and plumps out the shapes; control is achieved through the direction of the rolling.

The finished sheets of decoration are then press-moulded into anything from bowls and platters through to vases and, more recently, into fine tea and dinner services for sale in Europe, Japan and the USA. By the very nature of their making, each piece is a one-off design, but one of a set because of the matching press-moulds and colour designs.

FIRING: Usually Susan's pieces are fired to vitrification and need no glaze. A sanding between firings produces the smooth matt finish that Susan likes . . . but glazing is an option, as is a smattering of 9ct gold.

Plate – porcelain, slip-trailed (25 × 25cm/10 × 10in). Orla Boyle (Cork, Ireland).

Orla Boyle: Press-moulded Inlaid and Slip-trailed Porcelain

The pictures originated from line drawings of interiors, both in my own home and those of my friends. I most enjoyed the way they became abstract when cut up and pressed into moulds – they became fresh again.

Orla makes what appear to be 'flying' teapots as well as beautiful, earth-bound plates, but both are intended to be 'more decorative than functional'. She also makes animated films, which means that drawing with precision is ingrained in her technique . . . and there is just a suspicion that the teapots may be cartoon teapots in disguise flying through the celluloid. She lectures part-time, too, in Cork City, Ireland, where she lives.

Orla makes her neat, sensitively designed pieces from inlaid clay, which is then overdrawn with a slip-trailer. For this she has invented her own improved version to replace the usual cumbersome slip-trailers and bulbs which not only draw imprecisely, but are frustrating to use.

Teapot – porcelain, press-moulded and extruded (height 12cm/4.6in). Orla Boyle (Cork, Ireland).

Orla's Patent Slip Trailer

This is made from an old moisturizer tube, a piece of electric flex and a bulldog-clip. 'This lovely little tool,' Orla says, 'fits neatly into the hand for much greater accuracy, and rarely "splodges".'

Plate – porcelain, press-moulded, slip-trailed (20 × 20cm/8 × 8in). Orla Boyle (Cork, Ireland).

1. Cut off the (sealed) end of the tube.
2. Cut a short length of electric flex (about 5–7cm (2–2¾in)) and take out one of the coloured wires. Remove the copper wire, thus forming a hollow tube, then replace it in the flex (not all the way – allow a length of about 2–3cm (¾–1in) to protrude so you may see the slip coming out and better direct it).
3. Push the flex into the hole of the tube. (A snug fit is best to prevent leakage.)
4. Fill the tube with (sieved) slip and seal with a bulldog-clip (folding the end before clipping again also helps to prevent leakage).

METHOD: Orla works with Potclays porcelain (1147), which she chooses 'for better colour and its incomparable texture'. This is made into a slip and coloured with between 5–10 per cent Scarva bodystains (*see* Chapter 3). The white clay is wedged, then rolled into a slab of 1–1.5cm (⅜–⅝in) thick. Coloured clay is then applied, first with a thick brush (if the background colour is other than white), and then in coils and small flattened-out balls to produce the 'line drawing'. Added pieces are rolled flat into the slab (using a piece of material to preserve the picture and prevent it sticking to the rolling pin.) Teapots and plates are then formed by pressing pieces of the 'picture' into simple plaster moulds. While these are firming up, spouts, handles and feet are either thrown or extruded, added carefully, and sponged down to avoid smudging the colours. Finally the now-abstracted pictures are decorated with black and/or white slip-trailing, using the special device.

This final part of the process gave Orla, in her words, 'new patterns to trail over or between, and made a rather labour-intensive job much more bearable. It had the added bonus of making each piece entirely unique.'

FIRING: Pieces are bisqued to 1,000°C, then high-fired to 1,260–1,280°C and left unglazed. Their dense patterning reminds one of the ancient Irish scrolled designs on illuminated manuscripts and Celtic stones.

Jane Waller: Oolitic Bowls – Recycled Stoneware With Inlaid Copper Glaze

I took a plastic bowl and filled it with all the turned stoneware-scrapings from the wheel: tightly coiled whorls of clay, jagged serrations, small peelings, worms of interlocked bands – all of which had dried to leather-hard around the wheel-head.

These chattered wheel-thrown turnings are poured into a plaster mould like confetti, then sprayed lightly with water and pestled (with cheese-cloth/butter muslin covering the pestle) to compress them, gradually building up the sides by tilting the mould so that not all the pieces fall to the bottom. When eventually the whole mould is covered and a thick enough wall is made, the piece is completed with a rim; this is formed by pressing out a neat edging within the cheese-cloth.

Oolitic bowl – recycled stoneware scraps with a copper glaze. Jane Waller (Buckinghamshire, England).

Once the bowl has dried enough to come from the mould, it is scraped a little to neaten it, but without destroying the oolitic patterning, then dried and bisqued to 1,000°C. The weight of the pot feels strange, rather like volcanic tufa.

FIRING: A copper oxide green glaze is painted over the pot. This sinks right into the interstices of the patterned whorls, becoming part of the pot-wall itself. When the glaze is dried, a barely-damp sponge is used to wipe it off the surface, while leaving it in the interstices; this reveals a wonderful relief of patterning. (It might be interesting to paint with a coloured slip instead of a glaze?) The pot is fired to stoneware 1,260°C, and the oolitic pattern is fully glazed in the interstices – but only slightly glazed on the buff stoneware patterning, which is also lightly tinged from a faint trace of the copper oxide.

I called these pots 'Oolitic' after my local bridge, Waterloo Bridge in London, which is composed of a handsome pale stoneware oolitic limestone in which are embedded many crustaceous shell pieces, looking distinctly similar to my pots … although the shells were compressed into limestone some time during the Cretaceous period.

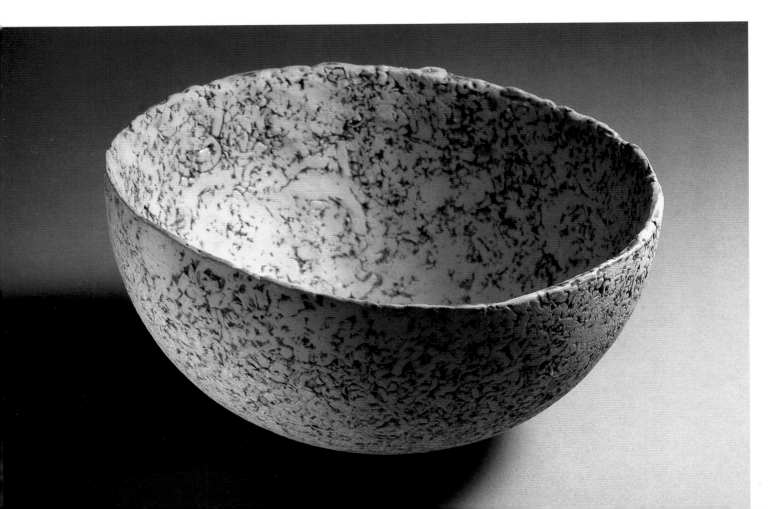

Michele Zacks: Soda-glazed, Recycled White Stoneware Clay

Jane Waller's Oolitic bowls gave me the ingenious idea of using this as a way to recycle slips that were not being used in the studio because the labels had fallen off the plastic containers and no one was sure which Mason stain number had been used.

Michele Zacks recycles scraps to make 'Oolitic' bowls. Her inspirational teacher was a Cherokee Indian who makes spirit masks and knows all about treating the earth well when it comes to recycling. Michele also says that her work has evolved from the biological at college to the geological when at High School, but that this particular colour in claywork of sculptured bowls with rough, jagged edges and textured interiors 'depicts landscapes from the perspective of a city dweller … the illusion of fragility is enhanced,

while the piece itself is dense from the extreme compression. The bowl safely rocks on a round base when handled'.

To form her bowls, Michele has taken up my idea of using a pestle from reading *Handbuilt Ceramics*. She leaves her rims with the jagged edges which result from this method of making, and so her bowls gain the desired fragility; but because they are pestled hard together they are much stronger than they appear to be. Each bowl is made from specks of coloured clay, and this gives them both the defiant quality of a conglomerate marble, and the gentle feeling of confetti which has been trodden underfoot after the wedding is over and the falling rain has matted it together.

METHOD: Michele recycles all the scraps of dried-up, uncoloured white stoneware pieces from tooling, together with the shavings of the same clay collected from slips and the dried-out remnants of the hand-building process. These she stains with ten to fifteen different Mason stains, giving them a new lease of colourful life: she sprinkles a carpet of them in a bowl-shaped

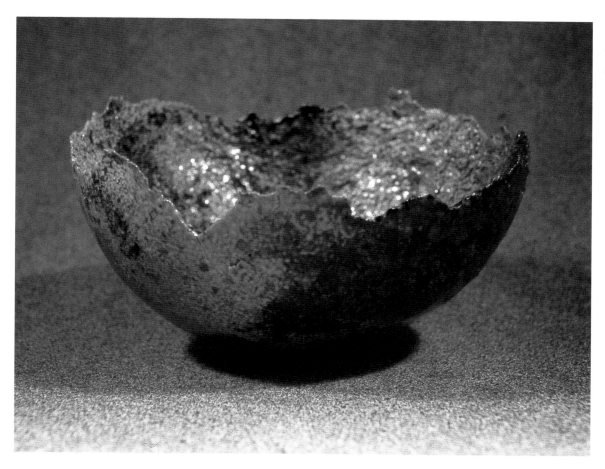

'*One Half of Winter'. Michele Zacks (Massachusetts, USA).*

'*The Discovery of Spring'. Michele Zacks (Massachusetts, USA).*

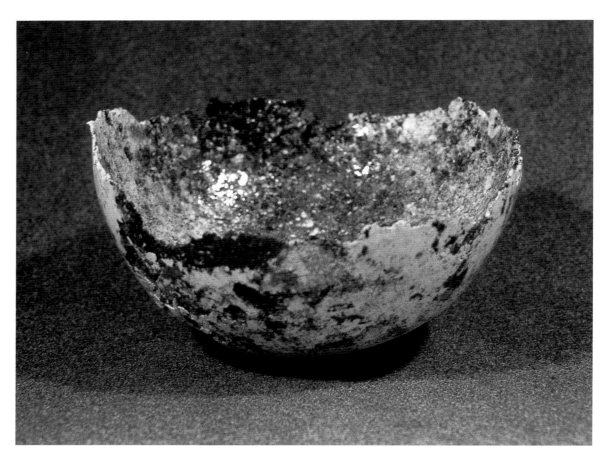

plaster mould … 'like spring, and all the colours that appear'; these are then sprayed with water, and further layers are added. In addition, the scraps are alternated with fine or coarse mesh grog or silica, and each layer is compressed with a pestle until the bowl is filled out. To prevent the pestle sticking, Michele either sprinkles dry scraps over the sprayed area or covers the pestle with canvas. The final layer always consists of scraps sprayed thoroughly until they adhere to the surface.

THE SODA-FIRING: The bowls are fired unglazed: if cone 1, then a soft, confetti-like surface is produced; if cone 10, the soda-firing results in more muted, dark colours, from spraying the soda solution into the portholes of the kiln. As Michele explains:

> I attribute my idea of using coloured pieces to recent works of Warren Mather, the pioneer of the soda kiln as an environmentally safe alternative to salt-firing. He embeds small pieces of coloured clay in his plates during the moulding process prior to soda-firing. In my bowls the soda creates a unique visual effect with the layers of colouring oxides forming a variegated texture and colour. One of the effects that results from deliberately drying out slips on plastic lids in a hotbox is that the stain becomes highly concentrated. The soda adheres to any loose scraps on the surface and tends to hit the edges strongly, bringing out the intensity of the multiple stains. In addition, the edges of the bowl become sticky due to the method of spraying with water. Thus, while it takes much longer for the clay to dry away from the plaster mould, the edges crack further upon removal of the bowl, resulting in more interesting edges and a motley colour pattern on both sides. However, to avoid excessive cracking, I often run a knife along the upper edge of the plaster mould. In contrast, the exterior is smooth, depending on the amount of water sprayed and the degree of pestling.

Michele's pots, she says, are the result of her own memories: 'I create abstract representations of campfires, rock formations, concrete sidewalks and sand dunes … all elements of the environment altered by human activity.'

11 Sculpture

This section of the book is about embedding oxides in the clay body before forming the material into sculpture. But sculptors are also putting other ingredients inside the clay, not only to strengthen the structure and open the body, but to reveal to us the internal volume of form. The materials incorporated range from metals, sands, fibreglass and perlite to chopped nylon fibres. Felicity Aylieff and Fred Gatley take coloured slips, fired to vitrification, grind these down again into a grog and admit them to provide surface speckling. All sorts of vegetable products including hessian, scrim, agricultural sacking, twigs, maize stalks, peat, sawdust, dung or ash are used. Patricia Tribble has even fired actual vegetables, enclosed in a coloured layer of slip. Seeds such as lentils, coffee beans, rice (or, in the case of Claudi Casanovas, flour) are mixed in.

Not only is organic matter used to create internal volume or structural lightness, it may also be combusted as a fuel to fire the end product, when it brings forth wonderful markings, glazes or colour reactions with the oxides. Often, when the oxides are drawn outwards through the clay during the firing, they create surface effects – such as turning copper oxide into its pinky metallic form. Elspeth Owen has used seaweed tucked around her pinch pots to bring out a response from the stains. All these inclusions bring a liveliness to both decoration and form.

Perhaps the most interesting recent development has been the invention of paperclay: it has transformed some artists' work, bringing them the freedom of folding larger forms into difficult shapes. It also lightens the body and introduces some transparency and, used with care, it could spell the end to many shrinking and cracking problems. Paperclay has only just begun to show what it is capable of.

As I was putting the book together, I couldn't help noticing that there was a tendency for the three main types of ceramic artists to be influenced in distinct ways: the sculptors by landscape and body forms; the throwers, pinchers and coilers by the work of former civilizations; and the inlayers, laminators and millefiori/neriage workers and so on by animal markings, flowers and fish.

'Moel Ky Uchat'.
Charcoal on paper.
Ewen Henderson
(London, England).

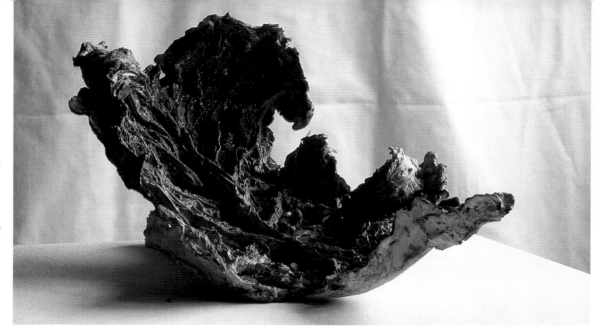

'*Leaf Form*'. Terra cotta was rolled out to form the basic leaf shape in a mould, after being mixed with paper, perlite and left-over cooked rice. The leaf ribs were formed from stoneware slip and oxided paper, scrim and hessian, with paperclay packed in between. Patricia Tribble (Bedfordshire, England).

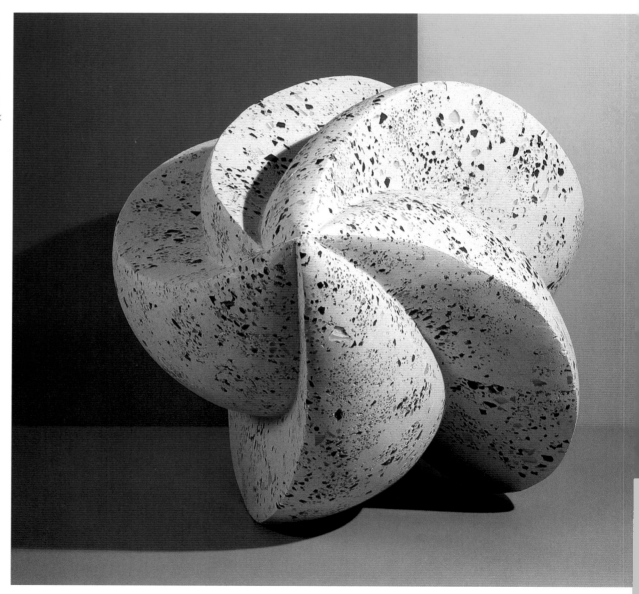

'*Twist and Turn*'. Press-moulded white clay body with aggregates of fired terra cotta, borosilicate glass and ballotini glass (114 × 70 × 75cm/45 × 28 × 30in). Felicity Aylieff (Bath, England).

Felicity Aylieff: Semi-porcelain Sculpture

It is my desire for both the form and the surface of the work to be emotionally satisfying through a visual as well as a physical sensuality … to produce an overall simplicity where the internal structure is described by strong, articulate, defining lines. It is important that the object does not acquire a presence purely by scale alone, but through its sense of volume, fluency and clarity of form and purpose.

Felicity Aylieff's sculptures are all hand-built and are massive – anything up to 1.4m (5ft) in height. Hard-surfaced and highly stylized, they look as though they have been extruded through a machine, like giant scoops of ice-cream or something found in the Science Museum – like a Frank Whittle stainless-steel jet engine, machine-tooled to an exacting degree. (One piece gives me the feeling that it is at the business end of the drill that has just tunnelled the Jubilee Line Underground Extension beneath my dining-room in Waterloo!) Yet Felicity draws her ideas from fruits, fruit seeds, and pods – and then suddenly you wonder if they have fallen from another planet and are almost ready to hatch into a giant plant.

'Spiral'. Press-moulded terra cotta brick clay body with aggregate of fired blue porcelain, fired black porcelain, borosilicate glass and ballotini glass (56 × 56 × 92cm/22 × 22 × 36in). Felicity Aylieff (Bath, England).

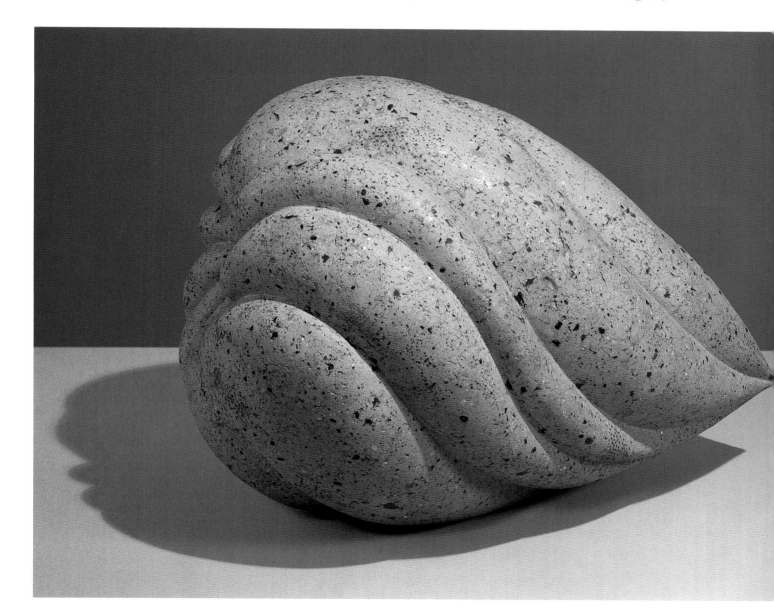

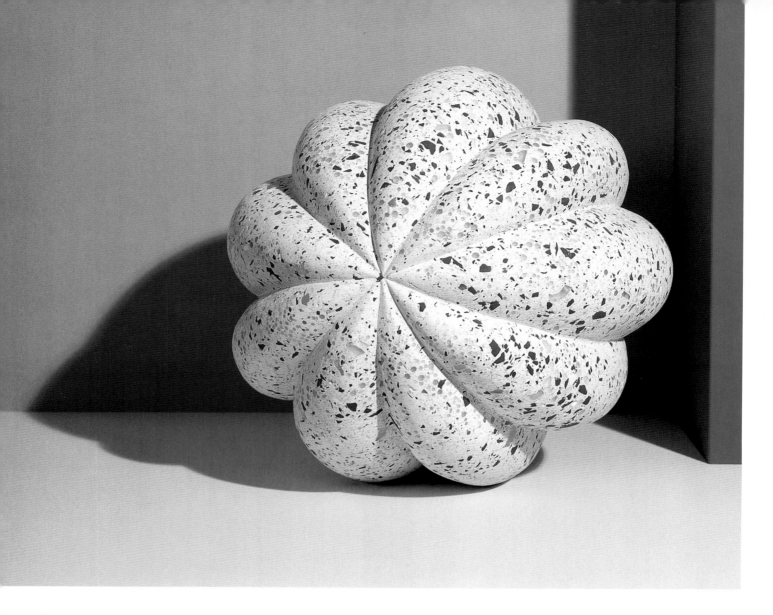

'Fruits of Labour'. White clay body with aggregate of fired black porcelain, borosilicate glass and ballotini glass; press-moulded (400 × 350 × 350cm/157 × 138 × 138in). Felicity Aylieff (Bath, England).

You know that hours and hours of labour have gone into their construction. Their impressive size makes them dominate their surroundings – which is good, because Felicity thinks of her pieces in relation to architectural rather than domestic settings. You wonder if they are heavy or not; they feel so solid because of their wonderfully unified surface, yet you know they must of necessity be hollow. They exist with a positive presence in a strange clean world – yet they are not menacing. You sense that a female hand has smoothed and curved the surface, albeit at the other end of a water-powered diamond drill, and probably heavily-masked and gloved. The surface, too, is architectural, influenced by marbles, granites, agglomerates – all the hardest rocks – which only increases the toughness of its personality. And you discover that Felicity's other influences are early pre-eleventh century Indian sculpture. Then you remember the wonderful red agglomerate

sculptures from Mathura. But Felicity's work sparkles; intrusions of glass – borosilicate glass and ballotini glass – twinkle next to the intrusions of coloured grogged clay. You need to feel the smoothly shaped surface with your hand to enjoy the pieces which are, in her words, 'exotically tactile, fragmented with colour and varied in visual texture, with an optical depth enhanced by the inclusion of glass.'

METHOD: Felicity uses a semi-porcelain with the addition of stain – 16 parts colour to 100 of clay. The powdered colour is moistened with water and wedged into the plastic body. This mix is then rolled into thin slabs, dried and lightly crushed. It is fired to 1,220°C – the optimum temperature for a good colour response, and also the vitrification temperature for this body. This means that the clay is hard. Now the coloured grog is graded – the dust being added to the clay

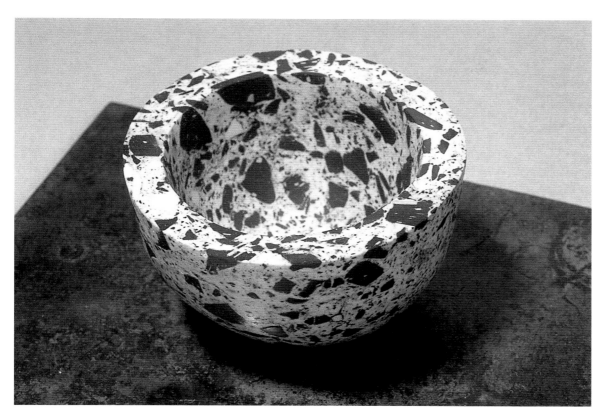

*M*ulti-coloured bowl
on patinated copper
base (width: 8cm/3in).
Fred Gatley (London,
England).

to form both the background colour and, of course, the strengthening layer vital to such huge pieces. The larger grog (from 0.5cm (³⁄₁₆in) up to 3.5cm (1³⁄₈in) diameter) is mixed with the clay that goes into the upper surface of the work. Felicity makes this composite mix from an aggregate of ceramic and glass to create a surface with, she says, 'physical characteristics that are those of strength and plasticity, providing the opportunity for the sculptures to be more extravagant in size than might be expected of objects more usually made from clay.' Hand-formed plaster moulds and Styrofoam come to the aid of construction; mini-cranes, hoists and large kilns help in their realization; the drying can take from six to eight weeks. What an undertaking!

After firing, the unglazed surface is worked on with painstaking precision: grinding, smoothing, polishing to technical perfection with electroface diamond discs. 'Because the grinder is water fed ' she explains, the ceramic surface is well lubricated for more efficient grinding, and dust is eliminated.'

Felicity's pieces are endlessly fascinating, and her style has developed into an extremely brave personal language – a strong signature that nobody else could copy. They are at the same time modernistic and monolithic.

Fred Gatley: Polished High-fired Porcelain and Bone China Sculpture With Colour Inclusions

My aim is to produce pieces of work with a balanced contrast. I hope to evoke various feelings with my ceramic bowls; they should be imbued with an almost tangible sensuality when they are handled, similar to that received from polished marble or granite, whilst they should also be reminiscent of birds' eggs to the touch, or smooth-polished pebbles still wet from the sea.

Fred Gatley has for many years been the excellent technician at the London Guildhall Ceramics Department. At the time of writing, however, he is following an MA course there, developing his own particular method that is 'less a blend of skills from various disciplines, engineering and silversmithing … but those of the ceramist are to the fore'. He says:

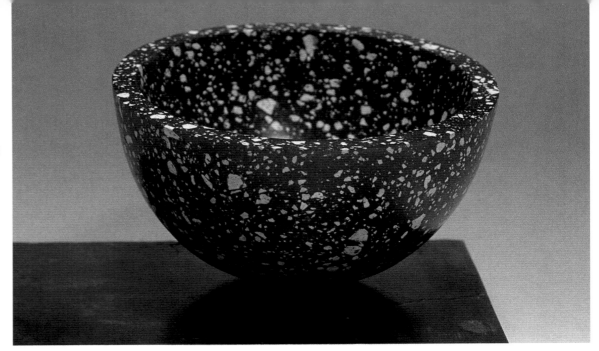

Black porcelain bowl with pink and white grogs on bronze base (width: 8cm/3in). Fred Gatley (London, England). (Courtesy: Harriet May Collection.)

I consider that I have taken these skills a stage further than the normal high-fired finish, and I have enhanced them by employing techniques normally used by glass polishers. This union is further enriched by incorporating cast-metal bases into each of my pieces, which themselves are further embellished with additions of precious metals, notably gold and silver. My work isn't about pots in any traditional sense ... but at times I have almost been made to feel like some sort of subversive ... crossing from one discipline to the other as I felt my work needed.

Fred began by kneading copper filings into a golf-ball-sized piece of porcelain, and with this he made a simple pinch bowl, firing it to 900°C. Its shape was refined with wet-and-dry abrasive paper, under a dripping tap, both to stop dangerous dust and to prevent the paper from clogging. At this stage the body had a consistency similar to chalk, and some hard fragments of copper became exposed. But when the piece was fired higher, to 1,220°C, copper inclusions 'erupted through the walls of the piece, some appearing as rough warts or blisters, others being almost semi-volcanic in nature ... which took considerable time to remove.'

Fred went on testing. The numerous metal inclusions in the porcelain in various particle sizes and percentages, as well as different temperatures, 'manifest themselves in various ways. Cracks appeared, there was often warping, also severe bloating, and occasionally just an amorphous lump in the kiln!' Fred persisted until he inherited a selection of low-fired bodystained test pieces from some silversmithing and jewellery students.

'These remnants were easily crushed into crude grogs using a pestle and mortar,' he says, 'and at last I had a solution to my problem: colourful, controllable, compatible clay inclusions.'

METHOD: First, bodystained grogs are made, crushed in various grades and incorporated in simple bowls, made using a moulding technique. (Goggles and a respirator are needed, together with adequate ventilation.) Potclays HF porcelain and bone china is used for the body; Potclays, Potterycraft, Degg and Sneyd colours for the bodystains.

FIRING: Pieces are first fired from 800–900°C, at which point they are refined with glass-polishing equipment, using small polishing burrs and a pendant drill to get at the insides. A higher firing of 1,200–1,240°C is made, followed by a further polishing using water-fed, wet-and-dry paper or diamond-coated abrasives.

Having failed with his inclusions of metal, Fred now puts them on the outside where they will behave. Every piece is presented on individually cast and machined metal bases made of deeply patinated bronze, copper, or steel: they should have ... 'the texture and feel of a cool larva field or sheared rough stone, and be so heavily textured that it almost jars, with the apparent smoothness of the polished clay.' Pieces may be polished with renaissance wax before or after patination, and almost all 'have gold or silver pinnacles on the upper surface to support and offer up the bowl form. They also have gold or silver feet which help lift the piece both literally and visually.'

Sabina Teuteberg:
Sculpted Wall-pieces

I constantly try to extend my vocabulary, finding new ways to leave marks on surfaces. Being an artist-in-residence in the North of England provided me with the time to re-evaluate my work, and as a result I learned to translate hieroglyphics. These are not only visual abstracts, they have meaning and tell stories.

Public art and private commissions have allowed Sabina Teuteberg to concentrate on a part of work separate from her tableware. She has travelled far and wide, undertaking workshops in Australia and the Far East, and this has inspired her with new ideas and new forms. She felt able to work on a bigger scale: she assembled plain, vitrified, hand-made floor tiles into a large asymmetrical pattern; wall-panels followed, and for both these and the tiles Sabina either adds molochite to her clay body or increases the stoneware content (now white earthenware 3, to white stoneware 1). Pieces are glazed in a bought industrial, mid-temperature, lead-free transparent glaze, firing to 1,160°C with a three-hour soak (on economy 7). 'This has produced excellent colours and vitrification,' Sabina says.

These ideas all stemmed from when Sabina made a wall-piece influenced by Egyptian art, called 'Egyptian Diary'. Composed of a family of inter-related hanging panels, these showed raised, slabbed, surface decoration which involved hieroglyphics. This interesting piece led the way to further sculptural pieces – notably an entrance lobby in Hammersmith, composed of floor tiles together with other coloured press-moulded components, one of which had to be a 'vandal-proof' seat! Again, Sabina's generosity of spirit resulted in a scheme of exotic statements all very direct and personal in style.

'Entrance Lobby'. Hammersmith, London. Vitreous commercial tiles with press-moulded, hand-made components. Sabina Teuteberg (London, England).

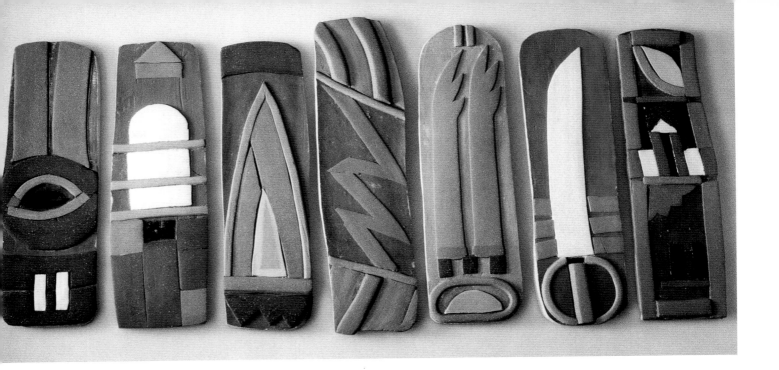

'*E*gyptian Diary'.
Wall piece (each panel:
15 × 38cm/6 × 15in).
Sabina Teuteberg
(London, England).

Linda Warrick: Porcelain Agate Sculpture

Porcelain, being high-firing and white, seems better able to carry good, saturated colour which can be offset well by areas of unstained body.

Linda Warrick makes her birds using various combinations of agating, laminating and distressing the clay. She does it, according to her, 'because it is a compulsion – I cannot *not* do it, and it's my way of articulating something about birds.' These shapes with their long, elegant necks may be inspired by the hull of a ship, the curves in a bridge, or the variety of tensions in a curve. Or she searches for 'anything very, very small and "imperfect" such as broken, sea-eroded shells, waste glass fragments, intriguing pieces of fish skeleton and many one-off "indescribables" that a compulsive beachcomber can find.'

Linda has discovered a most efficient aid for all those using colour in a clay – especially when handling white earthenware and porcelain – and that is clingfilm. 'Clingfilm allows me to move slabs of clay without marking them with my fingers. Also I can see what effects I'm achieving whilst at the same time protecting the clay against smudging and unwanted colour contamination.'

METHOD: Linda first prepares a large block by stacking up unstained rectangular slabs, each painted with slip. For this she uses high-firing Potclays porcelain stained with Blythe colours by volume, using 'one level teaspoonful as one unit to given weights of dried porcelain' (*see* Chapter 3). Clay and coloured slips are left for as long as possible to enhance plasticity. Clingfilm comes in handy to ensure that both unstained and stained clays are of a homogeneous consistency. Linda says that she 'sometimes needs to dampen down slabs/part slabs between damp cloths and clingfilm. Within hours I have the effect I need.'

Next, Linda takes slices off her mini-slabs, which are torn, pulled and generally distressed before being finally rolled out – all protected between clingfilm. She uses her own rolling-pins made from a wooden curtain pole (1¼in (3.5cm) diameter), as well as scalpels, and rolling guides (plastic or wooden rulers) or set squares of suitable thickness. The mini-slabs are now pieced together to form a patchwork, and when this is large enough, Linda uses a template to select the area she wants to use. Once cut, the decorated slab can be laminated onto a plain, unstained slab to enable her to make the addition of a bird's head, for example, or to join work made from more than one part. Then she drapes the slab over/into a former to dry slowly and evenly for a very long time – four to six weeks, depending on the form. (She also uses a slightly quicker method, making small irregular 'sandwiches' of stained and unstained clay and slip – again distressed, before being 'patchworked' into a larger slab.)

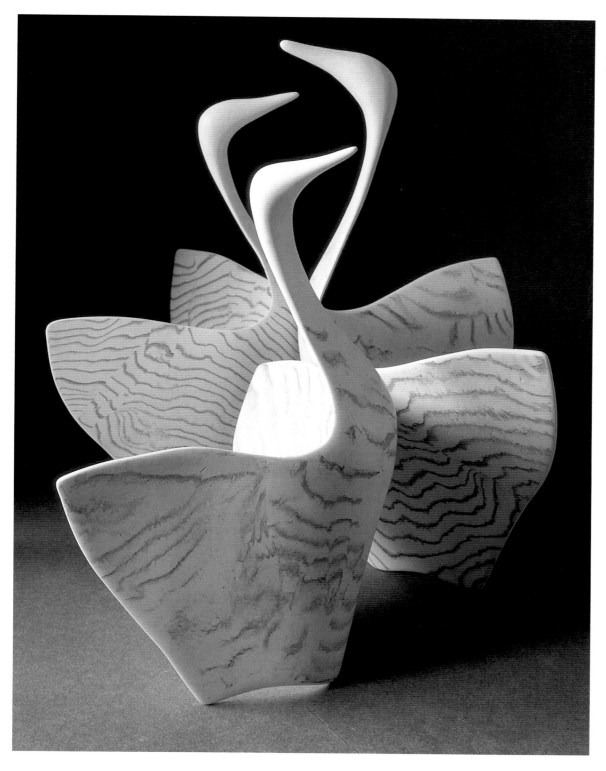

*'B*irds *(Type A)'.*
Linda Warrick (Kent,
England).

Not all Linda's forms survive the level of stress and pull that this method of working produces. She always has this in mind when developing new designs, or her losses from warping and cracking would be high.

FIRING: Linda's work needs to have the finish of a sea-worn pebble: 'very, very smooth, with a sheen, and extremely pleasurable to touch.' She achieves this by a meticulous process involving the use of a small electric craft drill with

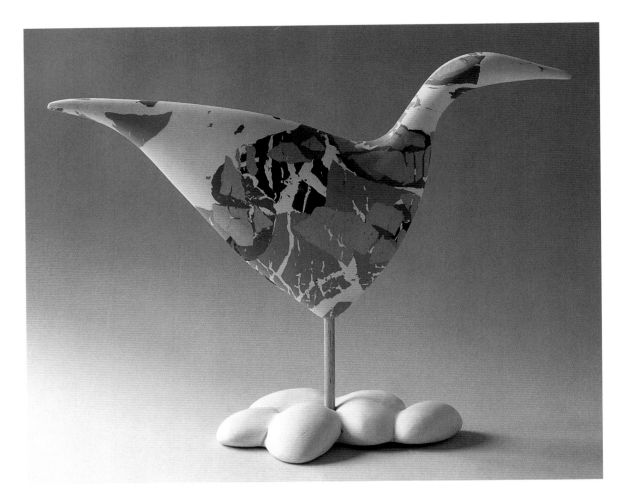

wet-and-dry paper of diminishing grades, once after the biscuit firing, and again after the final cone 6 firing in her electric kiln. She finds 240 grade paper particularly useful, but she will use grades from 60 to 1,000 (always wearing a mask). The work is fired slowly, resting on pur-pose-built supports, saggars and sand; all this to combine good saturated colour with the mini-mum of warping.

Linda has many colour test-tiles to help her 'explore' as she puts it, and she is constantly experimenting with new colour juxtapositions. For colour inspiration she will look very closely – often through a magnifying glass – at 'dying flowers, insects, tropical fish and even small areas of poorly printed colour photo in the newspapers.' Her patterning comes from her love of rocks; their 'machine-cut slices, machine-tumbled stones, jagged rocks recently fallen from the rock face.' This explains Linda's credo, which is this: 'for me, ceramics is tantamount to making my own rocks.'

Christine Niblett: Stained Porcelain Sculpture

The technique of stained porcelain is fascinating – it is a material which seems to take charge and have a mind of its own.

Christine Niblett went to live in Palma de Mallorca with a young family and a husband in business there. She fell in love with the local hand-painted bisque tiles with coloured slips, and these inspired her to join a course at the Applied Arts Academy in Palma; then she set up on her own.

Christine decorates her clay before forming. She cuts and rolls coloured coils and layers of stained clays into thin slabs. These laminated pat-terns are then draped or shaped into plaster press-moulds to form into exquisitely delicate pieces. At first she started with flat plaques and, like

myself, could not be bothered with slips to join the colours so simply rolled out the humid laminated porcelain sheets as thoroughly as possible. 'Arranging my individual pieces,' she says, 'needs to be done quickly, and I love to work fast and not think too much about the final outcome. I never know how the pattern will evolve, as the pre-set pieces deform on rolling and the true colours only become evident after firing.'

One day, Christine came across the most beautiful old shoe last in an antique shop: 'such a simple shape, but the perfect foil for the highlights I love to add, such as buckle, lace, wings, cord, or any other ideas my imagination can conjure up.'

So now Christine creates shoes combined with draped fabric forms. As these are extremely difficult to make (the pieces are almost impossible to fire or even handle before firing), Christine surmounts this problem in the following way: 'I make my very delicate pieces directly on the kiln shelf and do not pick them up until after bisque-firing. Then you can 'clean up' the back as necessary, sometimes with an electric drill attachment.

Though it causes constant problems, Christine cannot escape the fascination with fragility. Really, of course, she likes the challenge of the impossible: 'Maybe I'll be into mad exotic hats next,' she fantasizes. 'I could let them collapse on their own into the kiln and add lots of wild detail.'

FIRING: But in fact Christine fires very carefully, supporting each piece by using pre-fired stoneware forms to prevent deformation at high temperatures. After slow drying and bisquing to 1,100°C, the final touching up is carried out (which may mean perforating holes in her mounted plaques through the rock-solid Valencian 'Vicar' porcelain body she uses), prior to high temperature reduction firing in a gas kiln. It is now that her chosen colours: copper, iron, chrome and cobalt, may achieve some interesting firing effects (*see* Chapter 5).

Christine likes to leave her stained porcelain mostly unglazed as 'its unique quality and its gentle colours can be better appreciated without one, and I prefer the white achieved by reduction rather than oxidation.'

Her firing cycle goes as follows: reduce the porcelain clay body at 1,100°C for fifteen minutes (without any glaze) to achieve a copper pink body, followed by neutral to 1,200°C (five minutes oxidation just before 1,200°C to 'clean up' the porcelain). Then continue up to 1,260°C in reduction.

Christine's precious work – that which survives the firing – is so delicate that it is almost impossible to transport anywhere without breaking … 'and I live and work on an island!' she laments.

'Earth Legend'. (32 × 30 × 16cm/12.5 × 12 × 6in). Christine Niblett (Palma de Mallorca, Balearic Islands).

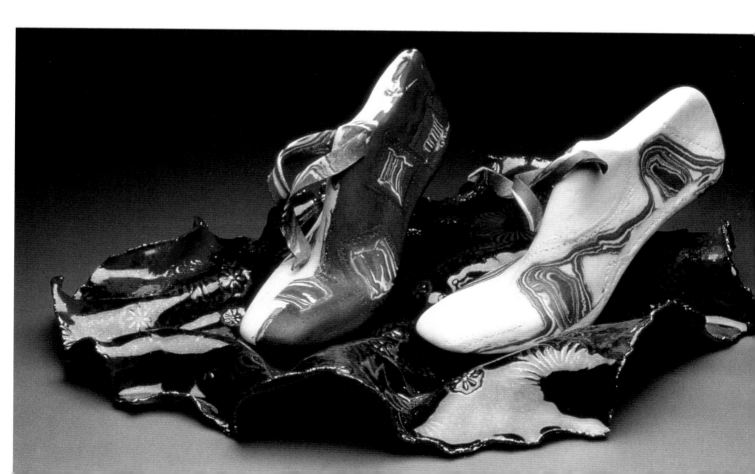

'*S*tep on Silk'. *(22 ×
14 × 15cm/9 × 5½ ×
6in). Christine Niblett
(Palma de Mallorca,
Balearic Islands).*

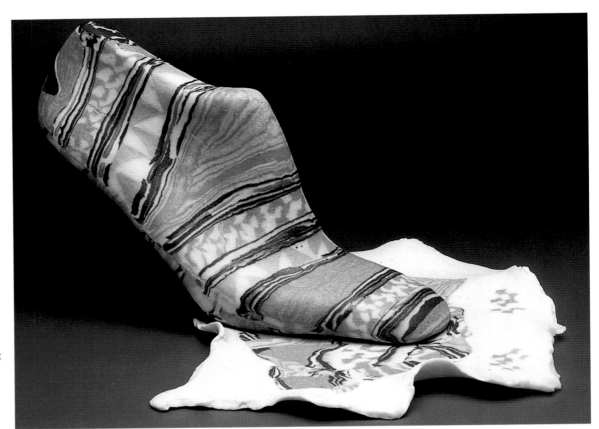

'*M*oonscape'. *(40 ×
33cm/16 × 13in).
Christine Niblett
(Palma de Mallorca,
Balearic Islands)
(below).*

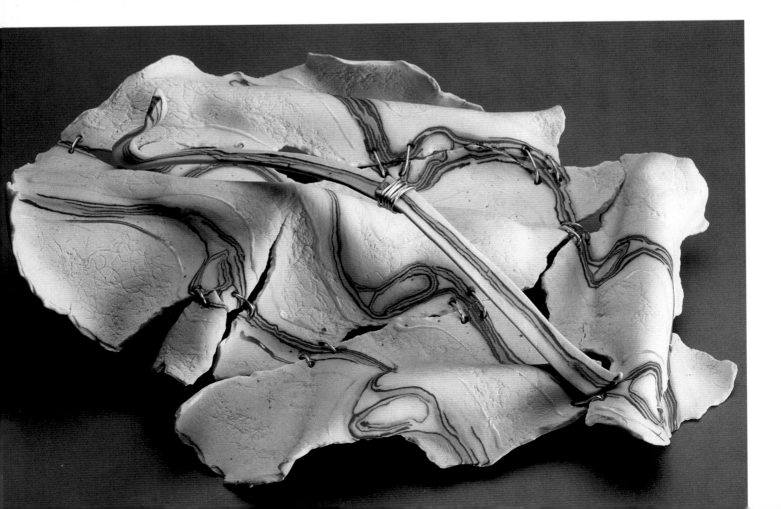

Vanessa Pooley: Sculpture Using C, Y, and T Material

I have come to realize that my work is based on enjoyment – enjoyment that comes of the freedom that 'making' allows; my space to do what I want in, bodies that I see and create for myself, the changing and engaging solid form; the observation of and fascination with the female form, and the reaction of people when they identify with my sculptures.

Vanessa Pooley is supremely contented both in her professional life and with her two young boys; she knows what she wants, and more importantly, knows when she has it. As well as drawing information from herself for knowledge of the female form, she is inspired by other artists, notably Henri Laurens, Picasso, Marino Marini. She loves the freedom of being in her studio, where working is paramount. I have known Vanessa and her sculpture over many years, and have always loved the way that she celebrates the expressiveness of female form. She adds friendliness and warmth, giving her figures an aura of self-satisfaction – much of which must emanate from herself and her own confidence as a sculptor. The finished pieces have a rounded completeness, often with a touch of humour.

It is a great art to be able to sculpt a figure where each of its parts add up, seemingly effortlessly, to make a whole. In Vanessa's sculpture, nothing is left 'out on a limb' so to speak: the end result comes from building out and whittling away the clay body, and Vanessa does this by working solid until everything is right. Then she will hollow the figure out so that it can be fired without exploding.

METHOD: 'Very simple!' Vanessa says. She works without planning, drawings or using an armature. She uses C, Y or T material, and into this she works her oxides – such as copper oxide and manganese dioxide – into a small bucket of clay, 'wet as a mulch'.

Once the clay has dried enough to wedge into a workable state, it can be sculpted. By working her figures solid, Vanessa can alter forms, weights and positions without the restrictions and restraints which are usually imposed by having to make an armature beforehand. Vanessa chooses this method for maximum freedom. 'On occasions a theme has to be worked on for a long time before I know what it is I want,' she says, 'but at other times, this does not seem to be necessary.'

The outer skin on Vanessa's sculptures is always 'fat', and firm and smooth, like a real woman's skin; but there is texture left from the scraping of grogged material which always gives the surface a lively, worked-on appearance. Once the outer skin has hardened, Vanessa begins to hollow out her figure from the base, and the more she hollows the more the piece is able to dry out. Work is fired to 1,120°C when absolutely dried.

Vanessa Pooley's female forms exist not only to be content in their own spaces, but they are eminently able to draw the eye towards them.

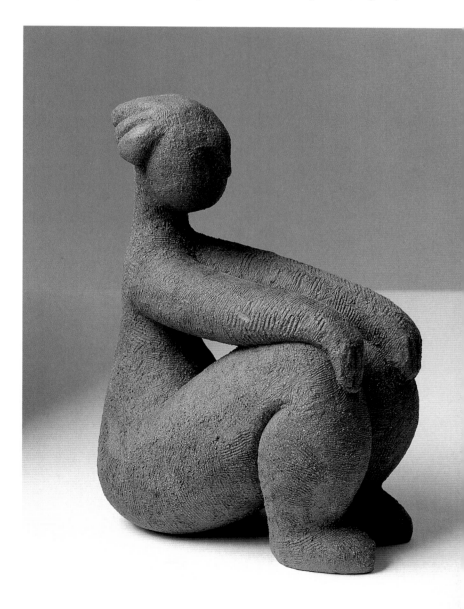

Female form, using grogged clay and stained with copper oxide and manganese dioxide. Vanessa Pooley (London, England).

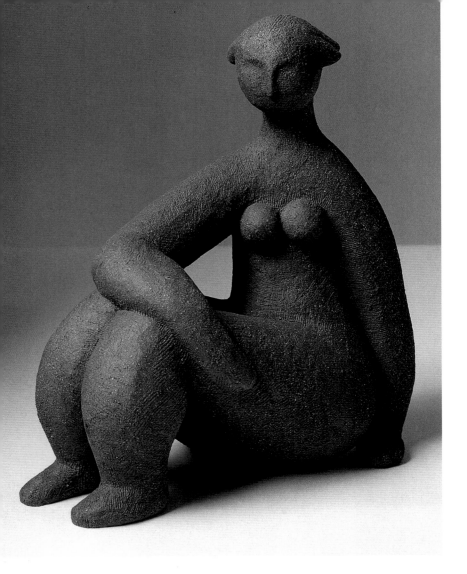

Alison Batty: Slabbed St Thomas and White Earthenware Sculpture in Low-temperature Reduction

Sometimes I am playing a game with a consciously restricted set of possibilities: a limited palette: a set of activities. I always leave room for the 'happy' effects of firing, the lick of flame, the addition of a reduction atmosphere to an earthenware firing process, an unusual combination in itself with some unpredictable results ... My sculptural work in ceramics has much to do with my enjoyment of soft clay – an engagement in making.

Alison Batty's work has a magic about it that is almost akin to alchemy. She is a wizard in the way she handles clay, which she does with such sensitivity. The pieces themselves are simple: universal forms, fresh and loose and strongly marked with character.

Alison is aware that it is only the results of oxides in the body reacting with the firing process of a low temperature reduction that

Female form, using grogged clay and stained with copper oxide and manganese dioxide. Vanessa Pooley (London, England) (above).

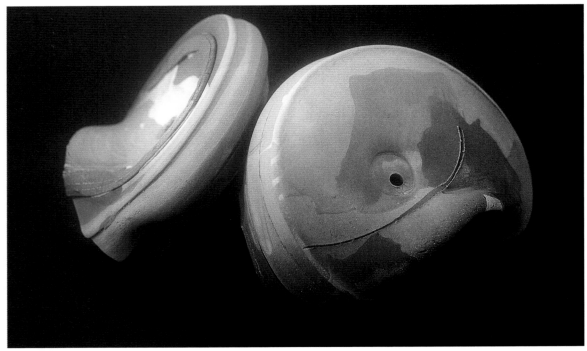

'Slabbed circles'. Alison Batty (Worcester, England). (Courtesy: Tony Birks Collection.)

transforms her work into something beyond any pre-conceived ideas. She frequently experiments with just a few oxides and some subtle differences in the firing chamber to alter the creative event of a piece; maybe using 'a small amount of salt vapour, and small crucibles of chrome, tin or copper' as if these were offerings to the kiln gods, to persuade them to transform her work during firing – with just a flicker of flame towards the crucibles – so that their contents vaporize to flash something extraordinary onto her work.

METHOD: Alison uses a mixture consisting of 24kg (53lb) of standard white earthenware, mixed with 9kg (20lb) of St Thomas stoneware (Potclays 1106) and 350–400g (12–14oz) of medium molochite grog to give strength and a more open body. Into this she will mix her stains in one of her famous clay sandwich mountains – rather like Indian dung-cakes (*see* Chapter 3). Her favourite mix uses cobalt and chrome together as they will produce beautiful blue/greens in the firing (*see* Chapter 4). Also she makes a beautiful red iron mix, which if used with a vanadium slip over it, often turns out like an orange Shino glaze.

Alison rolls out slabs, building deftly to construct cubes, ovals and round shapes in what she terms 'the magic of play'. She stains the slurry that she uses to join the slabs together, applying it evenly to the mitred edges. When these are squeezed during this process, she leaves the 'oozed slurry' as it is: 'I just stain it either with

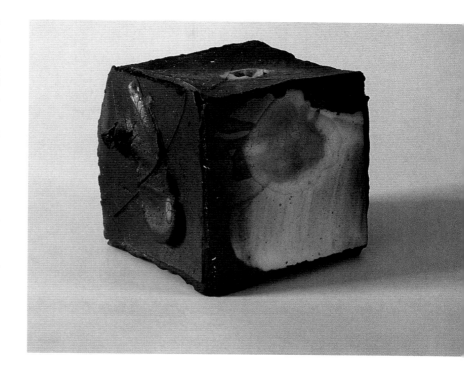

Potclays black stain – approximately 20 per cent – or with red iron oxide – until it looks right – to achieve a dark blood-pink. It's a very simple, but effective way of including process as part of the decoration, or of the final quality of the piece.'

Over her stained bodies Alison also paints coloured slips, and draws on her structures with further sweeping strokes of slip, or she cuts deeper gashes with a hard, sharp instrument.

'Single Box'. Alison Batty (Worcester, England). (Courtesy: Tony Birks Collection.)

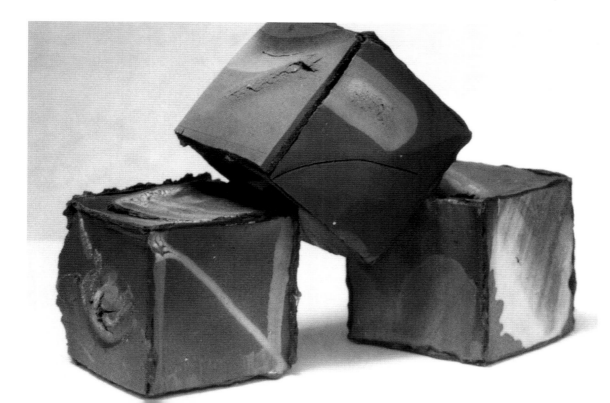

'Boxes' (10 × 10cm/4 × 4in). Slabbed iron body; soft reduction firing. Alison Batty (Worcester, England).

She describes these actions and her involvement with her surface decoration with great vigour:

> The vitality of my slip decoration – on the brink of uncontrol, yet clearly restrained – will mark the special relationship explored between slip and thin wet paint … there can be formal and deliberate marks, too, tooled applications … and there is an excitement and energy in the kinds of mark and line that hit the surface, and freeze there.

FIRING: In Alison's experience, the slower the firing in reduction – a soft, 1,180°C one – the better the results, so she tends to use saggars, which also stop the fugitive chrome from flashing where it isn't supposed to (*see* Chapter 6).

> I don't use much glaze over my work, as the variety of the colour in the body is something I don't want to mask. Rather I use vitreous slips, wood ash and a basic semi-matt clear glaze with a small amount of tin oxide in, as you might use paint on a canvas. The stain from the body permeates through to the sploshes of slip or the mop of glaze.

Alison's crucibles of salt, chrome and tin, or copper oxide placed next to a piece, produce unpredictable events that are nearly always a surprise … 'But that's the excitement in the game … You can see that it is all very open to experiment. I have a lot of fun with the work and feel that it is all the time evolving naturally.'

Judith de Vries: Weaving with Clay: Porcelain Sculpture

> I started weaving with coloured strokes of clay. To see how far I could go, I put the coloured porcelain into an injection needle and pushed it out into a bisque mould, so it could be fired in the mould, and come out like an open thread-like bowl. It worked, but the bowls were very fragile.

Judith de Vries wanted to keep the fragile, woven quality yet make the pieces much stronger. She began weaving with two or more colours of Limoges porcelain, enclosing volume in a way similar to that of basket-weaving. In a big, self-made plaster bowl-mould, she began to plait her strips of coloured clays from an evenly rolled slab 'one by one, next to and over each other, going up and down,' as she explains. 'In fact it's more like mat-plaiting. It is difficult not to break the strips, but when they do, it's possible to attach them again. However, that point will stay weak. Maybe paperclay would be a good alternative, although I've not tried this yet.'

The resulting forms make delicate, interesting shapes, rather like a weaver bird's nest or a tumble-weed blowing along in the desert. But made from coloured clay, they take on jewel-like identities. Her shell and wing forms are sturdier and more architectural, built using laminated pattern in her clever incremental method and closed together with a plain white piece of

*J*udith de Vries (*Amsterdam, Holland*).

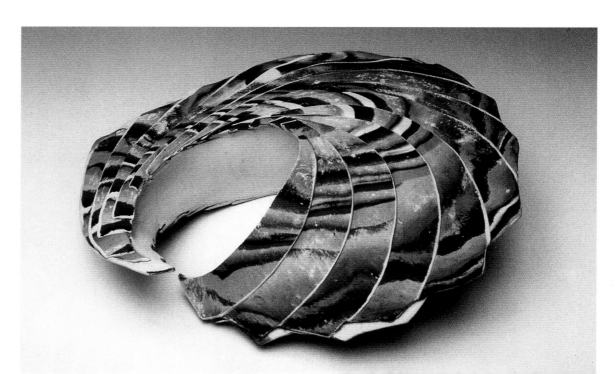

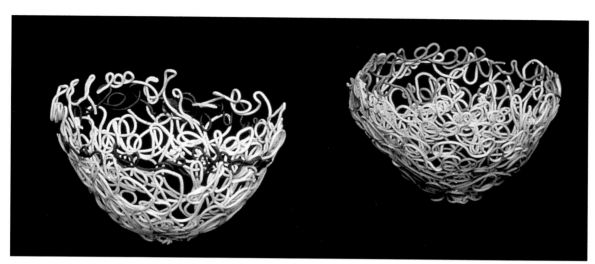

*E*xtruded porcelain.
Judith de Vries
(Amsterdam,
Holland).

*W*oven porcelain.
Judith de Vries
(Amsterdam, Holland)
(below).

porcelain. Judith de Vries is indeed a master of the overlapping form.

Paperclay

Many ceramists' work has been transformed by the use of paperclay. Here are some recipes and advice in case other artists feel the desire to take it up. In the words of Mal Magson:

> Paperclay is a wonderfully forgiving material. It can be used in conjunction with other stained bodies, either as a laminate or a ground for inlay or collage. Paperclay will take stains just as any other clay, although I use it for its particular whiteness and translucency. One of the problems in laminating different coloured clays is the different shrinkage rates of each, which can cause cracking. As paperclay will sit comfortably next to any other type without this problem, and can even be used to mend cracks which may occur between regular clay bodies at both green and bisque stage, it represents an exciting discovery.

Mal's Recipe for Porcelain Paperclay

METHOD: Mal uses Potclays Harry Fraser porcelain P1149/2 with white toilet tissue in a dry-weight ratio of 2 per cent paper to clay. Thin sheets of paperclay are formed from a slurry of this mix, which is then dried on plaster bats and stored for use later.

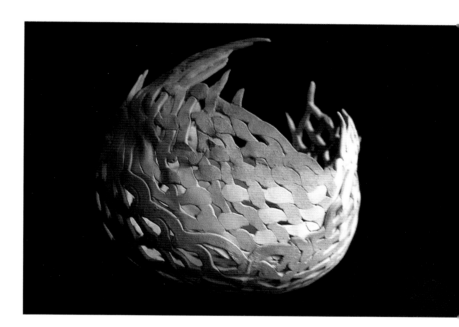

TIP

Whereas plastic paperclay goes off quickly, becomes smelly and discoloured, the dry sheets can be quickly hydrated using a paintbrush and water.

(This is perhaps the best tip of all for making paperclay, because its smell is the only drawback!)

Anne Lightwood: Using Paperclay for Sculpture

One of the advantages of using paperclay is that difficult shapes, including large, flat pieces, can be sculpted. Anne says: 'Originally I tried various

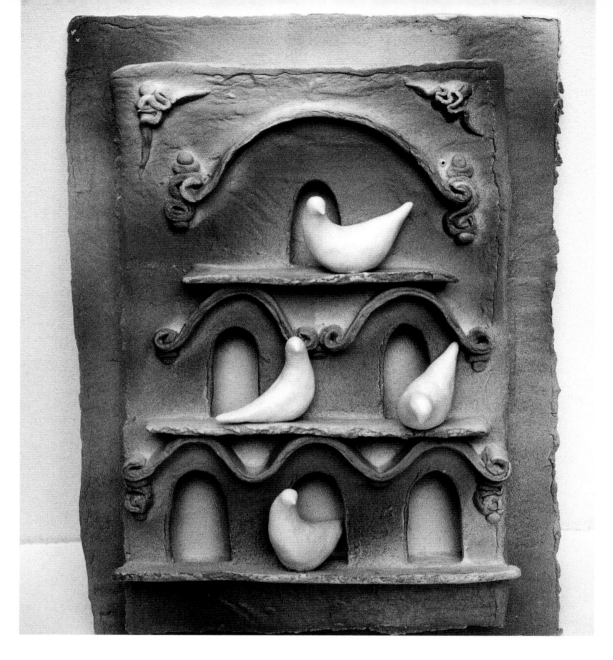

'Bird House'. Paperclay with porcelain slip and porcelain birds (46 × 38cm/18 × 15in). Anne Lightwood (Fife, Scotland).

slips and paper products and found that the result behaved like the clay used and the paper made very little difference except in handling while soft. Newsprint was a bit soggy to handle.' Now she uses porcelain, and says that her two ingredients – porcelain slip and newsprint – are always available. 'As the paperclay has the same shrinkage as the porcelain, it means that coloured slips can be used on it as well as coloured porcelain pieces added or inset.'

METHOD: Tear up the paper and soak in water, then mix in a heavy-duty mixer to a horrible-looking grey sludge. A heavy-duty mixer is a great boon and will repay itself in time and effort saved over the years. Using warm water helps to break down the paper.

TIP

A thinner mix blends better than a thick one; excess water can easily be poured off once the mixture has settled.

Add 2–3 parts slip to 1 part sludge (by volume). Well blend the mixture again, allow it to re-settle and then pour off the excess moisture.

Anne makes her clay sheets by pouring the mixture onto plaster bats, varying the thickness and levelling off using wooden battens as formers (*see* below); if the plaster is dry and the day warm, the sheet can be lifted off quite quickly. Anne likes 'the roughish surface and torn edges' so she doesn't do much rolling.

Once the surface has stiffened up a bit, the sheets can be further decorated. Anne finds the clay easy to join and has no problems with cracking. It also fires very flat without the edges curling or warping.

Amy Mumford's Paperclay Method in Porcelain

Method: 'I use from as little as 2 or 3 per cent up to 30 per cent paper pulp. The density of the blend varies depending on the effect desired.'

Using Larger Amounts of Paper

Thirty per cent gives a very strong material with which to work, but it produces a chalk-like texture and extreme brittleness after firing. If a more authentic porcelain quality is required, the amount of pulp must be reduced accordingly. (Ewen Henderson's mix is also 30 per cent pulp to 70 per cent clay slip.)

Moulds for Paperclay

Because paperclay does not shrink as much as normal clay, the use of moulds can be complicated. Amy suggests that: 'Plastic provides a better mould, as the paperclay sticks to plaster moulds like glue. An advantage is the lightness of the finished item, and the fact that relatively wet ceramics may be dried slowly in the kiln.'

Emma Vaughan's Recipe

I have sometimes acquired paperclay from a factory, but I usually soak it down myself – newsprint or egg boxes – anything that is plentiful and cheap.

METHOD: Emma usually adds one-third paper pulp to two-thirds clay; much more makes it too fragile after firing. Soak the paper in hot water, ideally overnight (or at least one hour), then blunge to the required consistency. (Plenty of hot water should be used to allow the paper to separate properly.)

Add by volume – the consistency should be like porridge. I used to strain the pulp through a conventional plastic sieve, but this took ages, and I found the process much simpler when I purchased a pink pillowcase from Oxfam because the mix can be poured in without threat of leakage. The pillowcase can then be strung up to drain, or the water squeezed out manually. But once made, use quickly! Before it starts to smell!

Emma includes a further tip from her friend, Jim Robinson: 'When constructing printed sheets of raw paperclay, using clingfilm is handy. Put it over the face of the print when joining, because it prevents the work being damaged.'

Firing Paperclay

Emma Vaughan gives the following tip: 'Be careful when firing thin paperclay to top temperatures because it can warp badly.'

And Eileen Newell's firing advice for sculpture is : 'Don't mix the paper fibre too thoroughly for sculpture. When the paper burns away, the remaining surface is more randomly pitted.'

Recycling Paperclay

Mal Magson writes:

Like most users of coloured clay, I produce a lot of waste scraps as a result of laminating. This *ad hoc* mixture of both coloured and other types of clay is collected and dried and put to soak in 2kg (4lb 6oz) batches; it must be well stirred at the slurry stage, then dried to a plastic stage on plaster bats. The result is always grey, occasionally useful but often not particularly attractive. Consequently I may add 50 per cent fresh clay to the scrap to make a more workable body, and this also allows for the addition of extra oxides, in small percentages, in order to create more interesting colour.

> **TIP**
>
> It is always necessary to test batches of reconstituted scrap clay before adding more oxide; you may end up with a coloured clay that melts or is simply dull, and the economics of such effort is untenable.

Anne Lightwood: Sculpture Using Paperclay and Slips

I realize that I have moved from rather organic 'pretty' pieces to something simpler and, I hope, strong.

The main advantage of using paperclay in sculpture is that large pieces can be formed. Anne Lightwood has used it successfully for wall-panels in a hospital, as well as for platters and wall-plates, her work advancing in leaps and bounds.

METHOD: Anne's two ingredients are always available: porcelain slip and newsprint. (For method, *see* page 133.) As the paperclay has the same shrinkage rate as the porcelain, it means that coloured slips can be used on it as well as coloured porcelain pieces added or inlaid.

Having made her paperclay and turned it out onto plaster bats, Anne levels it off almost like concrete, using wooden batten as formers

(*see* page 133). When they are dry enough to be lifted off the plaster, Anne decorates her lightly-rolled, rough-surfaced sheets by brushing or spraying on coloured slips. Then she presses the sheets over moulds once the surface has stiffened a little. She explains how she now proceeds:

I use a sort of collage technique where the coloured slips are sprayed onto thinly rolled sheets of clay and patterned by trailing, dotting and so on. Then quite large pieces are cut or torn and assembled over a mould in a double layer so that there is colour on the outside as well – one is working in reverse this way. Or the patchwork is assembled flat, and rolled together to make a sheet for a plate or a shallow bowl. In this case the underside is plain clay, often rolled onto a texture and then coloured with stain.

Anne's 'flag series' has led to 'signs and symbols', and she is currently working on nine wall plates (12in square) hung in groups of three, each composed individually, but with an associated theme. 'It's much more painterly,' she says, 'using slip instead of pigments.'

'Chequered Flag Platter'. Paperclay with porcelain slips (38 × 30cm/15 × 12in). Anne Lightwood (Fife, Scotland).

'*H*azard'. *Paperclay with porcelain slips (38 × 30cm/15 × 12in). Anne Lightwood (Fife, Scotland).*

Mal Magson: Sculpture Using Paperclay, Laminates and Collage

'*B*eyond the Sun'. *Wall panel, paperclay and porcelain with slips and inlays. Two sections linked with cord lacing. Anne Lightwood (Fife, Scotland).*

Paperclay has had a considerable impact on the forms that I make. My working practice, too, has now changed in that it has become far more experimental and exploratory. A change in life style – lecturing at degree level in the Fine Art Department of the University of York – has created for me an entirely new context for making … and at last the paying of bills no longer relies on sale of work alone.

METHOD: Mal Magson's new mix is made from Potclays' powdered Harry Fraser porcelain P1149/2, with white toilet tissue. A dry-weight ratio of 2 per cent paper to clay is made into a slurry mix which is dried to form thin sheets ready for later use. Mal's work is still made from a mixture of coloured clays, but these are laminated and collaged on a ground of paper porcelain. Her decision to use paperclay has enabled

■ *Sculpture*

'T*high Piece'. Paper porcelain moulded from laminated stained Commericial Clay's ST Material frame; connectors in coloured porcelain. Mal Magson (Yorkshire, England).*

'N*avel piece'. Paper porcelain with coloured porcelain agate inlay in stained Commercial Clay's ST Material frame. Mal Magson (Yorkshire, England).*

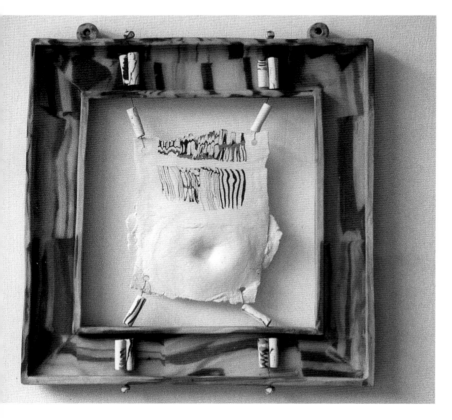

her to develop a way of working that is a radical change both in construction and conception of form. I'll leave her to explain it in her own words:

Paper clay has become almost as much of an obsession with me as coloured clay. I am able to mark, paint and draw in a free expressive way whilst still incorporating agate elements. The panels exhibit the scars and traces which are part of the making process and which for me have become useful metaphors for life experiences. I have also incorporated casts from my own body and impressions of actual objects to assert a much more personal focus and significance within the meaning of this new work. I have retained elements of agate patterning because, as well as embodying both a cultural and ceramic history, it is also significant for me in terms of the history of my own making. I am trying to establish a new language within my work which is a metaphorical interpretation of the process involved. Repetition of colour and motif, actions such as enfolding, arranging, masking, overlaying and cutting have additional significance.

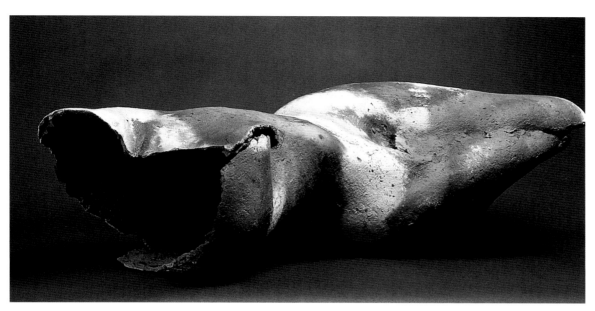

*'A*ltered Form III'.
Press-moulded brick
paperclay with red iron
oxide; fired to 1,100°C
then sawdust-fired in a
bath. Eileen Newell
(Carmarthenshire,
Wales).

I believe that the work's imagery and methods of assemblage possess a feminine agenda which is explored through the use of patches and fragments held together in a matrix of white porcelain, clay used almost as a fabric, forms stitched together with wire, and a self-conscious integration of body casts. The paperclay can be worked in very thin sheets and will accept strips, patches and layers of unadulterated clays such as porcelain or Commercial Clay's ST Material.

When fired to 1,260°C, the translucency of the porcelain is accentuated by inlay in a denser clay. It is possible to create areas of blurred coloration within the wall of paper porcelain by cutting and reassembling the sheets as it is composed. This kind of layering does create warping in the finished piece and considerable modulation of surface, particularly where the paperclay is thinnest. On flat works this is not a problem for me, because the warping is reminiscent of the behaviour of wet paper and creates a pleasing aesthetic. In three-dimensional pieces, however, it can be more problematic, often deforming a piece quite seriously. I have experimented with different ways of constructing forms: wiring fired elements together has been one solution, building forms using bisque in conjunction with wet paperclay another.

This current work reflects a far more introspective approach: it's about me, my identity and life. It is possible with this new method of working to increase the scale of the work in future and to push it beyond the domestic context which ceramics naturally inhabits.

Eileen Newell: Sculpture Using Paperclay and Brick Clay

My work has always been of a fragmentary nature, with broken surface, texture, edges and so on. I like the qualities of the clay to be expressive in themselves of the fractal quality of nature.

I was very struck when I first saw Eileen Newell's wonderful clay torso at the Degree Show Exhibition in Islington's Design Centre. The form was dynamic, with strong areas of carbonized marking created in a sawdust firing, but with other areas showing all kinds of buff colouring and patches of pure white, which seemed to be unaffected by the flames. On the inside was a contrasting dark, rich, matt, red-oxided shadow.

Eileen lives in rural Wales and her work has been dominated by two inspirations: that of the land and that of the female form. Her torsos combine both, searching to express the shared formal character of body and landscape, and she explains this in the following way: 'Hills conceal space, and yet when physically approached, start to reveal other elements of that same space. One becomes aware of the ambiguous rhythms and tensions inherent within organic form: the land and the body.'

Eileen has always drawn. Her research has mostly been centred around the female figure – a 2D activity helping an involvement in a 3D

activity. The influential master in her drawing is Michelangelo, and in particular she is influenced by his figures in the ceiling frescoes of the Sistine Chapel. His work, together with the paintings, sculpture, architecture and music of the Baroque period, has furnished Eileen with an appreciation of what she terms 'the sense of upwardly spiralling movement, and of weight freed from its restraints'.

METHOD: Eileen develops her work using her own body, plaster casts and moulds that will help manipulate the tactile qualities displayed by land and body:

> There is both a combination of fluidity and rigidity provided by clay, a material that is also visually characteristic of organic form. The land and the body become interchangeable, the negative and the positive providing a unity which makes both of equal importance, the interior and vice versa.

She has chosen to work in a lively, cream-firing brick clay, which she makes up into a slurry with 30 per cent paper fibre added. This paper-clay is used first inside the press moulds, but is subsequently altered and assembled in two large sections to make the finished form. The first layer (the outside) is 30 per cent Hyplas ball clay to 70 per cent brick clay. The second layer (the inside) is 15 per cent red iron oxide to 85 per cent brick clay. White slip is applied 'quite sparsely', and Eileen tells me that she tends to work in an intuitive way, using simple but effective materials and oxides, but always aware of the colours in nature. If using a glaze, she says that she 'will nearly always pour it across the form for a natural and more organic response.'

FIRING: The dried work is bisqued to 1,140°C for strength, and is finally sawdust-fired in an old cast-iron bath to create the wonderful carbon markings.

Eileen Newell's work is beautiful and expressive, and her forms show great tautness, tension and homogeneity. She deserves recognition.

Using Fibreglass in Sculpture with Porcelain Slips

Nigel Woods of the West Surrey College of Art gives the following advice:

> The trouble with using fibreglass in porcelain is that you are adding extra flux to an already highly fluxed material. To avoid problems, the work must be fired at lower temperatures – 1,200°C – or you must add the fibreglass to a porcelain body much lower in flux – that is, cut down or eliminate the feldspar. There is a tendency for oxidized porcelain to bloat anyway, due to the spontaneous breakdown of the small amounts of iron in the porcelain from the ferric to the ferrous state at high temperatures. This iron-bloating can happen even if the firing is strictly oxidizing, and the liberated oxygen causes overall bloating.
>
> Using fibreglass with clay won't reinforce the porcelain after firing as it will melt into the body like rain into a gravel path (on a micro scale). But it can be very useful in the forming, particularly as porcelain has such low green-strength. Chopped nylon fibres have been used for this purpose in the States and in Scandinavia, so this might be another path to pursue.

Polyester Fibre: Strengthening Coloured Clay Bodies

Polyester fibre (not fibreglass) put into clay as a means of strengthening it in its raw state is an interesting way of helping the ceramic artist, particularly in porcelain, where twisting and rolling thin is required for sculpted work. Only small amounts are needed: 1g per kilo, for example, does not seriously alter the handling of the clay, but gives it far greater green strength. It can be joined easily to a non-fibre mixed part, and, when used as a slip, the surface of drier clay will accept it in the same manner as clay would do in a non-fibrous state. Polyester fibre burns out in the biscuit firing.

David Cann has used it for throwing. Although he does not add colour to his clay, he has offered us his notes on how polyester fibre is used: 'Unlike paperclay,' he says, 'it does not "go off" after long-term storage, but can be kept in sealed plastic buckets for several months – and still smells as sweet as when it was first mixed.' (For supplies, *see* page 157.)

METHOD: 1 part of nylon fibre (three density fibre at 12mm (½in) lengths is added to every 1,000 parts of clay (i.e. 1g of fibre to 1kg of clay). Knead this in rather than wedging and cutting with a wire – which would defeat the object of putting the fibre in!

TIP

If the fibre is spread out on the bench, clay can be easily kneaded onto it until thoroughly mixed.

FOR THROWING: David has worked with fibre clay successfully, using 12mm (½in) chopped fibre in his porcelain mix. He says:

> If you are looking to fibre to improve difficult problems with throwing, it is less pleasant to use but not impossible. I found that it needed very little turning because the clay stood so well in throwing. Although a sharp turning tool is required (rounded edges will catch and chatter), I guess that you could probably halve the amount of turning necessary.

FOR COILING: This works well, as the natural strength of the mix can be exploited to coil higher or with more extreme angles while the clay is still quite damp.

FOR SCULPTURE AND SLABBING: Using fibre clay means that in most instances you can do away with propping the work in the early stages as the fibre acts as internal scaffolding. Sheets of it can be cut with scissors much like paperclay. Because of its nature, however, it does make cutting and scraping actions more difficult. It also leaves a hairy finish which can be dampened and smoothed with a rubber kidney; later the surface can be scraped with a hacksaw blade. Alternatively, when completely dry, the hairiness can either be burnt off with a blowlamp, or it will disappear in the kiln.

Although fibre makes a strong material to work with – and is as good as, if not better than,

most grogged clays – unpropped porcelain can still warp and collapse in the kiln once the internal support of the fibre has burned away, so care must be taken to house the work properly for firing.

FOR MOULDING: The addition of fibre to clay does not make the action of impressing it into moulds any more difficult, though the use of a tool can help.

RECLAIM: When a slip containing the fibre is passed through a 60s mesh sieve, most of the fibre can be separated, and the reclaim is usable as an ordinary slip.

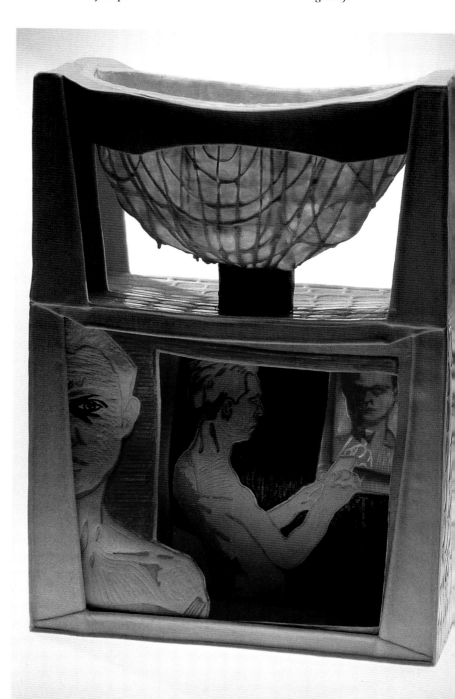

Composite porcelain light box using fibreglass paperclay layers, oxides and embossing (height: 45cm/18in). Frederick Payne (Somerset, England).

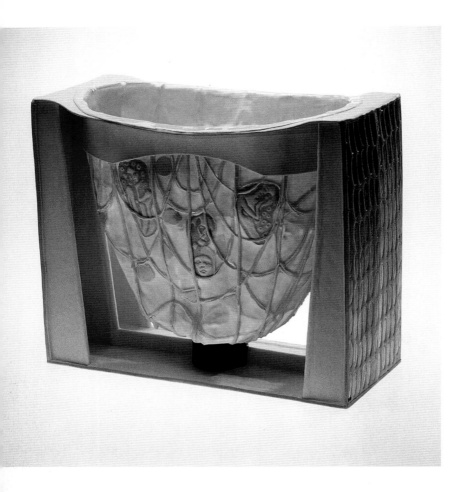

Composite light box using fibreglass paperclay and painted oxide layers (height: 32cm/12.5in). Frederick Payne (Somerset, England).

Fredrick Payne: Laminated Porcelain with Fibreglass and Lino-block Embossing

True porcelain is eroded granite. The process of erosion in the granite releases quartz which achieves the translucence … If you set fire to paper, the wood fibre structure burns away leaving an ash of clay. Use a felt that could support the clay and also combine with the china clay during the firing, and a porcelain sheet results.

Frederick Payne comes from Somerset, close to the home of Cornish china clay which is used in the porcelain he uses. Using a technique which he has patented, Frederick produces intriguing designs and colours that can only be seen when held up to the light.

His pieces are very individual, most of his influences having powerful family roots. His grandfather was a children's book illustrator who worked with cut lino blocks, his mother a writer, his father curator of the Royal Shakespeare picture gallery. When Frederick's father brought back posters for his son so he could draw on the back of them, Frederick remembers that he 'grew accustomed to the double image of my drawings shadowed by strange shapes when I held them up to the light.' He evolved a method by which he could later turn this early experience into his work. First, he learned discipline from being in the army for a while, then experimentation from subsequently going to art school.

METHOD: Rather than fashioning a lump of clay into a pot as thin as possible to achieve translucency, Frederick chose to approach translucency from the opposite direction: surfacing fibreglass tissue is dipped into porcelain slip to form a strong sheet, for Frederick discovered that when coating a glass felt with porcelain slip, the clay is absorbed into the structure and remains flexible without cracking. Only a minimum of clay is needed to achieve maximum translucency. Sheets are dried on plaster bats until leather hard, then burnished smooth with a spoon.

> **TIP**
>
> A layer of plastic sheeting prevents porcelain sheets from sticking to the work surface whilst burnishing (and any air caught between laminates can be also lanced whilst burnishing). Template designs are cut out and stored damp until used; when reworked, the sheets can be kept damp using a hand-held atomizer spray.

The colour in clay is partly introduced by dipping the fibreglass sheet into a stained porcelain slip, and partly by painting and drawing decoration with oxides. A second sheet can be laminated over this so that the design is sealed in; also, the structure is then automatically reinforced further. Frederick gets strong colour by mixing 5g (0.2oz) of bodystain to 100g (3.50z) of porcelain, but he warns: 'Never laminate porcelain with earthenware temperature bodystain as bloating will result due to the early melting temperature overfluxing the porcelain temperature.'

Additional design comes from relief patterning, in which Frederick uses the same kind of

lino print-blocks as those used by his grandfather. The fibreglass clay sheets are embossed by being pressed against these relief moulds, and 'done by finger to achieve crisp copy. The thinner the clay,' Frederick explains, 'the greater is the contrast of light and dark in the embossing.'

Frederick finally forms his sheets when they are leather hard, a state at which they can be cut and folded (like paper) into his light box structures. As these dry, they are totally self-supporting and, with their fibreglass interiors, shrinkage is kept at a minimum. The 'magic' part of the structures is revealed once the pieces are fired.

FIRING: Bisquing is to Orton cone 06. Then a leadless, transparent Bath Potters B276 glaze is applied (by dipping or using Bath Potters 'Brush on'), and fired to stoneware temperature Orton cone 9 in an electric kiln.

Now, any painted decoration between the sheets is revealed after firing, due to translucency; also, because the fibre has burnt away, the resulting pieces are light and delicate. Through the embossed part, the relief design varies in translucency and creates further shadowings. 'Then,' Frederick says, 'the resulting plain embossed sheet, when held to the light, displays the colour hidden under the surface, reminiscent of the double images of my youth.'

Water-soluble Colorants

Harry Fraser suggests that one way of saving money is by simply staining the surface layers of the body. This can be done by using pigments that are often the chlorides of the colouring element: for example cobalt chloride instead of cobalt oxide.

Being soluble in water, chlorides are drawn with the evaporating water and deposited in the surface layers; thus a much lower percentage of stain needs to be added. Any fettling, trimming or sponging of the surface will cause a shade variation as the surface layer is removed; this can cause either an interesting or an unsightly appearance.

The large '**but**' in this method is that the chlorides tend to be much more poisonous and need extra care in handling.

Gabrielle Amy Mumford: Using Porcelain Paperclay With Water-soluble Colorants

I have worked on my techniques sculpting the clay body and building up tonal values to create pictorial space; the use of flat, abstract painting, using colorants to subtly build up the colour to function pictorially, followed. This involved using advancing and receding colours in relation to one another to detach images from the picture plane.

Amy Mumford grew up in a pottery: her father and stepmother are both ceramists and also

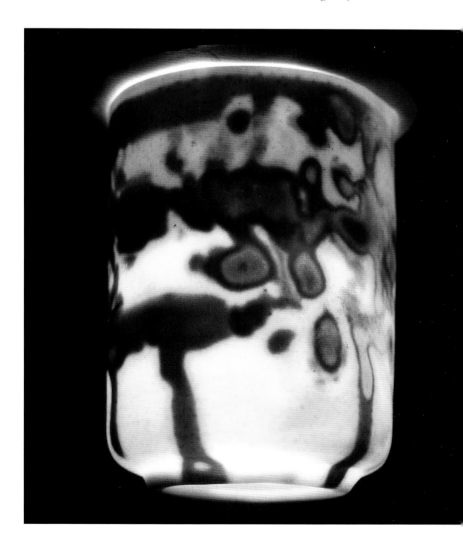

'Vase'. One-piece mould 'jigger' and 'jolly' process; own clay body combined with water-soluble glazes. Gabrielle Amy Mumford (Derby, England).

professional watercolorists, so it was natural for Amy to combine both professions and use water-soluble colouring in her paperclay porcelain. Also, during her five year as a teacher in South-East Asia, Amy observed and learned the use of watercolour dyes on silk and velvet. She has been intrigued ever since by what she describes as 'the effect of watercolour and its capacity to reflect, combined with the quality of surface texture of porcelain with both the green strength and the flexibility of paperclay.'

Working with chlorides has allowed Amy the freedom to paint abstract designs onto paperclay sheets when they are flat and leather hard, before they are manipulated into shape – or they may be kept flat as wall-panels. Her painterly influ-

ences are Kandinsky, Whistler and Andrew Wyeth; her colouring is inspired by Lucie Rie, her forms by Hans Coper. By using chlorides, Amy can put movement into her designs, and this forms her central theme. She describes it thus:

The manipulation of form and colour provoke the eye into unusual states of perception. I am trying to push the use of my current mediums, porcelain and colour glazes, to the limits of their potential … and to go one step beyond what conventional wisdom says can be done.

She was lucky enough to have access to a university chemistry facility where she could experiment with soluble chloride glazes. But she warns:

'Light Sculpture No 1'. Hand-built paper porcelain with weak solution of copper chloride. Gabrielle Amy Mumford (Derby, England).

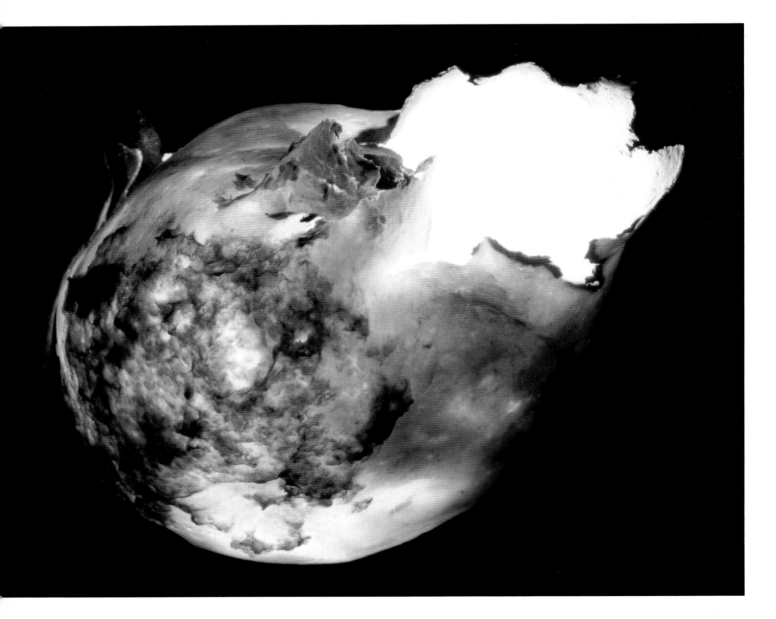

These have the disadvantages of being highly toxic in their raw state. Rigorous chemical lab safety regulations are essential to anyone considering working with such solutions. When ordering chemicals, the company also sends strict material safety data sheets.

METHOD: First the paperclay is prepared (*see* page 133; then very large, flat panels are constructed. The chloride colorants painted on will sink into and become part of the clay body in the upper surface. The porosity of the paperclay makes for interesting effects. Amy finds that her more detailed drawing is better done with iron chlorides 'if you want a sharp line, but more often the colorants will pool and work through the surface. Different translucencies occur, depending on the thickness or thinness of the surface and the lighting behind.'

MIXING:
a. Use plastic implements and containers, as the metal-eroding properties of the solution can contaminate.

TIP

Most of the solutions are very pale in colour in the pre-fired form, and a vegetable-based colour could be used to colour code.

b. Prepare only as much solution as you need (because specialized waste-disposal rules apply). Amy usually mixes about half a pint, depending on the area she wants to cover.

Freshly made solutions produce the best colour. However, this does depend on the chemical:

COBALT CHLORIDE: BLUE, with a tonal range of 5-10-50 per cent. This has a longer shelf-life and does not go off in the short-term, so larger solutions can be made up and kept. It can be used in oxidation and reduction. As cobalt chloride is very strong, beware! If the solution is stronger than the other components, then cobalt will take over and reduce everything to blue; '… but its spreadability makes it great fun to work with!', Amy points out.

COPPER CHLORIDE: PINK/GREY, with a tonal range of 5-10-50 per cent. Beware! Copper used in too strong a solution can cause the clay surface to blister, and can lift the clay during the

firing – unless these effects are required.

COPPER CHLORIDE and **COBALT CHLORIDE** together may produce a brilliant violet in reduction.

IRON CHLORIDE: YELLOW-BROWN, with a tonal range of 15-20-100 per cent.

COPPER CHLORIDE (weak solution) and **IRON CHLORIDE** (strong solution) together will produce green

NOTE: Both the iron and the copper need to be kept airtight and used fresh or they will oxidize.

FIRING: Amy uses both oxidation and reduction processes to produce the desired effects. In reduction, she finds she can get weird and wonderful colours: reds, purples, oranges and so on. And when the shrinkage of the material (which is 33 per cent) occurs, it only enhances the detail and decoration which become finer and more complex, while the colours themselves deepen. The more the clay fuses, the stronger the colouring becomes, and the colorants can operate at high temperatures without glazes. Amy is excited by the opaque/translucent effects which depend on the variation in consistency/thickness with the degree of firing. (Amy fires between 1,280–1,300 °C.) If she linneshes off the surface – uses a machine polisher – thus altering the thickness, then tonal variation will ensue.

Ceramic finishes are matt, but may be linneshed if a gloss is required, which can add extra tonal variation. 'By the way,' Amy advises, 'saggars are best avoided, as their use turns yellow to brown under heavy reduction. But with silver nitrate their use produces anything from dark grey to black.'

Amy is interested above all in the effects of illumination on the special transparent qualities of porcelain, and how this transforms the quality of colour in both oxidation and reduction. 'The colours are amazing,' Amy says, 'and it is difficult to convey them in a photograph.'

TIP

Amy recommends anyone interested in trying out water-solubles to read Arne Ase's *Water-colours on Porcelain.*

'Standing Fish' (height: 109cm/43in). Ewen Henderson (London, England).

Ewen Henderson: Sculpture Using Paperclay, Organic Materials and Different Clays Together

Seek for questions when you make sculptures – not answers.

Ewen thinks of his pieces as fluxed earth, not ceramic, and he derives most of his inspiration from earth-forms. The pieces I saw in his studio look as if they were a combination of coral growing beneath the sea or the result of a combusting volcano. Their roughness also gives them an alien quality, like a chunk of meteorite fallen from Mars, tufa-like in their roughness; and their scale is always a puzzle because, in reproduction, unless the dimensions are given, they seem to defy measurement. Ewen's 'Standing Wall', although in fact about a metre (39in) long and three-quarters of a metre (29in) high, could be hundreds of metres high, a thrust of headland thrown off into the sea, like Durdle Door in Dorset.

Although his output is continuous, he works in 'chapters', each one bringing something new to the next piece. Within these chapters he likes to work on many pieces at once, sharing his prodigious energy equally amongst them.

METHOD: Although they are three-dimensional, it is hard to believe that Ewen Henderson's sculptural forms begin their life flat, like an architect's plan. He will treat a fat layer of paperclay pulp with oxides worked into slips, and these are either painted or printed onto clay sheets in the manner of a monotype, thus making each unique. Although the pieces he is working on are always surrounded by pots of slips, his palette is restricted; sometimes he restricts himself to primary colours, at other times he will be searching for an elusive yellow or a tertiary purple, or will be content to use black and white.

As he works on his paperclay sheets, he may add a thin layer of bone china, or more layers of colour and slip in different stages (but using more paperclay towards the middle), until the treated sandwich of oxides and other base

materials, together with any patterning, is ready to be folded and formed into one of his 'Lazarus Heads' or an 'Arrow of Desire'.

Ewen makes sure that there is 'a different event happening in the inner form as well as on the surface', and it is essential to him that space exists inside his pieces as well as outside. There is never a dull moment in his work: movement, flux and metamorphosis are always occurring, and seem to continue even after the pieces are fired, or refired to make readjustments. For movement as well as space is important.

To create an inner space he may incorporate pieces of twig and organic matter which, upon firing, burn out. This leaves a negative imprint – a tunnel where a marine organism might have burrowed or a bivalve left its fossil-record. Some parts look smooth and gentle like a worn seashell; other areas can be unforgiving to the touch, rough-surfaced like a marine spiky sponge. Ewen likes to experiment, and he says: 'Everything I do is playing around with what you can't do with materials. Fusions of earths, metals and paper give the clay a different molecular structure.'

Going to Ewen's house in Islington, north London, is like walking into a living art gallery. It is an exciting privilege to lift up Ewen's pieces, especially since their weight can often surprise you. Some may look deceptively like weathered bone or volcanic pumice, but if they have a constituent of paperclay, when it is burned away in the first 1,100–1,150°C firing, it not only creates internal volume but also takes away weight – thus it leaves evidence of paper, and keeps its affinity with paper.

By contrast if, for example, the mix contains sirconium (a sand manufactured to withstand the higher temperature of Ewen's second firing of 1,220°C), the piece will be almost impossible to shift. This is because this material, being completely refractory, adds bulk, and the structure will feel more like metal or stone.

Throughout Ewen's work there runs not only a geo-morphology of landscape and earth

'Standing Wall' (100 × 75cm/39 × 29.5in). Ewen Henderson (London, England).

formation, but also a history of human emotion, sometimes monumental in scale. Reminders of early monoliths stand magesterially, often supported on seatings of iron rods. His drawings and paintings similarly reflect such influences, depicting henges and tumuli or drawing their inspiration from areas of landform.

If there is a magician powerful enough to form a modern 'Ring of Megaliths' to go somewhere in Great Britain, Ewen Henderson is the man to build us some standing stones on a chosen area of earth (*see* page 117).

'Connecting Forms' (18 × 20 × 22cm/7 × 8 × 8½in). Emma Vaughan (Denbigh, North Wales).

Emma Vaughan, Sculpture: Buff Paperclay with Inclusions

My work evolves around the theme of nature; research mainly focuses on the textural and structural formation of rocks. I aim not to copy from nature, but to explore and communicate those natural features through ceramic sculpture. ... I hope also to convey the impact that man has on the environment. Our inquisitive minds drive us

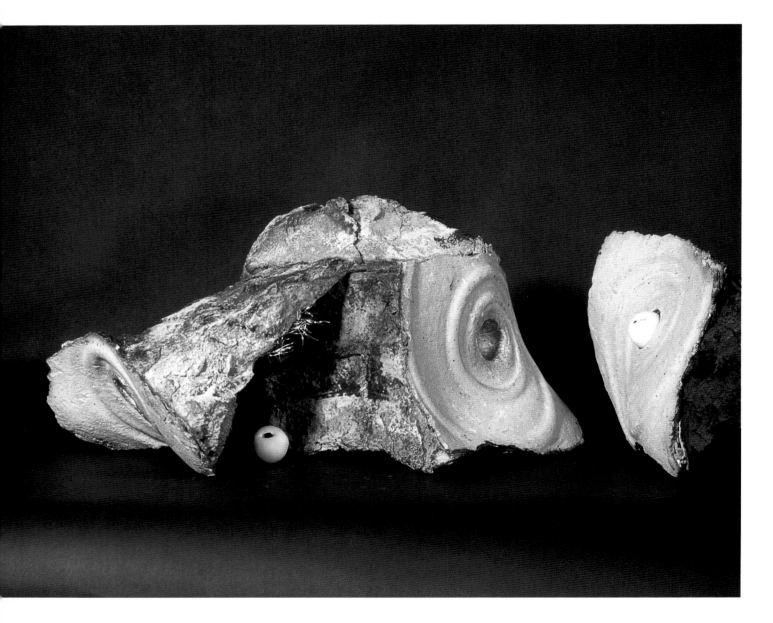

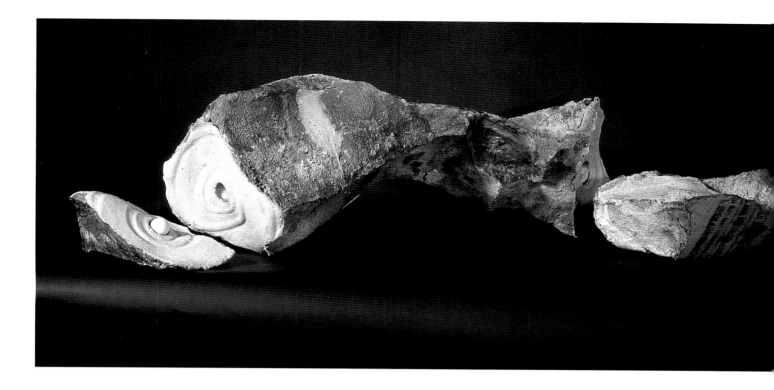

further along the path of discovery, often without a thought for the earth around us.

Coming from Denbigh in North Wales, Emma Vaughan has found that her total philosophy is bound closely with the earth: not only does she live in a landscape which fuels her inspiration, but she makes visits to Snowdonia, and travels farther afield to Derbyshire and Yorkshire, always, looking at 'rock formations' – limestones, gritstone … '

However, her themes are deeper: they encompass the lack of respect we humans have for our planet, the way in which we try to control the earth, but how we may well end up destroying it. She says: 'the meaning is sometimes hidden, sometimes graphic in my pieces, but using print enables me to put messages across. And the lightness that the burning-away paper imparts to the clay gives it a "throw-away" quality that suits the world we now live in.'

METHOD: Emma has been working with paperclay for the past three years, sometimes obtaining it from a factory, but more often soaking it down herself (*see* page 133). She uses colorants in a buff clay (*see* Chapter 4), adding basic oxides to transform the main body, which can produce 'magnificent effects when glaze is applied'. She also uses 'iron spangles and ilmenite sprinkled

into the clay in varying quantities; it gives a natural "rocky" type of effect to the clay. Ilmenite is my favourite as it leaves the fired clay sparkling.' Further various organic materials are introduced to build up texture and create crevices:

> … beans, rice, lentils and suchlike leave interesting holes, and they also leave a little ash behind to add to the glaze. Sometimes I will add my organic material direct to the paperclay slip before drying it in sheets; however, if this is done, it must be done quickly before it decays and begins to smell, which paperclay is known for anyway.

Emma often slab-builds her forms from dry sheets of paperclay, 'bending, breaking, fixing in a haphazard yet controlled way, to create natural shapes in clay.' She has also experimented with printing onto raw paperclay with coloured slips and wax resist to get interesting results, and it comes as no surprise to find that her great mentor is Ewen Henderson.

Emma requires exact qualities for her surfaces, building up texture in layers with coatings of stained slips and glazes. Small amounts of coloured clay are also involved. This soft clay is usually rolled between sheets of plastic until it is very thin, then it is torn and added. Some of Emma's pieces have been partly press-moulded, and slip-cast porcelain shapes may also be

'*Connecting Forms 2*' (80 × 30cm/31 × 12in). Emma Vaughan (Denbigh, North Wales).

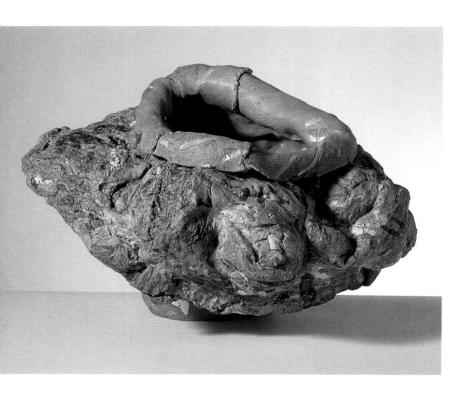

'Flying Rock'. Teena Gould (Carmarthenshire, Wales).

Teena Gould: Sculpture Porcelain, Stoneware, Organic Matter

I use coloured clays in a variety of ways: thin coils which I press onto the surface in linear patterns or as broken pieces; flattened circles which I can tear and apply in different arrangements. Sometimes I mix the coloured clays to a loose consistency which I can smear with fingers or tools.

Teena Gould works with an understanding reminiscent of the seismic variations of a volcano – folding and compressing as well as bubbling and vitrifying. She is clearly a sculptor who becomes wholly involved in what she does, able to put into her work the qualities which inspired her in the first place: the dynamic energy of rock structure, the weathering by water, a fascination with all natural forms. These forces work all around her in Wales; moreover they have taught her that there is endless variety, and need never be repetition.

But Teena knows she would not have been able to work in this way without a considerable bank of knowledge, of technical and aesthetic skill, and judgement: 'Without the exhaustive testing of clays, oxides, glazes and firings I did on my degree course almost thirty years ago', she says, 'I would lack the structure which now enables me to approach my work as if for the first time, and to take risks and experiment.'

A good sculptor is always aware of the internal geology of form, of the tectonics pushing outwards as evidence of inner structure. As Teena says:

> Surface is not sealed skin, but a series of layers erupting from the inner form, creating tension and expression in the very fabric of form. This is one of the reasons I like to work with coloured clay because it is integral with the body and seems to have a kind of integrity with the act of making.

Teena is also a force in her local art community and is the 'artist in residence' at a local school. She exhibits widely, and undertakes many mural and sculptural commissions.

METHOD: Teena constructs her pieces from irregular and patterned slabs or strips of clay.

incorporated. All these techniques are finally brought together to create a piece of work where several forms connect in a specific way. She describes her recent work thus:

> Fake rock structures that segment to reveal an alien fossil, like an interior which accommodates a porcelain sphere. The sphere represents the origin of life, the single cell, but on closer inspection it can be seen that the spheres have pitted surfaces. Thus these precious surfaces that should be protected from harm by the rough, rocky exterior, have in effect rotted from the core.

FIRING: Work is dried slowly, then bisqued, and further stains and oxides can be added at this stage, the glaze is then sprayed and painted on top, after which the pieces are fired to 1,260°C. Emma Vaughan's glazes are usually dry and textured. Barium, for example, will draw colour from the clay during firing, so that coloured clay patches affect the glaze (*see* Chapter 6).

Emma says: 'My work is a part of me which I feel very deeply about.' She urges us to think hard, too: 'Human nature has altered; spiritual has been replaced by material, and I doubt if this will ever change. Nevertheless, people need to get back to their roots a little and sympathize with their environment.'

She likes to use different clays together, such as porcelain with a stoneware body – a variation that will create shrinkage and provide an extra dynamic to her forms. Also she will use grog, sawdust, ash: anything to give texture to the coloured clay. Because she brings to her work what she calls her 'intuitive feel in approach', she has no precise yardstick, say, for choosing amounts of oxide and colouring stains; she writes:

> My method – or lack of it – can be a disadvantage when using strong oxides such as cobalt oxide, which appears delicate at the mixing stage, but bursts into a dominating colour when glazed. But I find that the greater the concentration of oxide, the more short the clay, which I can use to my advantage.

Although Teena Gould's method sits firmly within the ceramic process, she knows that strong elements of it relate to painting. For instance, she prepares slabs by first painting on areas of coloured slips, and then onto this barely dry slip she applies her coloured clays. The slab is then pressed into a textured surface. Now she works on the back of the slabs, pushing upwards and smoothing out to break up the surface, as if she were working underground.

When she has a number of such slabs she starts to construct the form.

Like tough veins of vulcanized rock resistant to being weathered, very thin laminated layers of coloured clay are involved within the slabs. Perhaps Teena may use a strip or coil of yet another coloured clay, folded in 'to achieve a more overall coloration of the form, but which will puncture and break up when the slab is pressed into the texturing form'. This layering and folding is largely unplanned: 'I work with a strong idea of the quality of the piece in hand, attempting to make the work as vivid and powerful as the creative process.'

The transformation of this clay by fire is done mostly by gas and sawdust, which not only achieves combustion of the raw materials, but, through a partly reducing flame, glazes the surface with components from locally gathered and prepared wood ash (*see* Chapter 6). This final transformation and solidification sets and vitrifies the volcanic activity of Teena's work, allowing the expressive movements – the evidence of energetic power shaped by her hands – to be captured and preserved. Her pieces retain the feeling of being freshly folded, not overworked, yet you know that great effort has gone into intense bursts of creative decision: a bit like action painting in sculpture.

'Conversation Peace'. Teena Gould (Carmarthenshire, Wales).

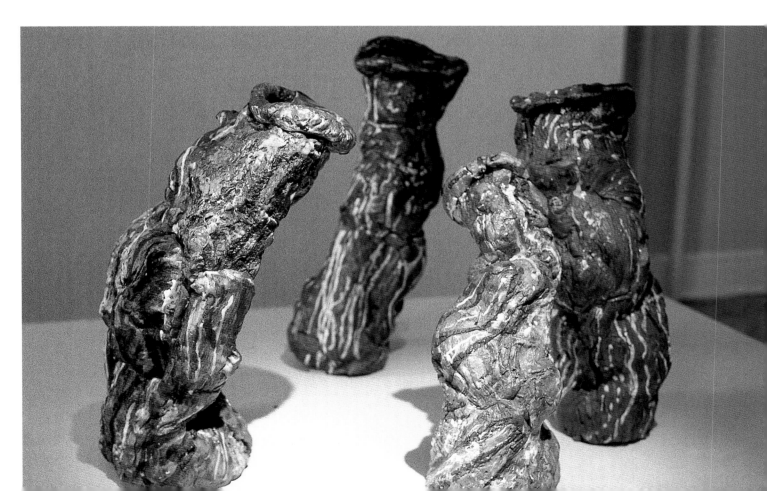

'Rock Slices' (height: 23cm/9in). Teena Gould (Carmarthenshire, Wales).

Patricia Mary Tribble: Sculpture With Inclusions

The ageing process strips away layers to reveal a unique ephemeral beauty and integrity. Surface change in organic matter is a visual indication of the movement of decay within, and may also serve to remind us of our own mortality, which cannot be denied.

Patricia Tribble's sculptural work originated when she was about to paint the Harvest Festival pumpkin, a brilliant golden sphere – but never got round to it:

> The little pumpkin sat quietly fading over a period of at least two years in my kitchen, until the day I picked it up and took a closer look. The colours were faded a soft pinky beige and brown, and the surface was softly rutted and contoured like the skin of a very old person. In my eyes it was a truly lovely thing in its own right.

This exciting transformation changed Patricia's outlook, causing her to research into an area fairly unusual for a ceramic artist. She observes very closely the aesthetic effect of decay upon organic matter: colour fading, structure collapse, textural alteration. In her college days, her colleagues helped out by leaving 'decayed offerings' on her work-bench.

METHOD: To begin with, Patricia constructed a series of pumpkin forms in various sizes – either freehand, or by press-moulding into plaster casts from the real thing. Simultaneously she experimented with different clay bodies: terra cotta, stoneware, porcelain and crank, to which was added perlite, grog (sands), peat, fibreglass, paper, oxides. These were bisqued to 1,040°C and either rakued or smoke-fired. However, Patricia felt that these lacked the sense of frailty apparent with age, so she switched to oxided porcelain and stoneware casting slips, combin-

'Pumpkin Form' (12.7 × 28cm/5 × 11in). Patricia Mary Tribble (Bedfordshire, England).

ing these with fibrous materials such as torn paper, scrim, fibreglass. She added cobalt or manganese into the slip. 'At times,' she said, 'I dipped the actual fruit – rotting pears and apples – into the slip, dried them overnight and re-dipped them the following day.' These were very delicate when fired to 1,240°C, and those which survived were coated with a matt glaze and fired to 1,120°C to strengthen the structure.

One day Patricia broke open a drying marrow form covered with layers of slip with scrim, paper pulp and bits of unfired twigs; 'The outside looked organic and solid in appearance,' she says, 'but breaking it open revealed an interesting inner structure.' Thereafter, Patricia concentrated on the insides: 'I began to create forms more open and fragile, relying on distortion both during the drying period and in the firing to resolve the final outcome. This distortion and re-alignment happens naturally during the process of ageing in organic matter.'

Nowadays, Patricia will make a supporting cone of newspaper strips dipped into a porcelain and stoneware slip. Although the bases are quite solid, the body is open to reveal a more vulnerable inner core and a frayed top edge (made from slip-dipping fibreglass), then it is bisqued to 1,040°C. The oxides used inside – a plum underglaze colour, for example – will look faded by thinning down with water. Diluted surface oxides are also mixed with her matt glaze, with perhaps additional colour involved during two or more firings at 1,090°C. Patricia feels this newer work is nearer to her original aims.

More recently still, Patricia has been reflecting on 'the winter landscape – skeletal trees and hedges, like bones holding residual form – a framework giving a fragmented glimpse into the beyond, which gives me a sense of continuity, of layers'. These pieces include further organic matter: twigs and cuttings from her garden, strengthened with scrim, hessian, paper, fibreglass dipped in slip and oxides – but always adding the earthenware matt glaze at the end, which allows her structures to remain intact, instead of collapsing completely.

Patricia Tribble's explorations into breaking through outer structures to reveal inner decay, together with her understanding of the frail beauty of things as they are transformed into another identity, make her work very special. And when we know that she has experienced the loss of her own (very supportive) husband recently from cancer, her work becomes the more poignant. We have much to learn from her.

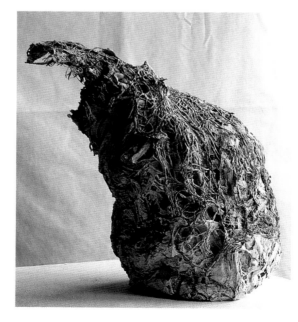

'Pumpkin Form'. Same form as opposite smashed with a hammer: 'I took a hammer to it and disclosed a far more interesting interior form …'. Patricia Mary Tribble (top).

'Curled Back'. Patricia Mary Tribble (middle).

'Garden cuttings'. Patricia Mary Tribble (left).

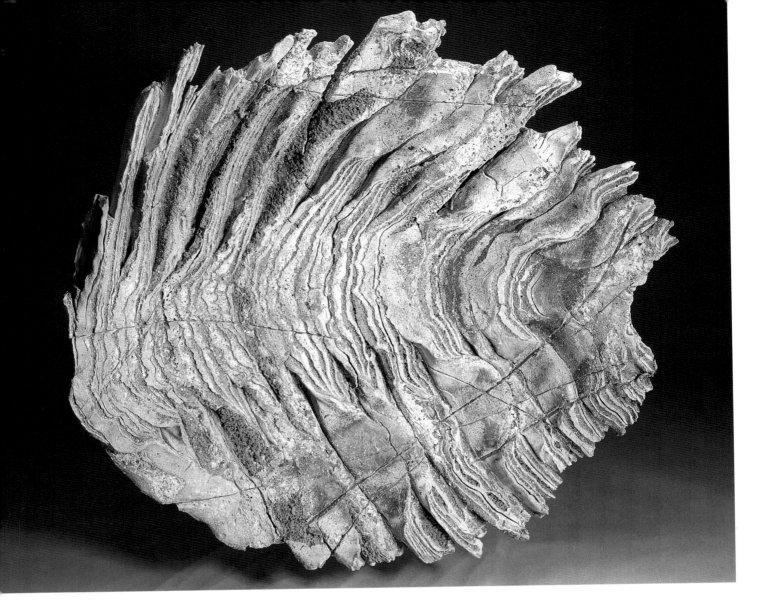

*L*arge plate (width: 140cm/55in). Claudi Casanovas (Catalonia, Spain). (Courtesy: Galerie Besson.)

Claudi Casanovas: Sculpture from Multiple Techniques

I learned about pottery from the wheel. With this simple tool, laden with history and memory, I came to know the waters of the earth, the motion of water, the weight of the earth and the magic that hides all movements of the hand and in a clean, simple, unique form, the same magic inside and out for vase and plate.

Claudi Casanovas produces such extraordinarily beautiful work that I can only write about it poetically. So here is a Claudi poem:

Claudi's Sculpture is

Packed and flaked, furrowed and folded,
Crinkled with age, yet freshly-squeezed;
Dancing with geology,
A fluid poem of earth
Caught haywire in mid-metamorphosis.

Claudi Casanovas lives and works in Spain, in Riudaura, near Olot in Catalonia. At first he studied drama, but he soon progressed to delivering his dramatic effects through ceramics. Everything he makes seems to be successful – though Tony Birks does point out, in his book on Claudi, that two 'massive desolate skips stand near his studio to collect the remains of objects either blown apart or below expectations!' However, since Olot is the centre of a volcanic basin, some explosions should be expected, and pieces regurgitated and given back to the ground.

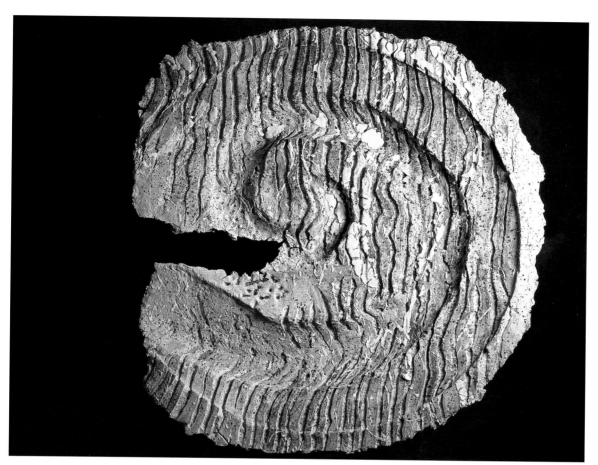

*L*arge wall plate; stoneware (width: 106cm/42in). Claudi Casanovas (Catalonia, Spain).

METHOD: Claudi's sculptural vessels are formed using a local mixture of clays, from the Garrotxa region – but there is also some stoneware clay imported from France. He uses many techniques: moulding pieces with steel, plaster, resin, plastic; using polystyrene cores (which are later dissolved so that the drying pieces do not crack when shrinking against them); or carving into the clay surface with roulettes.

He puts an intriguing range of components into the body: not only metal oxides and narrow strips of laminated colour, but also metal itself, together with all kinds of organic ingredients: straw, dung, rice, maize stalks – even flour, as though he were making bread! And what an adventurous mixture emerges from his wood-reduction firing, as happily and fresh as a new-baked loaf, with crevasses and cracks caused by the combusting materials as though the work had been channelled through with yeast.

His sculpture has much surface excitement. He may, for instance, spray on oxides between two firings, add further texture by sand-blasting,

or allow a little external dry engobe to curl off in an occasional playful exfoliation. But such choices never lead to a loss of inner strength, or the sacrifice of an internal spiralling balance if the pieces have been partly thrown.

Claudi Casanovas is inspired by a Japanese friend and thrower, Ryoji Koie, in whose studio at Mino he worked for some time. Having left the wheel for fifteen years, Claudi has returned to it again. Ryoji, he says, taught him another way with the wheel:

> The flow of the clay that never ends, turning, turning, that never closes into a circle, that ascends and opens, spiral upon spiral; the spinning clay of fun, mischief-making, joy, mistakes, lightness, surprise and freedom. The living, not the ideal.

Claudi is much loved not only in Spain but world-wide, and it is always a treat whenever there is a new exhibition and therefore new work to enjoy. Here are a few examples to smile over: 'Pieces almost found rather than thrown' (by courtesy of Anita Besson at Galerie Besson).

Group of tall amphorae; laminated stoneware. Claudi Casanovas (Catalonia, Spain).

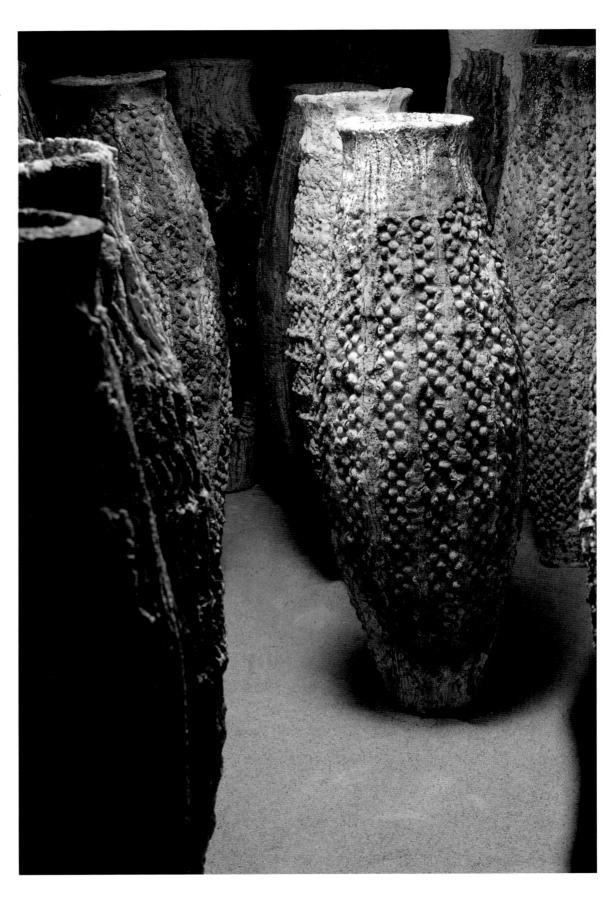

Supplier Information

Great Britain

Fibre in Clay
Cut Polyester Fibre
Pennine Fibre Industrial Ltd, New Mills, Denholme, Bradford, Yorkshire BD13 4DN.
N.B. The smallest amount they will supply is 5kg (approx. a binliner full). £17 per kilo plus carriage, which is enough for a ton of clay, so this could be shared!

Surfacing Fibreglass Tissue
Glasplies, 2, Crowland Street, Southport, Lancashire PR6 7RL.

Paper Clay Products, The Blacksmith's Shop, Pontrilas, Herefordshire HR2 0BB.

A Good Photographer
Crispin Thomas, 16–24 Underwood Street, Shepherdess Walk, London N1 7JQ. Tel: 0171 490 1960.

Pure Pigments
Ewen Henderson recommends a good source:
AP Fitzpatricks, 142, Cambridge Heath Road, Bethnal Green, London E1 5QJ. Tel: 0171 790 0884.

Roderveld (work tables and slabrollers), Unit 9, Crispin Industrial Centre, Angel Road, Works, Edmonton, London N18 2DT. Tel: 0181 803 1016.

Ceramic and Glass Supplies
WG Ball Ltd (Ceramic Colour, Glaze and Raw Materials), Longton Mill, Anchor Road, Longton, Stoke-on-Trent ST3 1JW. Tel: 01782 313956 or 312286.

Bath Potters' Supplies, 2, Dorset Close, Bath BA2 3RF. Tel: 01225 337046.

Johnston Matthey Ceramics & Materials Ltd, Woodbank Street, Burslem, Stoke-on-Trent ST6 3AT. Tel: 01782 524949. Fax: 01782 524950.

WJ Doble Pottery Clays, Newdowns Sand and Clay Pits, St Agnes, Cornwall TR5 0ST. Tel: 01872 552 979.

ECC International (for clays), Whitfield and Sons Ltd, Lakeside Festival Way, Festival Park, Stoke on-Trent, Staffordshire ST1 5RY. Tel: 01782 219933.

Potclays Ltd, Brickkiln Lane, Etruria, Stoke-on-Trent, Staffordshire ST4 7BP. Tel: 01782 219816.
Harry Fraser recommends any of the white-firing clays for staining, such as the smoother, ungrogged ones which give an even tone, 1141, 1142, 1106 and 1123. The ones with sand or molochite addition, 1106, 1106–30, and 1141–3, may give a somewhat speckled appearance. Colour additions into the buff bodies or the red clays will be modified by the natural fired colour of the body. If you want a dark brown or black colour as a base for an earthenware, it would be much cheaper to use a red clay (such as 1137) as a base since the natural fired colour of the clay does half the job for you. The 1131 clay family gives very good dark rustic red-brown colours in the range 1,170 to 1,230°C and rich red brown or purple brown from about 1,220 to 1,260°C. Gerstley Borate is also available from Potclays.

The Potters' Connection Ltd, Dept C, Longton Mill, Anchor Road, Longton, Stoke-on-Trent, Staffordshire ST3 1JW. Tel: 01782 598729.

Potterycrafts Ltd, Campbell Road, Stoke-on-Trent, Staffordshire ST4 4ET. Tel: 01782 746000. (Call for regional supply addresses.)
They recommend a range of clays to try from warm toasted buffs through to white: P1360; P1565; P1566, P1480; P1482.

Scarva Pottery Supplies & Mason Colours
10, Drummiller Lane, Scarva, Co. Armagh BT63 6BR. Tel: 01762 831864. Fax: 01762 832135.
They recommend Valentine's P2 Porcelain for millefiori and jewellery work. Earthstone Smooth Textured and Handbuilding bodies – like Earthstone F, a very plastic earthenware body – are ideal for larger work. Earthstone Handbuilding is an excellent T material type body. Two white sculptural bodies which are very suitable for Raku are Earthstone 20 and Earthstone 40 (like T material but giving a better glaze fit). Their oxides are recommended for adding 5–10 per cent to dry clay. They also have a new range of American Mason stains, and a translucent semi-matt glaze firing to 1,080°C.

Sneyd Oxides Ltd, Sneyd Mills, Leonara Street, Stoke-on-Trent, Staffordshire ST6 3BZ. Tel: 01782 577600.

Alec Tiranti Sculptors' Tools and Materials, 27, Warren Street, London W1.

Valentine Clay Products, The Sliphouse, Birches Head Road, Hanley, Stoke-on-Trent, Staffordshire ST1 6LH.

Watts Blake Bearns & Co. PLC, Courtnay Park, Newton Abbot, Devon TQ12 4PS.
For ball and china clays and prepared bodies.

Degg Industrial Minerals, Phoenix Works, Webberley Lane, Longton, Stoke-on-Trent, Staffordshire ST3 1RJ. Tel: 01538 752 2936
For oxides.

The London Potters, 105, Albert Bridge Road, London SW11 4PF. Tel: 0171 228 7831.

Periodicals and Magazines
Ceramic Review, 21, Carnaby Street, London W1V 1PH. Tel: 0171 439 3377.

Crafts Magazine, The Crafts Council, 44a, Pentonville Road, London N1 9BY. Tel: 0171 278 7700.

USA

Amaco American Art Clay Co., 4717 West Sixteenth Street, Indianapolis, Indiana 46222.

Art Studio Clay Co., 1555 Louis Avenue, Elkgrove IL. 60007.

Cedar Heights Clay Co., 50, Portsmouth Road, Oak Hill, Ohio.

Ceramic Supply of New York and New Jersey, 7 Route 46 West, Lodi NJ 17644.

Continental Clay Co., 1101, Stenson Boulevard NE, Minneapolis, MN 55413.

Del-Vel Potters Supply Co., 7600, Queen Street, Wyndmoor PA 19118.

Ferro Corporation, PO Box 6650, Cleveland, Ohio.

Mason Colour and Chemicals, PO Box 76, E. Liverpool, Ohio 43920.

Pemco Products Group, 5601 Eastern Avenue, Baltimore, Maryland 21224.

Randall Pottery Inc. Box 774 Alfred, New York, NY 14802.

Periodicals and Magazines
American Ceramics, 15, West 44th Street, New York, NY 10036.

Ceramics Monthly PO Box 6102, 735 Coramic Place, Westerville, Ohio 43086–6102.

Canada

The Pottery Supply House, Box 192, 2070 Speers Road, Oakville, Ontario L6J 5A2.

Plainsman Clays Ltd, Box 1266, Medicine Hat, Alberta T1A 7M9.

The Green Barn Potters Supply, PO Box 1235, Station, Surrey, British Columbia.

Blythe Colours Ltd. Toronto.

Ferro Enamels, 26 David Road, PO Box 370, Oakville Ontario.

Australia

Claycraft Supplies Lty Ltd, 29, O'Connell Terrace, Bowen Hills, Queensland 4006.

Claymates Pottery Supplies, 120 Parker Street, Maroochydore, Queensland 4558.

Clayworks Aust. Pty Ltd, 6 Jonston Court, Dandenong, Victoria 3175.

Jackson Ceramic Craft, 94 Jersey Street, Jolimont, Western Australia 6014.

Mura Clay Gallery, 49–51, King Street, Newtown, New South Wales 2042.

Northcote Pottery, 85A Clyde Street, Thornbury, Victoria 3071.

Potters' Equipment. 13/42 New Street, Ringwood, Victoria 3134.

The Pottery Place, 171 Newell Street, Cairns, Queensland 4870.

Pug Mill, 17A Rose Street, Mile End, S. Australia 5031.

Quinja Warehouse, 10, Ern Harley Drive, Burleigh Gardens, Queensland 4220.

Sovereign Ceramics, 502, MacArthur Street, Ballarat, Victoria 3350.

Periodicals and Magazines
Ceramics: Art and Perception, 35, William Street, Paddington, NSW 2021.

New Zealand

Bernies Clay Co. Ltd, Winchester-Hanging Rock Road, RD2, Pleasant Point.

CCG Industries 33, Crowhurst Street, PO Box 9523, Newmarket, Auckland.

Coastal Ceramics, 124, Rimu Road, Paraparaumu.

Cobcraft Supplies, PO Box 32024, Christchurch.

Potters' Clay (Nelson) Ltd, PO Box 2096, Stoke Nelson.

Southern Clays Ltd, PO Box 6323, Dunedin.

Waikato Ceramics, PO Box 12071, Hamilton.

Wellington Potters' Supplies, 2, Cashmere Avenue, Khandallah, Wellington.

Periodicals and Magazines
The New Zealand Potter, New Zealand Publications Ltd, PO Box 881, Auckland.

South Africa

Gillian Bickell Potteries, Old Pretoria, Krugersdorp Road, Milgate Agricultural Holdings, Northern Metropolitan Structure, Box 68624, Bryanston 2021, Transvaal.

The Clay Pot, 374, Louis Botha Avenue, Maryvale 2192, Box 51151, Raedene 2124, Transvaal.

Edgeware Ceramics (Pty) Ltd, 139 Old Main Road, Pinetown 3600, Natal.

Ferro Industrial Products, Box 108, Brakpan 1540 Transvaal.

Potters' Supplies and Mail Order (PSMO), PO Box 39, Henley-on-Klip 1962, 62 Kroonarend Road, Randvaal.

Reindeer Potters' Suppliers, Industrial Avenue, Kraaifontein Industria, Box 194, Kraaifontein 7570, Western Cape.

Other Ceramic Periodicals and Magazines (which will Include Ceramic Supplier Addresses)

Denmark
National Committee Denmark, c/o Dalhoff Larsens Fond, Gl. Kongevej 124, IV, DK-1850 Frederiksberg C. Tel: (+45) 31 316 126. Fax: (+45) 31 318 536.

France (and news of European potters)
Revue de la Ceramique et du Verre, 61, rue Marconi, F–62880 Vendin-le-Viel.

Germany
Neue Keramik, Unter der Eichen 90, D–12205 Berlin.

Keramik Info, Bienstrasse 31, 76530 Baden Baden.

Keramik Magazin, Rudolf-Diesel-Strasse 10–12, Postfach 1820, 5020 Frechen 1.

Greece
Kerameiki Techni, PO Box 80653, 18510 Piraeus.

Netherlands
Glas en Keramiek, Antwoodnummer 1516, 5720 XZ Asten.

Keramikos, Prinses Beatrixplein 24, 2033 WH Haarlem.

Spain
Ceramics, Apartado de Correso 7008, Pasoe Acacias 9, Madrid.

Buleti Informatiu de Ceramica, Sant Honorat, 7, Barcelona 08002.

Index

Materials, Techniques and Suppliers

Main entries are in **bold**.

Names